D1472877

A Nation
Lost and Found

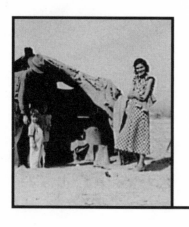

A NATION
LOST AND FOUND

1936 *America Remembered*
by Ordinary and Extraordinary People

Frank Pierson and
Stanley K. Sheinbaum

Edited by Mamie Mitchell

Tallfellow Press
Los Angeles

2002

Copyright © 2002 by Tallfellow Press, Inc.
All rights reserved.
No part of this publication may be reproduced,
stored in a retrieval system or transmitted in any
form or by any means: electronic, mechanical,
photocopying, recording or in any fashion
whatsoever without the prior written permission
of the Publisher.

Published by
Tallfellow Press, Inc.
1180 S. Beverly Drive
Los Angeles, CA 90035

Designed by SunDried Penguin Design

ISBN 1-931290-04-0

Printed in the United States of America
by Berryville Graphics

1 2 3 4 5 6 7 8 9 10

CONTENTS

THE OLYMPICS

THE HOLOCAUST 139

INTRODUCTION

———◇———

TODAY

When airplanes full of passengers were converted into missiles and flown into the World Trade Center time stopped, the thread of life was broken. Nothing, it seemed, from that time on would ever be the same. The future held its breath.

It was not the first time this has happened. The day Lincoln was shot "the solid earth seemed to bleed," a contemporary wrote. Black Tuesday, 1929, when Capitalism collapsed—that day cannot be forgotten by those who experienced it. The attack on Pearl Harbor blew to pieces the complacency of Americans safe in our island between two oceans. The assassination of Kennedy—who alive then does not remember with crystalline clarity the events of that day? After days like that, life is perceived in different colors; they are days when we reassess ourselves, change jobs, ask questions to which we thought we always knew the answers.

Then life slowly returns to normal. But what *is* normal is not the same as what *was* normal.

The "normal" we returned to after the collapse of 1929 was The Great Depression, a ten year economic ice age that left no one untouched. For even the wealthiest and most secure, "normal" became something else. Were there lessons from that time, that could apply to our current state of mind? It's too early to tell, and each of these shocks occurred to a nation at a very different point in history and in a different state of mind.

1929

America was riding "higher than ever in history," the President said, "on a wave of boundless vision, hope and optimism." Millionaires were minted overnight, the rich were getting richer, the middle class owned their homes and drove cars, the poor had hope. And America was happy.

Within a year of that President's ebullient statement the nation's banking system failed, a quarter of the population was out of work, the middle class was all but wiped out, factories shut down. The Great Depression had begun. Strikers and company goons fought in the streets with guns and tear gas. Starving people with crippled dreams and wildly idealistic hopes and schemes set out against an entrenched, powerful and frightened wealthy class, who saw their world about to be toppled into anarchy. Comparisons to France of the revolution were in everyone's minds. Rebellion was in the air, bank robbers like Dillinger and Clyde Barrow were pop icons, prison movies in which the stars were the prisoners and the cops not even supporting roles made Warner Brothers rich. Sympathy for the underdog was part of the new normal.

And life changed in very real ways. For most Americans alive now the kidnapping of the Lindbergh baby in 1934 has been forgotten, or was never known. But at the time, the idea that a child of privilege should be stolen and killed was an event that stopped time for the American wealthy class. They were already shaken by the economic and political devastation around them, and now the rich felt for the first time personally at risk. Old money began to hide. Gone was the flaunting of privilege and conspicuous consumption of the Roaring Twenties. The really rich began to drive Pontiacs and Oldsmobiles

instead of Rolls Royces and Cadillacs. For the most part they still do, only the Pontiacs are now the anonymity of SUVs. It was one example of lasting change from a social trauma. A new normal.

For most of the rest of the population the new normal was simply a daily battle for survival.

1936

This book began with a letter from a friend, Stanley Sheinbaum, recalling his adolescent encounter in 1936 with the just completed Empire State Building and Presidential Candidate Alf Landon. I (Frank Pierson) was amazed to discover I had lived in New York at the same time and there was this unknown *doppelganger* who was living through the same events and walking through the same places as I had, but seeing and experiencing them from a wildly different perspective.

I was from a WASP family that had lost its money and luck but not its pretensions and good opinion of itself; he was from a Jewish family lurching from bankruptcy to bankruptcy. Both of us sold the *Saturday Evening Post*, for a nickel, out of a canvas bag provided for the purpose. For both, the election of 1936 was a special event—he because he got a ride in a parade up Fifth avenue with the Republican candidate for President, I because my mother briefly got a job typing letters for Eleanor Roosevelt.

His letter was a sort of Proustian Madeleine transporting me back to a past I had lost the habit of thinking about. To most of us who lived through the Depression, memory is more than anecdote or family stories; memory is embedded as deep as instinct, as when—without thinking—I turn off lights when I leave a room, turn down

the heat at night, save money in bonds and utilities, distrust banks and avoid risk. I wrote Stanley a letter in return which became the opening piece (page 15). We began to write to friends, and then friends of friends, and finally strangers, searching further and further to extend our common view of that critical period that is fast receding over the horizon from living memory into history. The result is this collection.

President Roosevelt and the New Deal put in place safety nets for the poorest and a vast employment scheme under federal programs that eventually gave jobs to some 11 million people. They planted trees, built roads, post offices, schools, dams, painted murals, put on plays and operas. Hope began to dawn that we could avoid a revolution, for millions had turned to Socialism or Communism as a solution to the failure of unregulated Capitalism. But even as dawn light shone, a dark shadow passed over Europe—Hitler's dream of a thousand year Reich. Within three years, World War II would begin, and in becoming the Arsenal of Democracy, arming the world, America would at last reach full employment and the Great Depression would end.

This book is our attempt to give voice to the generation that endured both the Depression and World War II, a generation that first lost and then saved the world. It is not history that pretends to analyze and explain these events. It is the collective voice of survivors, with the benefit of 60 years of hindsight. Their memories are mingled with the voices of those long gone, who spoke out at the time to writers sent out by the hundreds by the W.P.A. writers' project. That Federal project gave jobs to journalists, novelists, poets, to document the lives of ordinary people. It was an extraordinary program—their voices wait to speak in the Library of Congress.

Among the survivor contributors are well known names—
Tom Wicker, Shirley Temple Black, and Leah Rabin, Dr. Ruth
Wesstheimer, Nobel prize winner Glenn Seaborg and many others,
whose stories and memories merge with the forgotten, to call out to
us from the past and present. What is remarkable and uplifting in
these stories is the way in which everyone soldiered on, never gave
up. Some danced to music of denial, others grew angry and bitter,
some fought, nobody seemed to give up. That was what was so
remarkable—the indomitable spirit, refusal to accept despair or failure.

Is there wisdom in this? Something to be learned, so we can
avoid the same mistakes that brought down the sky? I don't know.
That is not the purpose of this collection. We thought it best to
leave analysis, the allocation of blame, and suggestions for the future
to the reader. We are not historians nor political scientists, and the
attempts of the amateur to dig for truths in the ruins of this history
would be presumptuous, and our conclusions probably wrong—just
as wrong as the experts who fail us with such regularity. We simply
found ourselves—as revealed here—to be interesting and different in
how we handled the difficulties of the times.

It is a book assembled most unscientifically, without regard to
politically correct demographics. If this were formal history there
might be better balance, but we drew from the sources available
to us.

The book is meant to be browsed at random. In that sense it
is perfectly post-modern, in providing no narrative, leaving each
reader to find in it his or her own story that draws together these
disparate accounts.

What was happening in 1936 is not over. The same wars over ideology, race, Darwinian survival versus safety net, the privileges of the rich and the suffering of the poor, are all still being fought. All those divisions are still between us, though the names of things have changed—"capitalism" is now "free market economy," "relief" is now "welfare," but we still have no universal health insurance, and blacks continue to suffer the wounds of our national history.

We still seek bridges and solutions, but not in the dramatic and forceful way we did in the 1930s.

The conscious memory of us survivors is steeped in the pain, confusion and sweet hope of it all, and from where we sit, half a century on, we are still wondering where it will all end.

Frank Pierson
September, 2002

Frank Pierson is an Academy Award-winning screenwriter (Dog Day Afternoon), a veteran of combat in World War II and current president of the Academy of Motion Picture Arts and Sciences.

"Never learn to type," Mother *said. "Once they find out you can type, they never let you do anything else."*

———————◇———————

In 1936 my mother, father, sister Louise and I were living in a fifth floor walk-up at 643 Hudson Street, Manhattan, in five unheated rooms. I don't know what my father was doing that year. A close-mouthed man in any case, he didn't like talking about the work he didn't get and even less about the work he was able to get. He was 48 that year, and though he'd gone to Cornell to study engineering, he had run away with the soprano of a traveling musical (*The Red Mill* it was) instead of graduating, so he was without a college degree. The family's rose business went bust in 1928—he was fond of saying we were ahead of the times—and after going stone broke operating a combined drugstore/gas station/restaurant and nightclub in Orleans on Cape Cod, he and my mother went back to New York, where she got the only reliable employment they had during those years, on Relief.

In those days Relief required work and she was a fast typist. She had gone to Simmons College for Young Women, studying to be a secretary, after her father, the president of the Quincy Bank, died and turned out to have no money at all. She believed my grandmother's story that he had co-signed worthless notes that consumed his estate. The fact was, as we were not to learn until almost a hundred years later, he had embezzled from his own bank. To protect the bank from public disgrace, my grandfather was allowed to spend the remainder

1

of his life sitting in his great office, being paid his salary, but was not allowed to sign anything. For this he bargained away his estate, leaving his widow penniless.

They had lived in a large house with five servants, where my grandmother patrolled with a feather duster, keeping the cats awake because she couldn't bear seeing anything sleep in the daytime. After my grandfather died, my grandmother was supported by her two daughters, whom she had brought up to seek only a marriage into privilege. She seemed to go deaf whenever the subject of them working was discussed; it was beyond her imagination.

Mother determined never to be dependent on anyone again; she went to Simmons and learned to type. In later years she deplored the decision. "Never learn to type," she said. "Once they find out you can type, they never let you do anything else." But in 1936 typing kept us alive. She was assigned by Relief to work at the headquarters of the Democratic National Women's Committee during the campaign, where she was put to work typing letters, among them correspondence for Eleanor Roosevelt's signature.

I was 11 in 1936. When we moved to Hudson Street my job in the winter was to find broken wooden crates along the waterfront wharves and bring them back to the walk-up to burn in the fireplace–our only heat. Our clothes were bought at church rummage sales. My mother's patrician tastes, combined with her absolute disregard for anyone else's opinions and public attitudes, led to some bizarre results. The jodhpurs were the worst–she had paid for them and I was damn well going to wear them.

2

I walked every school day from Hudson and Horatio Streets down and across Christopher Street (then still loud with pushcarts and vendors yelling in several languages) past the Catholic school that served the Italian district, underneath the Sixth Avenue El to the Little Red Schoolhouse, a private school operated on advanced principles that was partially subsidized by the city. The jodhpurs inspired the Catholic kids to new heights of imaginative violence.

Mother had no sympathy for my welts and bruises; this was what life was like, and I would just have to learn to take it or do something about it. She didn't know those mean little Italian bastards. Their favorite weapon was an old silk stocking with flour in it. It not only hurt when it hit right, but the flour was driven into the fabric of whatever you were wearing and wouldn't come out until the third or fourth washing. I did something about it. I took a shit in the jodhpurs and left them where Mother would find them. Nobody ever mentioned them again.

Though we were poor, we never felt poor. Hungry sometimes, embarrassed by our threadbareness sometimes, but poor? No. Poor was a state of mind that had nothing to do with lack of money. Nobody in our family was poor, no matter how little money we had. While we scraped by on public assistance in 1936 my brothers were working their way through Yale on scholarships. The old family social connections still worked for our education; Mother's and Pop's old school friends and relations wouldn't give them jobs and (literally) slammed the door on them socially, but they could and did arrange for us children to go to the best private schools and for the scholarships to make it possible.

My first school in Manhattan was P.S. 64 (I think that was the number) next to the Women's House of Detention in Greenwich Village. I had a handicap that nobody paid much attention to until I was stabbed by another student. Then it was drawn to everyone's attention that nobody could read what I wrote.

My very first school was on Cape Cod, in the four rooms that housed the first four grades, where I sat bored and distracted day after day until the morning that I can still remember—diamond-sharp edges, sunlight and brightness filling the shadows. To pass the time, and out of curiosity, I tried writing so it could be read in a mirror. I swiped the mirror our classroom used as the frozen pond upon which Pilgrims and their Indian guests would skate in our classroom replica of the Pilgrims' first Thanksgiving.

It worked right away; unfortunately from that time forward I was able to do nothing else. Even reading became difficult; b's and d's looked identical, and the number 3 always seemed reversed. So, as we moved every year from one place to another following rumors of employment, in each new school the teachers tried some new way of teaching me to write so they wouldn't have to use mirrors.

After the stabbing (as I write I look for the faint trace of blue ink under my skin—an old-fashioned nib pen was the weapon—but time has at last erased the wound) I was sent to a Settlement House near Washington Square where batteries of tests were administered. A program left over from the Settlement House's early days, when it served the needs of Jewish immigrants crammed into the slums of lower Manhattan, was aimed at finding and assisting bright and needy children among the poor. That was in 1900. In 1936 it singled me out to go to the Little Red Schoolhouse on full scholarship. My

mother was ashamed of accepting help from such a source, but I only understood the nature of her anti-Semitism many years later.

I spent 1936 running away from the Catholic kids and making ceramic ashtrays. I'm not sure the Red Schoolhouse's progressive methods used books—I never saw any there. But they had kilns. The new teachers set out to teach me to print instead of writing longhand. They still needed mirrors.

In the Little Red Schoolhouse my best friend's father was not only Jewish, he was a Communist. His family lived in clean and well-lighted symmetry that I only realized in later years was Bauhaus Deco. It seemed queer and heavenly, suggesting the possibilities of whole new worlds. His mother was beautiful and young. They took me to march with them in the May Day parade of 1936. The sheer size and force of it, the river of people pouring down Fifth Avenue as far as you could see, uptown and downtown and from curb to curb, people throwing down confetti, and good feeling running like sweet fire through the marchers made me cry with pride.

The game Monopoly was new that year. It never struck me as odd that we played Monopoly in that elegant outpost of protest against Capital.

His father went away to Spain to fight fascism and never came back.

Pop must have worked in 1936 because when Mother went to work at the Democratic National Women's Committee she often worked late, and with Pop not being present I was given a quarter for dinner. I went to the German bakery on Hudson Street, where I had pork chops, mashed potatoes, peas, gravy, applesauce, a kaiser

roll, a glass of milk and a piece of apple pie for the 25 cents, which included a generous tip. The German couple who ran the bakery were okay with my parents, though the distant thunder of the coming war was welcomed by my father.

When World War I started in 1914, my father drove a Stutz Bearcat (given to him by *his* father) to Toronto and left it in the street to volunteer. He fought for four years in the British army (abandoning not only the Bearcat but the soprano and their baby, my half brother). In 1936 he felt much like some now feel about the Gulf War—we just didn't finish what we started, and Pop looked forward to finishing it. He was bloodthirsty about it. My mother showed me his medals and uniform and the rusty old helmet and gas mask that smelled like my brothers' football uniforms. But when I saw photographs of soldiers dying (Capa's famous picture in the new *LIFE* magazine of a charging soldier, his scalp flying away from a rifle shot) my mother and father both tried to convince me that the soldier doing the shooting had missed, because in war you just shot near the other side and tried to scare them off. But by 1936 I knew when they were lying.

When the Germans marched into the Rhineland, Mother and Pop were grimly silent. Mother cried. She quoted Lord Grey, who said, as England declared war in 1914 and he watched a lamplighter extinguish the street lamp outside 10 Downing Street, "The lights are going out all over Europe, and they will not be relighted in our lifetime." Her reading was dramatic, and I believed her. Her lifetime. But in ours? Is there a dim light by which we can see our shadow?

At the Women's Committee they had discovered my mother had a knack for writing pungent letters. Now she was composing as well as typing, including occasional letters for Mrs. Roosevelt. She told me

that before anything was said in the ladies' room everyone looked under the stall doors to check for Mrs. Roosevelt's big feet. Cardinal Mundelein was the Catholic presence in Chicago in 1936; he was anti-Roosevelt and anti–New Deal. A misunderstanding led to an exchange of press releases between the president and the cardinal, which led high-level Democrats to worry about Catholic voters who had not forgotten their Al Smith, who was by now supporting Alf Landon against FDR.

Mother was called upon by her old friend Harry Hopkins to help, as time was short and everyone else was busy: an exchange of letters between the cardinal and FDR ironing out the differences—or at least papering them over—was arranged. My mother wrote both letters, which were signed by the cardinal and the president and then released to the press.

We noted the irony when FDR won by a landslide, the Democratic Election Committee was disbanded, and Mother went back on Relief.

Grover Whelan, New York's official greeter, whose job until then had been meeting celebrities at train stations and airports with the key to the city, was already fronting for the New York World's Fair of 1939, which was really an excuse for Robert Moses, the parks commissioner, to bulldoze and build more of his dream city on the rubble of the old. Pop, with his background in raising roses and with some help from the Democrats, was promised a job planting trees in the gigantic dump that was the site of the World's Fair. Thus in 1936 the end of our nomadic existence was near.

My sister Louise—nine years older than I—had been paralyzed with polio since the age of four. In 1936, Sister Kenny's massages,

electric shock to stimulate atrophied muscles, psychics, Chinese herbs and mysterious card games played by Mother to coerce the heavens and the stars had all failed to give her the ability to walk. Mother found an experimental muscle- and nerve-transplant program at the Bellevue Hospital, where Louise spent months in agony, all useless. I went there past the rows of the poor and homeless who faked their way in among the sick and dying to escape the streets and the Hoovervilles to sit with her. The tall white rooms with their 30-foot-high windows looked like the illustrations from Civil War books I found in the library and the accounts of the Crimean War and Florence Nightingale. 1936 seemed close enough to merge in memory with 1836, 1863. We didn't seem to be getting anywhere despite the signs and portents.

I often spent days riding the subway lines, standing in the front car beside the motorman, watching the shining rails stretching away before us. I wanted them to go on forever and never get to the end, but we always did.

Then, as the motorman locked up his little steel cabin and walked back to the rear of the train, I followed. They never said much to me. When we got to the back of train, which now became the front, I took up my post and we glided, rattled and shrieked and groaned our way to the other end of the shining railroad tracks. Then we started all over again.

1936 was like that—all false starts, mistaken impressions, confusions, contradictions, truth and lies mixed together with no clear direction or way out. None of us felt the earthquake that was moving beneath our feet.

Col. Barney Oldfield,
USAF (Ret.), is a native
Nebraskan and former
corporate director for
international relations for
Litton Industries. He is the
founder of the Nebraska
Dollars for Scholars Program
and the Vada Oldfield
Alzheimer's Research Fund at
the University of Nebraska.
He worked as a film and
entertainment writer.

*"Politics was a very intimate
thing. All the devils were real."*

———————◇———————

1936 was the beginning of
everything. Most people
weren't aware of it. I was
working on a newspaper called
the *Lincoln Journal* in Lincoln,
Nebraska. I was being paid the
marvelous sum of $14 a week,
which was not bad in those days.
The year before I had gotten
married and when you get married
on $14 a week you've got to be
the world's greatest optimist.

About that time they had these big dust storms where the topsoil
from the Midwest ended up in the Gulf. It happened suddenly. It
was a bad time. We wondered if the soil was ever going to recover
and become agriculturally viable again.

I remember this with great fondness, because you learned a great
deal about how to entertain yourself. You couldn't plop down money
somewhere and buy it. You had to use your imagination. Play games
in your head. Things like this. Even if you were a farm guy and
would sit on a cultivator and look straight into the backside of two
horses on a half-mile corn row, you'd have to think about something
else because it's not what you'd call a real stimulating horizon out
ahead of you. I really believed it was of great help because you

resorted to your imagination a lot, and pretty soon you were pretty adept at a lot of other things that you were totally unaware of before.

The presidential campaign was so improbable. Alf Landon was not what you would call an inspiring-type candidate. The little luncheon group I gathered with each day consisted of a pool hall operator who was a real wild Republican and a billboard entrepreneur who had billboards along the state highway, and so they came up with a bet. The Republican guy said, "I'll bet you that Landon is gonna win, and if I lose I'm gonna walk from here to Grand Island, which is a hundred miles." And the billboard guy said, "If I lose, and I know I won't, I'll walk from Lincoln to Kearney." Which is about another 20 miles. The final day comes and it was a landslide, so we took the pool hall guy out to the edge of town, Lincoln, and put a sign on his back: "Don't pick me up, I'm the damn fool that voted for Landon."

So I would go out each night and find out where he was, interview him about his progress and what kind of things happened to him. He was about three miles from Grand Island and I went out to meet him. On the way back to the hotel I went into the Western Union office, which was closed, and I took one of their forms and typed out a message—*To: Jim Beltzer, walking marathoner, somewhere near Grand Island, Nebraska.* Here comes Jim, huffing and puffing, and I went up to him and I said, "I was given this telegram for you at the hotel," and he opened it and read it and it says: "If I had run as well as you had walked I'd be president of the United States, Alf Landon." I never did tell him it wasn't from Landon and that I was just having fun with him, and he died thinking that Landon had written him. Politics was a very intimate thing. All the devils were real.

A guy named Gabe York, who used to be the director of publicity for Twentieth Century Fox in the Zanuck days, asked me in the late '30s, "What are you planning to do with your life?" I began to sketch out all these things and he said, "Good God, if all that happened you'd have the dullest life in the world. You haven't left any room in there for something that's gonna happen by chance. Kind of relax and take a look around." Of course, World War II came along and took care of all that.

Judith Balaban Quine

is a civil rights, civil liberties and education activist and author of *The Bridesmaids: Grace Kelly, Princess of Monaco and Six Intimate Friends.* Her life changed on election night in 1936.

"I was lifted onto the window ledge in Dad's office and held there to look down at the throngs in Times Square. I felt certain that every single person in the world had come there that night."

———————◇———————

T he two youngest of my six kids—though they watched the first moonwalk on TV with the rest of us—presumed from then on until much later that people had been walking on the moon for years. With all the brain development research going on these days, I wonder if there will prove to be cells that grasp the concept of history, and whether—regardless of how good a memory a child has—a child cannot comprehend historical context or significance until those cells develop at a certain age.

Certainly I claim no such comprehension regarding 1936 when I was 3 and then 4. But for me personally, it was indeed a seminal year because of a specific night that helped to shape my life and a sense memory of it...a visceral, almost cellular experience that I can still (and often do) recall as though it happened yesterday. It was November of '36, the night when Franklin D. Roosevelt was elected president of the United States for the second time. My father, together with his brothers and brother-in-law, had already built Balaban and Katz into one of the first and best-known movie theater chains in America. The motion picture business had survived the stock market crash of '29 reasonably

well. (Perhaps going to the movies was the only entertainment most Americans could afford.) But the second crash, in '32, decimated the industry. In the aftermath, the banks and investment houses took a close look at the movie companies' administration and found them wanting. In Paramount's case, the banks took over and ran the company themselves. When that proved disastrous, they looked around and decided that since my father had proven himself to be an exhibitor with a solid management and financial record, they'd hire him as president of Paramount. Dad, however, admired, respected and cared for the incumbent, Adolph Zukor. Since Paramount was Zukor's baby, he felt it ought to remain under its founder's stewardship.

Early in '36, my father boarded the Super Chief in Chicago for a business trip to L.A. After kissing us goodbye on the station platform, he went into his drawing room to find none other than Adolph Zukor himself already seated there!

During their trip west, Zukor explained there was no option that would allow him to retain his position at Paramount. If Dad didn't take the presidency, the banks were going to shut the place down. Since he wanted the company to go on, Zukor convinced my father to take the job. So we spent the summer of '36 living on what had been Adolph Zukor's "farm" in New City in Rockland County, New York. Dad's yacht (the *Judith R*) came east with us and was docked nearby on the Hudson River. The farm had, among other luxurious features, an Olympic-size swimming pool, tennis courts, its own theater and an 18-hole golf course. (None of us played. I've never known if Zukor did.) When autumn came, we moved to Manhattan and into what was formerly the Zukor's 12-room duplex apartment on the 11th and 12th floors of the Savoy Plaza Hotel on Fifth Avenue between 58th and 59th Streets.

Life for me was a younger, 1936 version of *Eloise* at the Plaza. I frolicked in the playgrounds, fed the squirrels and pigeons, climbed rocks and visited with the zoo animals in Central Park across the street from our apartment. I took ballet lessons at Chalif's, ice-skated at Gay Blades or Madison Square Garden and regularly rode horses with my brother and my father out of Ayleworth Academy, just off Central Park West and around the corner from the Ethical Culture School, which I would later attend.

I made frequent visits to the kitchens, housekeeping headquarters and bellman's desk in the hotel, but my passion was learning to manipulate the big, shiny brass handles that operated the elevators so I could run them without giving the passengers whiplash. I remember my parents being invited to the opening luncheon for the king and queen of England. (I think both of them were there.)

Since Dad couldn't get back from a business trip in time, my 15-year-old brother, Burt, escorted our mother, dressed in his New York Military Academy uniform. Most of our family had red hair. In those days, redheads always wore green and brown, never colors in the pink-to-orange family. I was already used to being "greened and browned" ad nauseam. My father, and another couple who was going with them that night, waited for my mother in the foyer, while my brother Leonard and I played chess in the library. Hearing the grownups gasp, I rushed out to see our redheaded mother swooping down the winding marble staircase in a glorious, floating, tangerine-colored gown. I felt liberated, knowing I'd not be consigned to a green-and-brown world forever.

Does all this sound very young, very frivolous, very privileged and very removed from the America of 1936? Does it sound

callously distanced from the dreadful hardships so many American citizens and immigrants were suffering? And do you forgive me only because I was a mere 4 and would likely have to wait at least a few more years before having any real sense of what my country and its people were all about?

I didn't have to be any older than 4 to get it. Didn't have to wait past election night in November of that same seminal year. My brother Leonard and I were taken that night to our father's office on the ninth floor of the Paramount Building overlooking Times Square and its famous electric moving sign: known as "the zipper." I was lifted onto the window ledge in Dad's office and held there to look down at the throngs in Times Square. I felt certain that every single person in the world had come there that night.

I knew in my bones that something of vast importance was going on. My parents explained, simply enough so a 4-year-old could understand it, what was happening. They pointed to a large framed map on the wall. They showed me New York, at that time the entire universe to me, pointing out what a small part of the whole United States it really was. They explained that all over the country, grownups that day had gotten to pick the person who would lead all those places and all the people in them for the next four years. They reminded me I'd only just been born the last time this happened, and that I'd be 8 by the next time. They said we had way more of everything than we needed, but that too many people in America didn't have enough food or couldn't turn their heat on to stay warm when it was cold, because they didn't even have enough money to buy food or heat.

My parents explained that our leader, the person picked as our president, had to help those people. So all the grownups had to decide which one had the best plan for doing that. They said there were families all over that big map doing what we were doing, gathering together and listening to the radio to find out who'd been picked.

My dad said something about "rights." Mom could see that confused me. At age 4, "right" only meant the opposite of "left" (I was just learning which hand was which), or something that was not "wrong." So my mother explained the other kind of "right" in a 4-year-old's way. She said it was like when Leonard and I both wanted to play the radio but he wanted to hear one show while I wanted another. So our "leader"–Mom, Dad or our governess, Decky–had to decide who got the "right" to choose. Sometimes it had to be me, but sometimes it had to be Leonard. Because if one person got the "'right" all the time, my father added, it wouldn't be fair to the other. That's how America works, too, they said. In the following days I asked questions.

"What about the people who picked the man that didn't win?" I asked. "Are they mad?"

My mom said, "Maybe a little mad. Maybe sad, too…for a while."

Dad added, "But no matter who wins, we all have to try to work together because, in spite of all our differences, that's what makes us America."

So, though I already knew where I lived and how I lived, it was during that late November night, looking out at Times Square from a ninth-floor window in the Paramount Building when I was only 4 years old, that I learned–for all time–where I truly came from.

Lila Garrett is a two-time Emmy-winning writer and liberal social activist. She is president of the Southern California Americans for Democratic Action and has served several terms on the board of the Writers Guild of America.

"'Is it true?' she barked. I wanted to die, but dying is not that easy."

◇

I was in the second grade and we had a Red Cross drive. My teacher, Miss Cornell, made a big thing of it. I remember she showed us pictures of hurricane and flood victims being helped by young women with white kerchiefs on their heads adorned only by a red cross. Their beatific smiles as they doled out bandages and doughnuts made them look like angels of mercy. Our teacher wanted us to have 100 percent class participation, the best in the school. Each child was asked to contribute a dime. We left school that day feeling noble and competitive, an irresistible combination.

At dinner that night I excitedly told my parents about the Red Cross and how our class was going to get the best record for giving. My mother immediately opened her bag to take out a dime, but my father stopped her. He looked at me hard, the look that told me he was about to deliver a lecture. My father had a deep, resonant voice that was always the same whether he was talking to one person or hundreds. In a crowd that voice was admired because those people came specifically to hear him speak. But when two or three of us had innocently sat down to dinner and he decided to use it as a lesson, his surround-sound voice made us feel like prisoners. My brother, my mother and I were doing time, lots of it, because my father always had a lot to say and none of it was short.

My father, Joseph G. Glass (he insisted on the "G"), was a Socialist. Not just any Socialist. He ran for mayor of New York City, governor of the state and for U.S. senator. My brother and I were weaned on the facts that wars are simply for profit, religion is the opiate of the people and the working class is the only true aristocracy.

My father railed against the Red Cross, which, he said, never gave an accounting of the money they raised. He then regaled us with the catastrophes they refused to recognize: strikers brutalized by police; rioting of the unemployed; African Americans (then called Negroes), particularly in the South, who were regularly beaten, burned and lynched. The list was long. And so was the lecture. Bottom line: I was not to contribute to the Red Cross. He did, however, give me 50 cents for my dance class the next day.

When I got to school all my classmates handed in their dimes. Only I was left. I remember sitting in my seat at the back of the class— I was tall—with my head down, and hearing my teacher quietly say, "Lila?" Without missing a beat, I went to the front of the class, handed her the 50-cent piece and sat back down. Miss Cornell didn't let it go at that. She beamed with pride. She praised me for my patriotism and had the class applaud me. Now we would surely be No. 1. And all because of me. It was the highest moment in all my 8 years.

My dance teacher called that evening and asked why I was not in class. Unfortunately my father picked up the phone. He repeated the question to me and it came so without warning that I blurted out that I gave the dance money to the Red Cross. He looked at me with such fury that if my mother had not stepped between us I thought he would kill me. "Why?" he bellowed. "Why would you do such an irresponsible thing?!"

"My teacher made me do it," I lied. This immediately allied him with me and redirected his fury toward her.

I feel sick thinking about it now, just as I did then because I loved Miss Cornell. I was always a rebellious child, coming from that background, but when in class I called Thomas Jefferson a hypocrite because he had slaves, Hamilton a fascist (correctly) or Benjamin Franklin a bigot (I forget why), other teachers were appalled. Not Miss Cornell. She praised me for my independent thinking. I didn't burden her with the source of my "independence." I was simply grateful for the approval. Now I had betrayed her. And I did not know how to get out of it. I forced it out of my mind; tomorrow it would all go away.

Tomorrow came, and to my relief, the Red Cross had been forgotten. We started a new project—Bible stories—when a note was delivered to our room. Miss Cornell said, "Lila, dear, you're wanted in the principal's office." She smiled and whispered, "I bet she heard about your contribution." I tried to smile back, but I remember wishing I was Lot's wife and could turn into a pillar of salt.

I walked into Miss Cain's office to see my father sitting there ready, eager for battle. Miss Cain, well named, was a hard old maid with small jagged teeth and no lips. We kids were terrified of her. Without inviting me to sit down she demanded, "Did you tell your father that Miss Cornell ordered you to give your money to the Red Cross?!" I whispered yes. "Is it true?" she barked. I wanted to die, but dying is not that easy. So I compounded the lie and nodded.

Miss Cornell was called down to the office. Miss Cain confronted her with my accusation. I remember my beloved teacher silently

looking at me, first with disappointment, then with unbearable understanding. While I stood there like a prisoner about to be hung, longing to be hung, she gently explained that she may have exerted a pressure I couldn't deal with and she was truly sorry. She was taking the rap for my sin and apologizing for it! I was too numb to cry. But I remember looking at my humbled father and hating him because I had failed everyone, including him.

That night I told my mother the full story. She had a quiet discussion with my father in the bedroom and took me to school the next day. She and Miss Cornell became friends. My father never interfered in school matters again, although he still lectured us a lot.

I never intruded my politics on my own children because I did not want to become my father. But I still believe that war is for profit, religion is the opiate of the people and working people are the true class act.

THE WORKS PROGRESS ADMINISTRATION

From 1934 until 1941 the Works Progress Administration (WPA) employed thousands of artists to decorate public buildings, most notably post offices and libraries, to provide employment in hard times. Together with the WPA, the National Recovery Administration, the Civilian Conservation Corps and other New Deal programs, some 11 million people worked for pay; built bridges including New York's Triborough Bridge and the Key West Causeway; reforested the Dust Bowl; built dams, roads, colleges and saw to the education of the poor, including president-to-be Nixon. Unemployed journalists, novelists, even poets were sent to interview people at random. John Steinbeck recalled writing a census of the dogs of Monterey County, California. The stories of the people they interviewed live on in the Library of Congress and are available on the Library of Congress home page at http://lcweb.loc.gov, under American Memory.

A poster announcing the Writers' Project.

*"I'm reaping in tears what
I sowed in fun."*

——————◇——————

DESCRIPTION OF
PLACE: I look around
the old store with its
adjoining residence. One corner
was partitioned off for a liquor
store, whose fixtures included a foot rail, so prevalent in the saloons
of previous years. In the rear of the store a stairway led to a large
dining hall, where Mrs. Carter had formerly operated a nightclub.
Because of ill health she had been forced to close it. The entrance
to the residence is through a long hall that leads to the dining room
and kitchen on the first floor. Another stairway gives on to a second
floor where there are 13 rooms and a bath. The entire floor is
handsomely furnished and represents an outlay of many dollars.

Mrs. Carter was seated by an electric heater, crocheting a
bedspread for her niece who is to be married in June. Mrs. Carter
is rather attractive with her wavy, blond, bobbed hair and smiling,
blue eyes.

"The serpent entered my garden of Eden in the form of a woman.
I know my husband loved his boy and me but he just couldn't resist.
He was weak enough to fall for their line and just wouldn't see that
his money was all they were after. Finally we separated in 1920 and I
got this place in the divorce settlement. For a while my business was
fair, I was breaking better than even and living well. Along came the
Depression! One by one, the plants closed. Then the International

22

Agricultural Corporation closed and the farmers couldn't get a dime. The only plant that remained open was the Buckeye Oil Mill, and a number of their employees were cut off and the rest of them worked only three days a week. Some of the folks had spent their money with me for years, and I couldn't refuse to help them now that they needed me. We all thought the trouble was only temporary and that the plants would open again in a few weeks or months at the longest, and then business would adjust itself. I never dreamed it would last until my shelves were empty and my drawing account dwindled. I kept on buying and selling on credit until my last dollar was gone. I had $6,000 in diamonds; one ring alone was worth $3,300. I sold all of them with the exception of my engagement and wedding rings.

"Then one day my husband wandered into the store and asked me to lend him a dollar. I complied gladly but he never lived to spend it. He just sat down in one of the chairs and died—a broke, disappointed man. I buried him, and I had to do that on credit. You see, he was still my husband and the father of my child, regardless of divorce laws."

"What happened to him? How did he lose all his money?"

"When the warehouse closed he had nothing to employ his mind. He married one damn crook, quit her and went to California with another. For this last offense he was put in jail for violation of the White Slave Law *[The Federal Mann Act, which prohibited transporting women across state lines for sexual purposes—Ed.]*. This cost him plenty before he was free to return to Augusta. Then he got in with Barrett and Company and we all lost this time. I had $8,000 invested and had endorsed notes for him amounting to $16,000. I am still paying on them."

"How is your business at the present time?"

"Rotten! I take in around $200 a month and my overhead is approximately $300. I am nearly crazy and don't know which way to turn. The chain stores have just about ruined the independent ones. During the week people buy from me on credit, then when they get their cash on Saturday they go and spend it at the A & P. About two years ago I opened a nightclub and installed a heating system that cost me $700. I really made good and would have soon paid my debts, but it came near killing me. I couldn't burn the candle at both ends. I tried to work in the store all day and in the club at night."

"Why couldn't your son help you?"

"He is not dependable. He stays drunk for weeks at a time. But I had it coming. When he began to talk, we would sit him on the counter of the bar and give him wine and sometimes whiskey to drink. We also taught him to curse. It was funny then, but I have lived to regret it and am reaping in tears what I sowed in fun a few years ago."

"Mrs. Carter, you have a liquor store here. How did you get the license? Do they issue liquor licenses to women?"

"No, the license is in my son's name."

"What do you think brought about the Depression?"

"What do I think caused the Depression? Well, I don't know, I haven't given it much thought. I was too busy trying to fight my

way out and make a dollar for myself. We all owe President Roosevelt a tremendous debt for pulling us through this far and we want him for another term. If we don't get him, or someone like him if that were possible, who will carry out his ideas and plans, we are headed for plenty of trouble.

"And you say the final question is what I think of women in business. Well, I think they make good managers. As a rule they use more judgment and are much more considerate, especially in the liquor business. About 75 percent of the homes were saved during the Depression by wives who planned and sacrificed in order to keep a roof over their heads. When a man gets in trouble it takes a woman to pull him out. Take me, for example. My husband came to me for help and died under the roof I had saved for myself and my boy."

Stanley K. Sheinbaum

is an economist, a publisher active in liberal politics in Los Angeles, a former regent of the University of California and former president of the Los Angeles Police Commission.

"Governor Smith reached for me and had me sit in the car between Landon and himself, and off we went to the cheers of all those Republicans."

———————————◇

The construction of the Empire State Building was a major event for any kid growing up in New York City. I lived in the Columbia University area and went to high school from 1933 to 1936 at DeWitt Clinton in the Bronx. I remember vividly the destruction of the old but truly elegant Waldorf-Astoria on the site reserved for the Empire State Building. Exactly what year that was finished and done with I cannot be certain, but I would guess around 1929 or 1930. Its end was very symbolic, being coincident with the great stock market crash of 1929. Either one would have been depressing, but even at the age of 9 or 10 either event was hard to cope with. With almost everything else going negative—soup lines and bread lines and the Hooverville encampments along the Hudson and East Rivers and then between 25 and 30 percent of the nation's workforce being without jobs—the planning for so giant a monument as the Empire State Building seemed unreal. Former Governor Al Smith, who had lost the 1928 presidential campaign to Herbert Hoover, was one of the few to land a good job—that of masterminding and then running the construction of the Empire State Building. In 1932 Roosevelt was elected to his first term, with the completion of the Building shortly thereafter. The combination of those two milestones became sheer excitement, even for a 12-year-old, what with FDR's positive rhetoric for "moving the country ahead."

As for me, our family of three boys had escaped in 1929 to Flatbush because of the dire and stringent conditions that the Depression had thrust upon us. And finally, around 1931, the family moved back to Manhattan to the Hotel Royal on the northeast corner of Broadway and 104th Street, where the three sons and the parents lived in a single-room apartment with a kitchenette.

My father, who had been a successful leather-goods manufacturer in the garment district sewing up belts for various garments, then embarked on a series of cycles in which he would go into business, get wiped out in bankruptcy, and then keep managing to reopen a new one. He must have gone through that cycle four or five times in the next ten years. *Struggle* was hardly the word.

My older brother and I sold the *Saturday Evening Post* for a nickel on the sidewalk from a canvas bag made for the purpose with a strap to put over our shoulders. On rainy days we would wait by the subway exits with umbrellas and walk people to their homes for 10 or 15 cents. My mother sold hosiery from door to door in the seemingly posh apartments on West End Avenue and Riverside Drive, and in those dismal days the word *seemingly* was most apt.

Finally, from 1933 to 1936 I was at DeWitt Clinton High School, not exactly breaking scholarly records. I used to love going downtown on the No. 5 double-deckers of the Fifth Avenue Bus Company—although our route was on Riverside Drive—cutting eastward on 72nd Street, then down Broadway to 34th Street, where we would get off and watch this massive piece of construction reaching to the sky. Al Smith may not have known it at the time, but he was our first Keynesian economist even though the money for the project came not from the government but from the DuPont family.

All the while I had been a Boy Scout at Troop No. 566 at P.S. 165 on 109th Street between Broadway and Amsterdam, exactly where I had done my grade school work.

By the time I became the Senior Scout Leader in 1936 I hit upon an idea. I had graduated from DeWitt Clinton in June of 1936, so with no college and with no job I went down to see ex-Governor Al Smith to persuade him to let our troop perform reveille and taps on the roof of the Empire State Building. So, with my full colorful Boy Scout uniform, I embarked on that venture.

At the time Roosevelt was completing his first term and was running for a second against Governor Alf Landon of Kansas. Landon, of course, was the father of the recently retired Senator Nancy Kassebaum. All that is very relevant to this tale.

By this time I was working intermittently as a delivery boy of my father's belts to the ladies garment factories throughout the garment district. The district ran from Fifth Avenue to Ninth and from about 30th Street to 40th Street. Actually that working career had commenced while I was still in high school, and in the afternoons I worked in the plant with Stanley Garew, my older brother, Herbert, and my mother. Also there was a cousin, Mark Selden, and perhaps a dozen or 15 other not-very-promising working people. To repeat, it was always touch-and-go in terms of survival of the little company. Fortunately for me and for future jobs I learned how to be an operator, that is, running sewing machines to stitch cloth onto the artificial leather backing, the cloth coming from the same material used for the dresses of the companies for which we subcontracted.

Late in October or early November 1936, I showed up to work in my spectacular Boy Scout uniform, having made an appointment to see ex-Governor Al Smith at the very newly finished Empire State Building. That alone was great excitement, and when I did get in and provided him with my credentials about Troop No. 566 he felt it would be good publicity for the building, which was not exactly fully rented at the time. Anything would have helped.

When I took my leave of the former governor and went downstairs, I was already aware that the presidential campaign was nearing its climax. I also knew that both Roosevelt and Landon were at some point going to make the traditional election parade up Fifth Avenue. Downstairs, at the Fifth Avenue entrance to the Empire State Building, things were bubbling with excitement, and out on the street the crowds were anxiously awaiting the parade. I must have stood there 10 or 15 minutes when of all people Al Smith, smoking his traditional cigar, came out and spotted me. He was there apparently to meet Alf Landon, having earlier bolted from Roosevelt's Democratic campaign. He drew me to his side and urged me to wait with him. After a few minutes the Landon motorcade drew up on Fifth Avenue to pick up Al Smith, who would sit in the open sedan convertible with Governor Landon. When that finally occurred, Smith reached for me and had me sit in the car between Landon and himself, and off we went to the cheers of all those Republicans as we went north up Fifth Avenue to 42nd Street. I, obviously one of the showy pieces of the campaign, joined the two ex-governors in waving to the crowds. I probably thought I would be named secretary of state—or something. To put it as mildly as possible, it was quite an experience.

After going up Fifth to the corner of 42nd and Fifth we made a right turn going east for about a block and a half to where the still-

existing overpass from Grand Central Station begins its own thrust down Park Avenue. As we crossed Madison Avenue there was suddenly a huge roar from the crowd, which by that point was packed on both sides of 42nd Street. What was happening was that Franklin Roosevelt and his entourage were coming across that overpass going south, and there were the two candidates and me within approximately a block of each other. Even though I was a loyal Democrat and riding with the enemy, I could not help but share in the excitement. Finally at Park Avenue the Landon motorcade made a right turn and pulled up in front of the old Murray Hill Hotel. The candidate and his sponsor, Governor Smith, went inside and I, having served my colorful role, was left outside to appreciate Governor Landon when he stepped out onto the sill of a second-story window to address us. President Roosevelt had already gone on his way down Park Avenue. The crowds duly cheered and dispersed, leaving me in my Scout regalia, my brief moment of fame already passed, to wend my way home to the Bronx.

William Ruder is president of a public relations company in Manhattan. He was assistant secretary of commerce under President Kennedy, and is vice president of the United Nations Association and a board member of the University of Pennsylvania.

"Rudolph Valentino died of constipation and the street hawkers had the magic cure for that and just about everything else."

◇

I have always resented the Empire State Building. One Saturday my father took me to the Chrysler Building while it was still under construction and billed as the tallest building in the world. The lobby of the Chrysler Building was made from lava from Italy, and one of the workers gave me a piece of it as a souvenir. For the next five years I took it to school for "show and tell." It was a lifesaver. But then came the Empire State Building, which didn't even give the Chrysler Building 10 minutes to be recognized as the tallest building in the world. I never forgave it. As a matter of fact, my kids took the lava to school, each of the five of them in seriatum for "show and tell." I got my money's worth out of the Chrysler Building!

My first awareness of my surroundings began when we lived on University Avenue—1683 to be exact—where, incidentally, I was born on the kitchen table. It must have been when I was 6 years old that I went directly into first grade because kindergarten was too crowded then. The school was so crowded that we had classes in the assembly hall—six or eight of them—separated by those old-fashioned blackboards on wheels. I can still remember sliding off my seat and hiding on the floor so the teacher wouldn't call on me. But one day she caught up

with me, I guess in the second grade, and wrote the letters T-H-I-C-K on the blackboard. She asked me what it spelled and I didn't know—at which point she hollered, "Thick, just like your head!" I still can't ask for a thick chocolate milkshake without feeling queasy.

Anyway, those were pretty good days and my father was an ardent Hoover supporter. I proudly wore my Hoover button though I didn't know what it was all about. My father still thought he was upwardly mobile and life was rosy.

After that, lots of things happened—the Crash, the first of my father's biennial bankruptcies, and the first of our biennial September moves to a new apartment and neighborhood because we were behind in the rent and because my father needed the month or two concession that new landlords used to give to new tenants. Wherever we moved we were always on the ground floor in the back, an invitation to robbers and other intruders. But we never got hurt.

And then come the memories of the rough times, the men on the street corners selling apples, the hawkers of laxatives making their speeches on street corners telling you that Rudolph Valentino died of constipation and their potion had the magic cure for that and just about everything else. They were fabulous, those street corner hawkers. They stood on wooden boxes with an upright box as a pulpit—and of course the American flag, which was necessary then either by law or because they didn't want people to think that they were Communists. Of course there was President Roosevelt, who was the really great father figure of my life. That was the time of the NRA. (The National Recovery Administration, formed by President Roosevelt, was bitterly opposed by business interests.) And how excited I was. I could do my bit by wearing my NRA button. My mother was sick so I did a lot of the

shopping, and I simply couldn't go to a store that didn't have the "We support" sign with the eagle and the NRA letters in the window. I was devastated when the Supreme Court declared it unconstitutional. It was such a big ray of hope and it was something we could all do together. I was a kid but I believed.

And every two years when we moved and I was a stranger in a lousy new apartment in a lousy neighborhood and in a lousy new school, there was President Roosevelt and the NRA that gave my family and me a glimpse of a good future. As a matter of fact, one of the things that made me so proud was my cousin Hershey who joined the CCC because he couldn't get into the Army since half of the 18-year-olds in the country were trying to get in simply to have a place to eat and sleep. *[The Civilian Conservation Corps recruited young unemployed men and women to plant trees, fight forest fires and build parks.—Ed.]*

One of my uncles had a small taxicab business in Harrisburg, Pennsylvania. He managed to write a bad check and somebody had it in for him. It was either pay up or go to jail. All my aunts and uncles from Philadelphia and Harrisburg sat around our table, the women taking off their engagement rings and wedding bands and dropping any other jewelry in the center of the table, and the men putting their pocket watches with the gold chains in the pile, too. My father then took them all to the pawnshop in a little brown paper bag.

They were tumultuous times. I'm sure that I knew what was right. I learned the cornerstone lessons that I think still shape my life and my relationships. As I am writing this I am sitting here smiling and feeling so good about the last 70 of my 76 years. And that's a wonderful way to feel.

Daniel Schorr, journalist, historian and senior news analyst for National Public Radio, attended college in New York. Colleges at the time were a ferment of hope and desperation over solutions to the collapse of the world economy, capitalists versus Communists and the endless quarrels between subdivisions of each, Stalinists versus Trotskyites, Keynesianism versus Free Market people and paper money versus gold standard—all while the war in Spain seemed to many to presage a world on the brink of something like the French Revolution.

"I had a police press card in the form of a shield, which did wonderful things for me. I could go free, with a date, to the top of the Empire State Building, providing a view that enhanced romance."

———————◇———————

As a token of the Depression, I remember the sign on our favorite delicatessen on Jerome Avenue: "Eat here or we'll both starve."

I was in City College, jousting in the Alcoves over the Ping-Pong table and with the Stalinist students who demonstrated for "Books Not Battleships" and argued with me about the merits of the brave new world in the Soviet Union.

With a widowed mother working in the dress trades and receiving welfare under Roosevelt's program—"relief" they called it then—and with a brother suffering from polio and operated on, it sometimes seemed, every second week, I remember best how close we walked to the edge of impoverishment.

The National Youth Administration, an FDR New Deal program, helped with 50 cents an hour for sorting library cards. I became a stringer for the first (and last) English-language Jewish daily newspaper, the *Jewish Daily Bulletin*. One of my assignments was covering the local Nazis, the German-American Bund, which turned out to be less hazardous than I feared. But, because the *Bulletin*, like many of the media, loved fear as a circulation builder, my lurid stories of men in swastikas and jackboots rallying in Yorkville with dire threats to the Jews brought me more income at space rates than a staffer was getting. So they made me a staffer, and I transferred to night school to finish my college education.

Because of an assignment, I missed my January graduation. Thanks to the *Bulletin* (and the Jewish Telegraphic Agency, which I joined when the *Bulletin* folded), I had a police press card in the form of a shield, which did wonderful things for me. I could go free, with a date, to the top of the Empire State Building, providing a view that enhanced romance. I could get into Carnegie Hall free and collect wonderful new classical record releases. At JTA I rewrote cables from Europe, full of stories about the depredations against the Jews by Hitler's minions. The Yiddish press carried these stories with screaming headlines. The general press, which we served, the wire services and the *New York Times* generally ignored these stories, counseled by the State Department that they were just Jewish propaganda.

JTA was also where I learned the wonderful language called "cablese." Cables, paid by the word, were very expensive, even at press rates. So we found ways of using Latin prefixes and suffixes to condense a couple of words into one.

Thus, someone Londonwarded Prorefugee Conference Arriving Sinebaggage. It was in those days that Downplay was born, newly adopted into the American language. Soon the teletype machine, where one paid by the minute, would make cablese obsolete.

Mort Walker is the creator of the comic strips "Beetle Bailey" and "Hi & Lois." His career took off at the age of 13, as his diary recorded.

"I have not been to school lately. I get tired and feel sick. Mother doesn't believe me."

———————◇———————

January 3, 1936, I was visiting my aunt Florence and she took me downtown for lunch. Something didn't agree with me and I upchucked it. She hailed a cab to take me home. The cab driver didn't want me to mess up his car and made me stick my head out the window. The next day I woke up with the flu. I had never been sick before and it frightened me.

January 15

I have not been to school lately—it's so monotonous. I get tired and feel sick. Mother makes me stay in bed without any comic books.

January 18

I drew a comic strip called "The Limejuicers," about some sailors and sent it to the *Post* to see if they would print it. It would be a good start for me. I dread to think of tomorrow. SCHOOL!

January 20

When I got up this morning I didn't feel well. Mother doesn't believe me. She has given me a nasty-tasting medicine (quinine?) every two hours. It makes me shiver every time I take it.

My first comic strip, "The Limejuicers," ran for a year in 1936 in the *Kansas City Journal.* I was 13.

January 24

Today the paper comes out that maybe it will have my comic strip in it. Some of the boys from school came over to see me. Everybody tells me I should come back to school or I won't graduate. I have been waiting impatiently for the paper. I came downstairs to see if it had come yet. Daddy was grinning from ear to ear. My comic strip was in it. My first printed strip. Boy, am I excited and proud. We sent Mary Lou out asking the neighbors for copies.

January 27

I started back to school today…the first day in 36 days. Mother will give me a dollar if I go steady for 30 days.

June 3

I missed 12 days of school because Bob Ellis had the scarlet fever and they made me stay out. Up to today I have had over 75 drawings published.

(I didn't graduate and was held back a semester, but my career was launched.)

John Tebbel is the author of 40 books and an equal number of others in various kinds of collaboration, as well as more than 500 magazine articles. His four-volume *History of Book Publishing in the United States* is the standard work in its field.

"...there rose one of the most chilling sounds I have ever heard: the mingled cries, moans, shouts, even screams blending into a dull roar from the throats of 3,000 homeless men sleeping in the park."

◇

A s a very young city editor of a mid-Michigan newspaper in the mid-1930s, I saw both sides of America that existed at the same time—cheek by jowl, poverty and despair rubbing shoulders with affluence and rising expectations.

I was sent to do a few pieces on the Century of Progress when it opened in 1933 in Chicago, a city celebrated by Carl Sandburg and sanctified by Colonel Robert R. McCormick. It was a glittering display of an America that had been and of a nation that would rise from despair to live again. Patrons were entertained daily by the Chicago and Detroit symphony orchestras; exhibits of every kind displayed a wealth beyond the reach of most citizens. It was America at its boastful best.

I had so little money that I could afford my two-week stay only by booking myself into a shabby South State Street hotel, in the midst of the city's poverty. On my way to the great fair every morning I saw garbage trucks followed by ragged people with desperate eyes, trying to find something edible in the refuse being

hauled away. I was horrified enough, even though I had read about such things. Until then, they had seemed far away and unreal.

Going to the Century of Progress from Michigan Avenue meant traveling over a long, arching wooden bridge constructed from Grant Park to the exhibition, which had been built on made land in Lake Michigan. By day it was a cheerful sight, with fairgoers coming and going, but late at night when I finally left the agreeable rooms provided for the press in the Swift Shell, as it was called, the walkway was a different matter. There were few pedestrians then, and from below, in Grant Park, there rose one of the most chilling sounds I have ever heard: the mingled cries, moans,

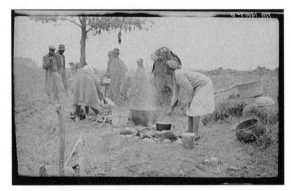

Roadside sight: the homeless making do.

shouts, even screams blending into a dull roar from the throats of 3,000 homeless men sleeping in the park. I never forgot it. Nor did I forget one of those men who accosted me on the bridge. He pretended to have a weapon concealed in a ragged pocket, and demanded all the money I had. What I had was 3 cents, because at that moment I had run through my meager resources and was not much better off than he was, except that I had access to other resources. That night, on the bridge, I willingly parted with my three coins. The man growled, explored my pockets to see for himself that it was all I had, and with a cry of miserable frustration, threw the money over the rail.

"I'm Amelia Earhart," she said. She put down the bags and gestured like a boy. "These are for you."

———————————◇———————————

In 1936 the cheapest entertainment and relief from summer heat was at the movies. They cost 10 cents in first-run theaters. The box-office queen was 8-year-old (passing for 7) Shirley Temple, of whom the columnist Walter Winchell wrote, "Sex can't be important in films, the world's leading film attractions remain Charlie Chan, Boris Karloff and Shirley Temple." One of the preoccupations of the wealthy in 1936 was the fear of kidnapping—the shadow of the tragedy of the Lindbergh kidnapping two years before. This is excerpted from **Shirley Temple Black's** memoir, *Child Star.*

The *Motion Picture Herald* reported I was the biggest moneymaker of the year. Not for myself, of course, but for the studio. In the spirit of Santa Claus, however, the studio announced my weekly salary was being doubled from $1,250 to $2,500, and that during 1936 I would be paid $64,000 apiece for four motion pictures, for a total of $256,000. To dramatize the comparative magnitude of my raise, the studio cited $55,000 as my earnings the previous year. Studios must have arcane reasons for what they say, even when they warp the truth, both ahead and behind. In 1936 I would actually receive $120,499, less than half the amount publicly announced. During the previous year I had actually been paid $71,923, a third more than claimed.

If eyebrows rise on a point of accuracy, they should stay elevated on the point of generosity. The average cost for each of my recent films had been $300,000. Because each required about six weeks to

make, my cost to the studio at my weekly salary would have been about $7,500. Upon release, each film earned about $1.6 million, leaving studio and exhibitors an even split of about $800,000 apiece. Thus, my $7,500 earnings represented a thin 1 percent slice from the studio's earnings pie. Doubling my salary to 2 percent was gratefully noted by my parents, but it was hardly a sacrifice to the giver.

As further benchmarks of value, the Texas Centennial Exhibition commissioned me, in absentia, an officer of the Texas Rangers, dangling at the same time $10,000 for a week-long personal tour in Dallas. Promoters from the New Jersey State Fair topped that, offering $12,500 for a single day.

All this unsolicited bidding was not lost on Darryl Zanuck, the head of Twentieth Century Fox, who decided to physically protect his potential asset from the threat of kidnapping by detailing burly John Griffith as my combination chauffeur-bodyguard.

An ex-carnival roustabout, Griff squinted a lot, sending darting glances around as if searching for danger beyond our normal ken, and made no effort to disguise the hard bulge of a holstered .38-caliber pistol near his armpit nor the flat leather belt case that held folded handcuffs. I regarded him as a playmate. His primary task was to keep me in sight. Naturally, mine was to escape. His feet were flat, his wind short, and he huffed like an elephant. In any game of pursuit, I was the easy winner.

He showed me how his pistol worked, unloaded of course, then snapped me in and out of his handcuffs. But his playfulness had limits. When I locked him in his own cuffs and then hid the key, his patience ran out with a rush.

He taught me card playing. Rounding off my education, he showed how to cheat. With eyes narrowed and voice lowered to a conspiratorial whisper, he demonstrated how to double deal, palm cards, and reverse the deck. Cheating was never presented as immoral, simply a tactic for winning. From then on I rarely lost to him in cards. I was too young for ethics.

A personal bodyguard was only one aspect of the studio's coherent plan to preserve my value. In case of my demise, they would be well paid. Life insurance in the amount of $795,000 was placed through a syndicate headed by Federal Life Insurance Company of Chicago, with the studio named as sole beneficiary.

"We welcome this risk," said Vice President L.D. Cavanaugh. "She is…sheltered, supervised, lives in a fine home…addicted to neither alcohol nor tobacco…and has gained 20 pounds in two years…."

With me physically monitored, personally protected, my value insured, Zanuck passed instructions to maintain my upward artistic momentum. Keep her skirts high. Have co-stars lift her up whenever possible to create the illusion now selling so well. Preserve babyhood.

I was a voracious, indefatigable listener, and radio was my most important porthole on the world. This devotion had two principal origins. First, living as I did in crowded family circumstances, almost everything I did was done with something else going on. Perhaps it was conversation, or general bustle, kitchen clamor or living-room hum typical of any small home. Movie studios, with all the complexity of overlapping activity, merely intensified my ability to work in a busy environment. At home and at work I concentrated best in the presence of background noise.

Wanting to listen to two programs at once on one radio, I started flicking the dial, and soon could follow both. Mad scientists with disintegration ray guns ran parallel to the lonely Whistler who set spines atingling. What better way to spend an evening than to flip the dial between the squeaking hinges of *Inner Sanctum* and the demented laugh of *The Shadow* confirming that evil lurks in the hearts of men?

The Lone Ranger offered a three-speed bike in a slogan contest on bicycle safety. I signed my entry S.J. Temple and won. When the sponsor asked if I was any relation to myself, the studio told them any publicity about the award would infringe on their exclusivity to the use of my name. With that, the sponsor reversed its decision and gave the bicycle to somebody else. Undaunted I sent in Puffed Wheat Cereal box tops, plus a dime for a Dick Tracy 18-piece detector kit for fingerprints and invisible writing and another box top for a sunburst-shaped decoder pin that glowed in the dark and unraveled secret messages sent over the radio.

Although I was comfortably spellbound by bizarre possibilities, my parents continued to fret about kidnapping. As their concern for increased security and privacy coincided with increased finances, our modest, curbside bungalow was put up for sale and a more isolated four-acre piece of wooded property in nearby Brentwood was acquired.

Spotted among native California live oaks and looming eucalyptus, long ago introduced from Australia, stood pepper trees, branches heavy with gaudy clusters of red berries, silvery green cedars, conical evergreens and exotic pines with giant cones.

In good time a shingle-roofed English country house arose on the wooded lot, with a view from its windows of the distant Pacific

Ocean. On clear days, 30 miles beyond, Catalina Island barely smudged the horizon. Flagstone terraces and pathways linked the main house with a swimming pool, a poolside guest cottage, and beyond a rustic stable and riding ring sheltered among towering eucalyptus and dense pines. An interior decorator did my bedroom in multiple hues of blue: ice-blue tiles in the bath, deep French blue carpeting, woodwork trim and moldings sky-blue, the two-inch border on my chintz curtains gray-blue, and even my bedspread quilts, hand embroidered by a 92-year-old fan, depicted little girls in blue poke bonnets. Beautiful but cool, all this blue cried out for warmth, and soft pink roses from my wild rose bush had a habit of appearing in a water glass on a table, by my chaise lounge, or floating in saucers.

Along the street, stone masons were still laying up an imposing fieldstone and mortar wall. All day on the hour tour buses unloaded tourists outside along our wall with cameras clicking. Speaking through a megaphone, the tour driver recited everything he knew about us and the house, while his customers snatched leaves and small branches from the shrubbery as souvenirs, sometimes even scooping up pebbles and fistfuls of dirt for a remembrance. Whenever the buses arrived I would crouch out of sight, peek and listen, but before long I realized that the coincidence of a steady supply of mortar from the masons' work and the repeated presence of souvenir-conscious sightseers presented an irresistible business opportunity.

With Griff watching protectively, arms akimbo, I struck a deal with the stone masons to share their wet mortar, which I formed into small pies using tins borrowed from our kitchen. When the first bus arrived I had a supply of damp pies ready at curbside, priced from a

nickel to 25¢, depending on size. I sold out instantly. One tourist wanted my handprint, so I made a special pie on the spot, imprinted it, and charged 50¢, plus another 50¢ for the pie tin carried away. I was in business. The driver was enthusiastic, but the demand was only partially met, so I set about making fresh pies for the next bus.

Griff, sensing risk in every stranger, told Mother, who came bustling to the gate and shut me down.

"No more mud pies."

"They aren't," I replied. "They're cement."

Mud, cement, no matter. She ushered me back inside the unfinished wall, issuing stern reprimands about dangers in fraternizing with strangers. My objection that strangers were customers willing to pay me money made scant impression.

Later Griff tried to excuse his tattling. "After all, you get a weekly allowance. Everybody knows all your money goes into a trust fund. You don't need any more, ever."

His explanation was slight consolation. "Maybe she's fixed up everything so I'll never be poor, but I only get $4 a week. I'd rather be rich now."

Meanwhile, I was at work making movies. We had a war going, replete with cavalry charges, thundering cannon fire and infantry locked in hand-to-hand combat. An acrid pall of black gunpowder fogged across the set and death and destruction were everywhere, at least until quitting time. The action then dissolved to a military

prison, where the only sounds were heavy footfalls and clanking keys as a Union jailer moved along the tier, stopping at last before my father's cell.

"I'm afraid I've got bad news, Captain," he said softly.

Suddenly from offstage rose a mournful cooing noise from some caged doves already used in a happy plantation scene.

"Cut," muttered director David Butler. "Somebody get those birds out of here!" While a grip went to move the cage, I walked up to Butler.

"Why can't they stay?" I asked. "They make a pretty sound!"

"Not in a military prison," he replied impatiently. "Doves go with peace, not war, like…" He seemed distracted. "Well, like down in Africa."

Noting my puzzled expression, he stopped what he was doing and explained how the radio was just reporting Mussolini's invasion of Ethiopia.

"Why doesn't someone make Mussolini stop?"

"Take your places," Butler called, then turned to me. "We can talk later."

We didn't, but someone overheard our exchange, and national wire services carried my forthright solution, a news item predestined to sit poorly with the local Italian consul general. When Mother wrote asking him to obtain Il Duce's autograph, she was haughtily

informed he could not be bothered accommodating people critical of Italian foreign affairs.

Life was developing into a sort of ham sandwich. One piece of bread was work, the other, school. In the middle was the ham, me, and unexpected visitors, the spice. The woman standing at our cottage door was reedlike. Glimpsing me, she smiled, disclosing big, even teeth. She wore slacks and a pullover sweater, no makeup, and carried two blue suitcases.

"I'm Amelia Earhart," she said. She put down the bags and gestured like a boy. "These are for you."

Earhart's hair was steeply shingled up the back and tousled, an informality that instantly pleased me. The top edge of each ear poked in sight as she stooped, rapped the suitcases with her knuckles, and said they were made of a special light material suitable for air travel. Mother commented she would worry every minute if I were ever airborne, a remark upon which Earhart seized.

"The time to worry is before a flight," she said, eyes rounded and sincere. "Worry is a hazard to action. That's why Hamlet would have been a bad aviator."

"Hamlet who?" I interjected.

"Someone who worried too much," she answered.

"Do you like chewing gum?" she suddenly asked, offering me a stick of Beechnut. Stripping off its wrapper, I popped it into my mouth, avoiding eye contact with Mother, who always voiced strong

disapproval of gum because it tended to remove my caps and got stuck in my false plate.

With both hands calmly folded together in her lap, Earhart again inclined toward Mother, saying her husband believed in wives doing what they did best, despite the risks. Almost in an offhand manner she mentioned her intention to circumnavigate the Earth. At this Mother inquired why. Because such a flight would both demonstrate aircraft safety and dramatize that women deserved parity with men in aviation.

From Mother's smile, I knew she appreciated the reference to feminine independence, but she reiterated her ambivalent feelings about air travel.

"But women must try to do things," Earhart replied, "just as men do. Even if we fail, our failure still serves by challenging other women to try."

Attempting to derail this topic of conversation, Mother only provoked Earhart to emphasize that exclusion from opportunity in flying was denying women a chance to share in the total human experience. Utterly unaware how women related to aviation, I listened unbelievingly. So far as I knew, everyone could work happily at what he or she did best. Having been emancipated to the workplace at age three, I just listened while much of the rush of feminist chatter sailed comfortably over my head. What captured my attention was Earhart's casual attitude toward mortal risk, her tousled, unaffected appearance and the chewing gum. She was a notable exception, someone quick to speak about concerns totally alien to my life and therefore provocative.

Success is like currency—it attracts. Visitors had begun to
windmill past, for the most part joined in a blurred memory of
curious, kindly smiles. Neither surprised nor bothered, I realized
I was on exhibit, with a duty to respond not unlike a call for
costuming, makeup or camera. I was seldom provided a meaningful
advance introduction. What I did was usually extemporaneous,
actions modulated by secret instructions from Mother.

Categorizing visitors among those who came to ogle, to bring
something or to get something, Mother had devised a set of private
signals to guide what I said, and whether a visit should be stretched or
cut short. Their interjection while I was mid-sentence signaled a need
to change the subject and to retreat to neutral ground. A squint alerted
me to some controversial trap ahead. Eyebrows arched indicated keep
going. An averted gaze alerted me that I was already in deep trouble
and should get out. Occasionally she interrupted, closing the visit on
some pretext and afterward explaining where I'd gone wrong. Her
system struck a nice balance between my independence and her
restraint and was enormously helpful as an international rainbow of
strangers continued to appear.

Governor Ben Ross of Idaho commissioned me a lieutenant
colonel on his staff. The vision of an army and maybe a uniform
delighted me; I was unaware that I was entering politics and that
my photo would appear on a poster endorsing Ross as Democratic
candidate for reelection.

A delegation of Chilean naval officers, resplendent in golden
epaulets and peaked hats with shiny patent-leather bills, christened
me their navy mascot and provided a uniform to match my title.
Conductor Leopold Stokowski held my face between his outstretched

fingers and called me "a divine instrument," a description evoking my laughter, to Mother's dismay.

Albert Einstein observed that he, too, was poor at arithmetic, which convinced me he was not very remarkable. U.S. Treasury Secretary Henry M. Morgenthau, Jr., returned three times and a Missouri politician stole two pencils from my school desk as a souvenir.

The objective of stardom is broad public response, but on your seventh birthday such affection can turn into a pounding headache. Mine came in the form of 135,000 gifts and greetings. To physically open that many parcels and letters was daunting, so the task devolved on the studio. From Switzerland had come a trained St. Bernard puppy, complete with an empty brandy cask. From Antwerp, Belgium, a hare. From Ireland, lace enough to trim 10 trousseaux. From everywhere an unstanched stream of dolls. Little could be done with such an avalanche beyond sending our thanks and redirecting everything to worthy local children's charities.

Streaming onstage during the final moments of *Dimples* came the full two dozen members of the Los Angeles County Grand Jury to investigate my working conditions. Their visit reflected a national groundswell of support behind a proposed child-labor amendment to the U.S. Constitution. Proponents of this measure claimed little people my age were being abused and exploited. Their visit was too late.

A boisterous tale about gaslit New York with Frank Morgan as a tophatted swindler, *Dimples* pitted me against an accomplished veteran of the legitimate stage who was not about to let any little curly headed kid steal his scenes. Competition for camera attention

had always been a fact of life for me. The kid and the expert could not help but collide.

With Morgan even childhood was no refuge. In my close-ups he proved skillful at monopolizing the camera eye. His hands were always at my eye level. When not shooting his cuffs or wiggling a top hat to deflect attention from my face, he could be counted on to toy with white gloves, wring his hands, or flick a handkerchief in some broad gesture. Both of us knew perfectly well what he was doing. There was no way I could cope, short of biting at his fingers.

Only one of my habits—yawning—seemed to baffle Morgan to the end. Yawning was my natural way to relax. Between the call for "roll 'em" and "speed action," that was the moment. Shutting my eyes, I let the yawn build and run its wide-mouthed course. Right afterward my nose usually itched, down at the end. A quick rub with an index finger fixed that little problem, and I was ready to go.

My mannerisms alerted Morgan, probably because few actors can indulge in them. Pancake can show creases after a yawn, and rouge smears, so wide yawns and rubbing the nose are luxuries denied those wearing makeup. My bare face provided latitude to yawn or rub to heart's content.

Everyone on the set seemed to be following our jousts with silent fascination. One was Helen Westley, a gifted Theatre Guild actress. In a scene together, I stumbled badly. Normally my little mousetrap mind snapped shut on lines and never let go. In this case everything came out as memorized, but it no longer made sense. The lines were gibberish, utterly out of context. Twice I faltered, each time wrecking

the scene. Nobody seemed to know what was wrong. Suddenly Westley covered her face with both hands and moaned.

"God forgive me," she said, "I left out a whole speech." Concentrating on my moves, she had skipped a section of script and provided me a cue completely out of phase, but one obviously calling for a response. Her preoccupation with my technique had done us both in.

Having already survived Morgan's repertoire of abuse, at last I had him in a corner where he had no escape–dancing. When a kid is dancing up a storm, even a pro has enormous difficulty robbing the scene. At the time my Uncle Billy was making a film on an adjacent stage and helped coach me. Aware of my continuing tussle, he added a succession of gestures and rhythmic pauses designed to defeat any attempt by Morgan to deflect attention to himself while I danced.

"You sure do like to dance," Uncle Billy said, wiping his forehead. "You'll never peter out. Guess you'll just grow up."

"I'd much rather dance than act," I replied feelingly.

At noontime following one of the rehearsals, Uncle Billy and I left the set walking hand in hand. Two little black children, bit-part actors I think, caught his eye. We dropped back a little and he asked them if they had money for lunch. They both shook their heads.

"See you later, darlin'," he said, releasing my hand and gathering up the two boys. "We're going to the snack shop. They aren't allowed in the commissary."

"Neither am I!" I called after him, but he didn't hear.

By traditional 1936 definition summertime living was supposed to be easy, a respite from concern, a time of calming restoration of the spirit. For my parents it turned out the reverse. Father had traded in his old LaSalle for a Cadillac, the first of six cars acquired during the next three years, and proposed an auto trip through coastal redwood forests to Vancouver Island, Canada.

By nightfall we reached Eureka, a lumber and fishing town, and driving cautiously in the dense coastal fog, we found our small hotel, facing the railroad station. There an urgent message from the studio awaited. I was the subject of a $25,000 extortion threat, it read. Consider returning immediately; exercise extreme caution.

The threat was contained in an anonymous letter posted 10 weeks earlier to the studio, where it had become commingled with several thousand fan letters and only recently read. Unless the blackmail money was dropped from an airplane on May 15, 1936, near Grant, Nebraska, my life was in danger. That the deadline had already expired lent urgency to the warning from home. The FBI had assumed jurisdiction since interstate blackmail is a federal crime.

The death threat really was no problem. I knew from *Gangbusters* on radio that the FBI always got their man.

My confidence in the FBI was not ill-placed. On July 31, 1936, a 16-year-old Nebraska farmhand was arrested and charged with attempted extortion. Agents sent to stake out the field designated for the earlier air drop of money had encountered him, hoe in hand.

"I didn't mean to go through with it, honest," he pled. "I just did it on impulse after seeing this here picture show about a ransom plot."

Ironically, the sort of film which inspired him had recently received the personal endorsement of FBI Director J. Edgar Hoover. Appearing before a congressional subcommittee, Hoover had expressed support for gangster movies, saying they educated the public that crime is an organized business and that gangsters are "rodents that must be exterminated."

In his one-room farmhouse, the young man's father only shook his head. "Almost as soon as he mailed the letter, he realized it was a crazy thing to do. Now he's arrested. I don't know what to make of it, hardly."

Neither did my parents.

We were greeted upon arrival by another extortion attempt. "Get $25,000," began this letter from Atlanta on August 17. The denominations were specific: $10,000 in $5 bills; $10,000 in $20 bills; $5,000 in $1 bills.

"The boys are plenty sore, and you'd better get those G-men off my trail. Remember, send money if you want to keep Shirley!"

Events again moved quickly. Father purchased a Colt Special six-shooter and a box of shells. The trip ended abruptly. Southward we sped, toward the presumed sanctuary of home. A wretched mood of anxiety shrouded the front seat, but in the back, where I rode in queenly solitude surrounded by books, there was only a sense of excitement, as if the drama were on radio rather than in my life.

Neither bravado nor escape from reality were involved in my attitude. Risks had always been weighed carefully and danger sidestepped where possible. And obviously I acknowledged the perils inherent in threats from extortionists.

Mother resorted to prayer and fairies on my behalf.

From her Hollywood Hotel suite, Carrie Jacobs Bond, optimistic composer of "When you come to the end of a perfect day…" sent me a handwritten note:

"If it should ever get dark and still, light the candle and ring the bell. If the fairies are at home, they will help. I know, because I lighted the candle and rang the bell. The fairies were at home!"

Forget the fairies, I reasoned. A better bet, ring for the FBI.

At home each thump in the night sent Father stalking through the house with his gun and Mother tiptoeing to my doorway to verify that I was alive. Africa, our chauffeur, drove with his upholstered revolver on the seat beside him while I hid in the back seat under a lap robe, my purse nearby stuffed with pebbles and a favorite slingshot.

Just as on *Gangbusters* on September 15, 1936, the FBI seized its latest public enemy, another 16-year-old.

The return address in Atlanta had turned out to be that of a grocery store. Nobody recalled the name at the bottom of the extortion letter. However, the owner did vaguely recall a former part-time clerk inquiring about the expected arrival of a package from Hollywood.

The rest was a breeze for the FBI. Dressed in high-waisted gaucho slacks held up by suspenders, his hair oil-slicked and sporting a gaudy necktie, the boy quickly confessed. The whole idea, he explained, was inspired by a character from a gangster film.

Mother was concerned about my slow growth, slopey shoulders, stocky legs, and rounded middle, all characteristics remindful of Father. Her willowy grace had left little trace on my looks. In league with Dr. Sands and his innovative pediatrician brother, a program was devised to inject pituitary extract into my knee joints to stimulate leg growth. Hopefully, in place of my compact self would emerge someone tall and leggy. While they were plotting how to make me tall, all over Hollywood mothers were doing everything this side of strapping bricks on the heads of their prodigies to keep them short in my image. I need not have worried. In the end my knees strangled the medical scheme in its crib. X-rays proved conclusively that my joints were already fully formed. Despite Mother's impatience and the studio's desire, I was growing up.

Maintenance of my footing at the pinnacle of popularity was by no means certain. To be sure, optimistic estimates of audience appeal abounded. My motion pictures were estimated to have been seen by 240 million people, double the cumulative audience of venerable Greta Garbo and twice the United States population. For the first time my name was listed in Who's Who with a biographical sketch one line longer than that of Governor Alf Landon of Kansas, the 1936 Republican candidate for president. In Europe my popularity was still running a dead heat with the ubiquitous Mickey Mouse, born the same year I was.

Almost 90 percent of the studio's reported corporate net profits were attributable to earnings of my four most recent films. Major

corporate eggs were crammed into one small basket. Lacking
diversified sources of income, the studio was under an uncomfortable
imperative: preserve my earning potential. But that led to one
pounding headache of a problem. Exactly what to do with me now?
In this context and in order to intelligently maximize its economic
return from me, the studio found it critical to clarify the answers to
two questions: first, was my public film image an extension of myself
or one created by the industry; and second, did my popularity stem
from acting, dancing or singing, and in what combination?

The answers involved not only artistic judgment but finance.
Given its tumultuous corporate past, the studio measured good and
bad less by artistic achievement than by bottom-line financial results.
To accede to recommendations for better casts and stories meant
increased costs and reduced profits. It was just that simple. Art had
little to do with it.

One way to handle me was to resist change and stay put, a
strong argument. My formula was working—perpetual childhood
and cheerful resolution to any problem, whether divorce, deceit,
mayhem, loneliness or war. The temptation was awesome.
Simply repeat me, again and again. As long as I was a winner,
it was relatively effortless and profitable. Afterward? Forget me.

Annie Lee is a retired housekeeper now living in Tuskegee, Alabama. As an African American in the South, her working life was at an opposite pole to that of movie stars.

"He didn't like to see me with a black eye. It upset him too much."

———————————◇———————————

I couldn't work in a store as a clerk. Some people worked in private homes in Birmingham. I worked for Mrs. Kanter, Joe Kanter's mother, Sylvia, in Terrace City. It was a lovely place, five to seven miles from Birmingham. I rode the streetcar from Birmingham to Terrace, the No. 22 streetcar. If you missed it you had to wait 30 minutes. I was married. I remember too well. My husband worked as a waiter at a hotel. I had a black eye; my husband was the kind that always blacked my eye. We were eating and Joe, who was 13, left the table in a hurry. He didn't like to see me with a black eye. It upset him too much.

We had a room in a house. Our rent was $8 a month. We had an outdoors bathroom on the porch. You reached up and flushed the water with a chain. I took a bath in a tin tub unless at the Kanters' home.

Some white people were going to Washington to march. They were out of the service and couldn't find jobs. They were going to Washington to complain about not having jobs. I fixed them black-eyed peas, fried chicken, okra and mashed potatoes and some sandwiches.

Every month a different band came to the auditorium in Birmingham—Count Basie, Duke Ellington. My husband and I would dance to their music. You could take $5 and spend it at the grocery and three people would have to take the food in. Spent $1 for dinner for a family then. You could get a decent pair of shoes for $3.80. About $10 for a dress.

Boarding houses were a fixture in 1930s society, all but forgotten today. They were something between a working-class hotel and a bed-and-breakfast, because the owner-proprietor lived on the premises. WPA writer Grace McCune visited **Mrs. Brittain's boarding house** in Athens, Georgia. For all her generous views of life, her way of speaking of African Americans was typical of the time.

"It ain't no wonder that you're a widow. I don't see how your husband lived with you for 18 years." I told him if my husband had ever been in the condition he was in, he wouldn't have lived for 18 years."

———————◇———————

Mrs. Brittain's large two-story house was painted brown and trimmed in yellow. A sign on the front of the house read: "Rooms and meals, very reasonable." The yard was small but clean and had recently been freshly spaded and a few flowers had been put out. The front door was open. The large room was very clean and attractive. Its walls were done in a light cream color, and the woodwork and doors were painted to resemble oak. Freshly laundered curtains were draped at the three large windows over cream window shades. The floor was covered with a linoleum square of dark brown and green. The long dining table was covered with a fresh, clean white cloth, extended almost across the room, and in the center of it was a vase of artificial sweet peas that I at first thought were fresh, but I found that they were artificial and of surprisingly natural appearance. The other furniture included a large buffet, china closet, Frigidaire and radio. A card table, folded up and leaning against the china closet, and a Chinese checkerboard on the buffet gave evidence that the dining room was also used as a living room part of the time.

A small fox terrier came to see if it knew me. As I patted the dog's head, a large black cat jumped in my lap and wanted a share of the caresses. The cook came in to get some dishes and, seeing the cat and dog, laughed. "Lawsy Missy," she said, "you done been 'dopted in dis fambly, cause dat black cat sho don't make friends wid every body dat come hyar."

Mrs. Brittain came in at this time, a tall, dark-headed woman of good figure and medium weight dressed in the very latest style.

"After thinking about everything that I knew how to do I realized the fact that I was better at cooking than anything else, and that is when I thought of a boarding house. Boarding houses are like any other kind of business. Someone is always trying to do you. And this was true in my case. My rent was $30 a month. A woman just below me on the same street was also running a boarding house. She was always wanting to know how I managed so well, and how could I keep my boarders so long, as hers were just coming or going all the time. I worked hard, and told her that I did most of my own work and that my children also helped when they were out of school. We didn't pay out everything we took in to servants, and our personal work and attention helped to keep satisfied boarders.

"Even at that, she wasn't satisfied and told the man I was renting from that she would give him $15 a month more than I was paying. He said that I could stay on if I wanted to pay the extra money. I didn't feel able to do that, so I told him I'd just move and she could have the house. I rented this house and have been here ever since.

"The other woman moved in, took part of my boarders, as I did not have room for all of them here. But child, it never pays to try to

undermine anyone, for in a very short time she was almost without any boarders at all. It looked like bad luck hit the poor woman, who got the house from me, and I was really sorry for her, for she just kept going from bad to worse, and few years ago she was so up against it that she drank poison and died before they could get her to a hospital.

"One of the greatest problems in this kind of work is keeping good help that you can depend on. This is such hard work they get off in the afternoons, but how they do hate to come early in the mornings. Most of my boarders are all working people, and they want breakfast not later than seven o'clock. My day's work starts around 5:30 to 6 in the morning. I usually get the breakfast started before the cook gets here, but she's pretty good and it's never much after 6 when she gets here. I pay her $4 a week and feed her and her little boy.

"She was off sick and sent another cook in her place. The first night after supper, this new woman asked if she couldn't just take her supper home and eat while she rested. I said alright. But as she was leaving eggs began to roll down her sleeves and hit the floor. She must have had at least a half a dozen up her sleeves. She was scared so bad, she didn't wait for her supper. I had to scrub the floor and that cook didn't come back. That's the trouble with help. We cook with wood and I keep a good supply on hand at all times. And the cook I had—that nigger was helping herself to wood. Yes, ma'am, she loaded up a wagon full. A policeman came by and asked her what she was doing. She told him that she worked for me and she furnished her wood. He told me about it and said he had noticed her sending wood out several times. That's the thing you're up against.

"We have dinner from 12:00 to 2:00, as we have a good many students for meals, and most of them meet here by two o'clock, but

when they can't, she fixes them their plates and puts them in the warming closet on the stove.

"Sometimes they slip out owing me a month's board and some beat me out of more than that, but for everyone that does that way I usually find someone else that is a good honest payer. When the overall plant near here opened up again after it had been closed for some time, the man that came here to run it came to me and made arrangements with me for his meals. Well, I never got a cent for them. But I was not the only one he caught, for he used the firm's money, gave the help bad checks and owed everyone in town who had let him have anything on credit. Yes, he got out of it some way. I never could understand how.

"I have some boarders that have been with me for seven and eight years, and there are other people that have just been having meals here for that long. My daily rate for board is $1 a day, but the weekly rate is $6, and by the month $25 for the men, $20 for women and students. Meals are 25 cents, and you know I make good on those meals. The other houses around here say they do not see how I can clear anything the way I feed, but I do.

"I think the working class of people suits me the best. They are more considerate. I guess it's because they have to work and know how it is I work, too, and then the students I have are very quiet but they are all congenial, and every night they play cards and checkers or some just sit around and play the radio, or read and study.

"They all like to tease me and play jokes on me. For instance, not long ago just at lunch time when most of them were here, a very nice-looking middle-aged man who said he was a Methodist preacher

came here with a young man that he said was his son. He said they were going to be in town for a few days and wanted a room and meals. I showed him a room, and they took it. Well, they had lunch, came back for supper and everyone liked them. After sitting around and talking for a while they said they were tired and were going to their room. And that was the last we saw of them, for instead of going to their room they left without paying. Oh, yes, the boys sure did tease me about that. I am a Methodist, too, and they told me that if it had been a Baptist preacher he'd have paid for his meals. I told them that if they had been Baptist they would have at least slept part of the night, instead of leaving a good bed like that."

Just as fast as one table finished eating, the table was fixed for the next, and they didn't stop coming until about two o'clock. There was plenty to eat, most anything that one could ask for, even two different desserts for 25 cents. As lunch was almost over a boy came in and said, "Well, folks, the Music Man's in town." Everyone looked at Mrs. Brittain and laughed. A very neatly dressed, well-groomed old man came in. He was greeted by them all and asked, "Am I too late for lunch?" Mrs. Brittain told him she was sure they could find enough food for him. He then wanted to know about a room. One of the boys said, "Put him in the room with me. We'll be all right." The old man said, "That's all right with me. That boy has been needing a spanking for some time, and now I'll have a good chance to see that he gets it."

Mrs. Brittain's daughter said, "That's the Music Man. He tunes pianos for the music houses here, and also teaches music. We tease mother because he's a widower, and he really wants to get married."

Mrs. Brittain said, "Well, from what a man told me the other night, I'll never be able to marry again. I had a new man who had

only been here a few days. And he came in late and got in his room without me knowing he was beastly drunk. He stumbled over the chairs and tables and then fell out of bed. I heard the other boys laughing, so I got up and went upstairs and told him he would have to get out. He finally left, but he stopped at the door and looked at me, and said, 'It ain't no wonder that you're a widow. I don't see how your husband lived with you for 18 years.' I told him if my husband had ever been in the condition he was in, he wouldn't have lived for 18 years.

"One of my neighbors said, 'Mrs. Brittain, how in the world can you give away so much? I can hardly meet my bills. I don't know why it is, I just can't keep any boarders, and what are here don't pay half of the time.' But this neighbor of mine doesn't take an interest in her work. She will not fix for her boarders as I do. She will get out for her bridge and other pleasures and let her work go undone. I don't know which is right, she or I.

"I have learned many things in running a boarding house. One thing I have not been able to learn very well and that is to turn away people that I feel like really need help. But I do now require traveling people and others that I don't trust very much to pay in advance for their room. I guess if I had done this long ago, I would have saved something.

"It's been a pleasure to have you and I hope you'll come back again. But you really should stay, for I see the Music Man coming up the walk."

Ron Postal designs and manufactures men's clothing. He is past president of the Financial Council of Men's Fashion. He grew up in another universe from Mrs. Brittain's boarding house.

One day I see a crowd standing along there. I said to someone, "What do you think they're doing?" "They're digging up some bodies."

———————◇———————

We lived in Brownsville, Brooklyn. Brownsville of today is far worse than it was in my day. The tough people, like Mike Tyson, come from there. In my era, it was gangsters. Mobsters. Murder, Inc., that was the gang. There was a bar and tables and chairs and a back room, and it was the hangout. It was called the Kit Kat and it was located in a four-story tenement. The tenements didn't have elevators. Three or four flights and they'd have a pigeon coop on the roof where they'd raise, breed, just play with pigeons. It was a fascination. These tough mugs, the way they would carry on with these birds. And now these guys turned around and killed people for a little money at that time.

I lived just across the street and the neighborhood was tough in a different sense. Joe "Pretty Boy" Amberg and his chauffeur, Morris, would give me a ride every now and then in their big beautiful Cadillac. Across the street in the garage, they had parked their car. And they got killed. It was a gangland slaying: both Amberg and his chauffeur got killed in the garage. It was a nice day. There was an area known as Canarsy. The Canarsy Flatlands. It was an empty area. One day I see a crowd standing along there. I said to someone, "What do you think they're doing?" "They're

digging up some bodies." And two men, the Shapiro brothers, were buried with their penises in their mouths. Which meant they were snitches. Squealers. This was Christopher and Blake area where this Kit Kat club was. Some of the upper echelon in the Mob were on Saratoga and LaVonia Streets. A.B. Reles was a top mobster. He would get drunk and yell, "The niggers, the niggers." He was terrible. He would shoot any black guys that he saw. He would just shoot

A New Deal program to combat slum crime: subsidized public housing.

randomly. The blacks would see him and yell, "A.B. Reles is out," and they'd close their doors. A.B. Reles was involved in something and they had him in a hotel in Coney Island, the Half Moon Motel, I think. And one day he was found dead, plunged from the window.

Murder, Inc. That was the gang. They hung out on Saratoga, LaVonia, Christopher and the Blake area. Some would take contracts for very little money. And they'd go out and kill one another. Nothing unusual. They were bought cheaply.

I set my life's pattern at that time. I graduated high school, Thomas Jefferson High. What was a Jewish kid to do as far as work? So you'd go to the garment industry. Fortunately if you had a relative and didn't mind working for them, you had a job. Jews were discriminated against. I recall the forms in personnel when you applied for a job. They had religion as a question. At that time you had to put down Jewish and you were a dead duck.

My father was a shoe worker; he worked hard. That was the essence of the immigrant. His donation to this country, the work ethic. My father used to go to work in the morning in the shoe factory. And then he would go and sew, sew ladies' slips. Like a sheath. He would cut, sew and peddle them at night so I never really had a relationship with my father as a result. Time consumed away. Which is atypical of most immigrants.

I used to go to school and worked doing laundry. I also worked at a light manufacturing company. I'd deliver the clothes on the subways and Els. And for Hallmark we would fold cards. Stretch, Reles—I used to run errands for them. That was the best job of all. They paid very well. They liked the Jewish delicatessen, and there was a deli a block

and a half away from the Kit Kat and they'd send me over. I'd run when they had the taste for a hot dog or pastrami. They wanted it then and there. A lot of them had quality sides to them. They had great respect for their mothers, women per se. Girls who lived at home.

One time I was asked to deliver a package about the size of a dictionary to the Park Central Hotel in mid-Manhattan. I got a big tip, I remember. When I returned, Stretch, who had taken a liking to me, said, "Come here, kid. Where ya been?" I gave him a vague answer. He said, "Where have you been?" Then he said, "I know you want to keep your mouth shut, but when I ask yousomething, you answer me." I wouldn't tell him. You learned to keep secrets. I wouldn't say a word. And he bawled me out and he finally got the information from me that I had delivered a package and who had given it to me. And he went over to Pickles (he ate a lot of pickles and used to send me to get him pickles and a piece of brie), the mobster who hired me, and had a talk with him. It was dope that was delivered. Stretch was protecting me.

It afforded me an opportunity to understand life a bit. What was the easiest way to get out of your situation at a low level? You became a fighter or a boxer or a gangster. What is happening today? The same thing. Today they have more opportunity because sports are in a greater number.

My family was typical of that generation. They were distinguished by their lack of display of tenderness or compassion or an expression of how much they loved you. I think that accounted for a lot of youngsters who grew up in my time without an open expression of love. But you understood that the love was just as great. You didn't need it expressed every day.

71

Studs Terkel is a historian of life and manners with the instincts of a performer and the heart of an actor. *Studs' Place,* in which Studs was the proprietor of a fictitious diner, pioneered new dramatic ground on TV. He has published 10 books of interviews with street people, the rich and infamous, trendsetters and trend followers. In fact, he invented the kind of book we've made. Here is our interview with Studs.

"We're suffering from what I call a massive Alzheimer's disease. The kids are not told about the Depression by their parents...their parents were ashamed..."

———————◇———————

Roosevelt was elected in 1932 and passed various laws and regulations that saved the hides of the various ones who condemn big government today, you know. Or the ones whose daddy's or granddaddy's asses were saved by big government, by the New Deal. But the big year for the New Deal, the big term, was 1936 to 1940. Those were the great years when the big changes took place, when the WPA came into being. And the great thinker of that time was Henry Wallace, Secretary of Agriculture. All kinds of help came to the farmers who were starving and dying. All sorts of regulations were passed to help the farmers, and the Department of Agriculture also created something called the Resettlement Administration (later named the Farm Security Administration). He played a role in that. The photographers Margaret Bourke-White, Walker Evans and Dorothea Lange depicted that. In Roosevelt's second inaugural address in 1937, March 4, he said, "I see one-third of a nation ill-fed, ill-clothed, ill-housed." No president had ever spoken that way.

The federal government played an important part in our lives.
Before the New Deal the federal government played no part in our
lives except for the post office. But the New Deal saved the country
from God knows what, the greatest depression we ever had. The
very ones that think of privatization today and too much big
government are the ones that erased our memories of what happened.
When I wrote the book *Hard Times* (in the '70s), about the Depression,
I went to see one of the wise men of Wall Street who was there
in the Crash of 1929. Sidney Weinberg was a senior partner of
Goldman Sachs, a very respected investment-banking house. He
didn't know what the hell was going on. I said, "Tell me what
happened that day when the Crash occurred." Because the '20s was
like now, everybody investing in stocks, going crazy and all that and
then–POP!–something happens. The big government saved their
asses. And these are the very ones who say today, "too much big
government." The reason it's important that you do this book is
to re-create the memory of it. We're suffering from what I call a
massive Alzheimer's disease. The kids are not told about the
Depression by their parents. They were never told what it was
like to be poor during the Depression because their parents were
ashamed themselves. They blamed themselves. The American
dream went kaput. And these people live the American dream. If I
work hard and do well, I'll be the boss behind the mahogany desk.

That year I was in Chicago. After leaving law school, which
I hated, I got a job as an actor in soap operas. Then I got a job on
the Writers' Project, the WPA. We did scripts. I was in the radio
division. I had a civil servant job in Washington for a short time
that year. It paid $1,260 a year. I was going nuts with that job, so
I came back to Chicago and got an acting job. '36 was also Spain,
the Spanish Civil War. I was sympathetic to the Republican army.

The first time in history the peasants had had an election and they won. The Socialists won. But meantime the Fascists, Hitler and Mussolini, were starting and they hated the Republic, so they helped Franco, who was a Fascist general and of course they beat down the peasant army. And then American boys knew and those from other countries joined the International Brigade. A lot of them were killed. There was an embargo on Spain and the embargo meant that Franco was going to win. There were people campaigning, Lift the Embargo on Spain. I was one of them. Franco won. And this was the overture to World War II. These peasants and farmers didn't have a chance and only volunteers were helping. A very gallant effort. So Hitler and Mussolini helped Franco overthrow a legally elected government, and we've been doing that ever since in Latin America and elsewhere.

1936, great ideals and hope and trauma.

John Wadleigh's journey from Depression slums in New York to a novelist's life as Oliver Lange is a darker and unforgiving view of what others in this collection often seem to recall as a kind of familial paradise.

"Children are, by and large, as fragile as granite boulders. They survive."

———————◇———————

"C ulturally deprived" is as adequate a term as any to describe my condition in the Depression years. Luckily, I had no idea I was deprived; if I had I wouldn't have known where to go to register a complaint. My mother, grandmother and I lived in squalid eastside cold-water flats along with an ethnic salad of Slavic, Italian and German poverty-stricken losers. Such apartments rented for $20 a month and there was in fact no hot water, only a single tap above the big kitchen sink. They lacked heat, too, except for a coal-fired stove for cooking. Dangerous kerosene heaters warmed the bedrooms.

On each floor there was a communal toilet. If the johns on other floors were broken, the tenants patiently queued up on our floor. A waist-high boy like me tended to notice that his bottom often smelled of dried shit. With neighbors, it paid to maintain a polite distance. Health was poor because of bad diets—potatoes, cabbage and Crisco. There was great flatulence. It was heard everywhere. Teeth rotted. A mouth-to-mouth kiss was not something to be undertaken lightly. People scratched a great deal, from vermin bites, scrofula, ringworm, scabies.

Tenement dwellers were not big on personal hygiene since there were no bathtubs and, anyway, water had to be heated on the

kitchen stove. Laundromats, along with Puerto Ricans, had not been invented, and refrigeration was limited to wooden iceboxes.

The buildings dated from the 1890s and were appallingly filthy and neglected, but, oddly, everyone took pride in having sparkling clean windows, perhaps so that nosy neighbors could look in and satisfy themselves that nothing unseemly was going on across the alley. Rarely, the apartments were redone with an eye-watering oil paint laced with arsenic and lead. It affected infants teething on, say, a nearby windowsill molding, crippling their growth and mental facilities. Nobody knew why. Mothers sighed and said it was God's will.

Rotting garbage accumulated on each landing. Among families, rape, incest and other interesting perversions happened. The poorly lit cellars were scary, gloomy dungeons containing junk and occasional creepy child molesters; no kid played in a cellar. Booze, not religion, was the opium of the masses—it was the slumdweller's panacea. On Saturday nights things got fairly noisy, what with spouses and kids being smacked around, but drugs, even marijuana, were used only by the "sex-crazed coloreds," who were kept up in Harlem, thank God!

Powerful prejudices shaded every opinion and were taken quite seriously: garlicky Italians who lived two blocks south had fine teeth but were syphilitic, it was a scientific fact that Negroes were an inferior race—all you had to do was look, if you had a Hungarian for a friend you didn't need an enemy and no Jew had ever committed suicide by jumping overboard in the mid-Atlantic because he'd feel cheated of the full fare he'd paid. Even then there were jokes about dumb Polacks.

A few, like my grandmother, could write their names or read simple words. Education was viewed with suspicion. A strong back and a willingness to literally work yourself into an early grave for a pittance were valued more than books. Too much schooling made a kid uppity, and if he brought home a report card with A's and gold stars his parents scowled, "Don't get above yourself!"

In the back alleys, German oompah bands—cornet, trumpet, trombone, sousaphone—played corny Strauss waltzes for pennies, and the knife-sharpener, with a grinding wheel strapped to his back, sang his services: "Fi' cents, sharpen you knifes like-a you never saw!" There was the organ grinder who pumped out tunes on a hurdy-gurdy, accompanied by a wizened little monkey tethered on a long cord and wearing a tiny jacket and red fez, who scampered after coins flung from above. Kids thought it sidesplittingly funny to heat pennies red-hot on the stove, scoop them up on a spoon, toss them to the monkey below and then watch him go nuts trying to pick them up.

Nana, my grandmother, supported us by scrubbing floors in swank office buildings from midnight to dawn for pay as low as 40 cents an hour, a pitiful wage even in those hard times. My dad was a hopeless drunk who'd gone out for a drink with some pals in 1932 and forgotten to return. My mother, who also had a hollow leg, was a sort of Depression-era liberated woman. Still in her early 30s and pretty, she enjoyed men and night-long carousing—the two went together—an unrepentant hellion, and she didn't care who knew it. She had a stunning lack of morals and maternal instincts, and was the neighborhood disgrace. Everyone said she would come to a bad end, and they were right. Oh well, *de mortuis nil nisi bonum*—of the dead say nothing but good.

Early on, I picked up the few rudimentary skills necessary to take care of myself and developed the idea that from what I could see of people, I was probably my own best company. Since then not much has happened to change my mind.

In those days a nickel had value. For a nickel you could telephone anyone in New York City from a glass-paneled booth on the corner. But there was a problem: In all the world I didn't know a soul with a telephone. No one in the tenements had one. Like deodorant, telephones were an unheard-of luxury. Moreover, for some unfathomable reason, I was terrified of them. I understood vaguely that the mysterious dial was connected somehow to a vast electrical network, but my mind was confounded by those fingerholes with their enigmatic letters and numerals. Suppose you put in your coin and accidentally dialed some secret number that blew up every circuit in the city? Suppose you dialed the wrong number? What if some total stranger answered, "Hello, who the fuck is this?" All you could do was hang up and run for your life! You couldn't even apologize because your voice might be recognized and reported to the police.

So I avoided phones. In school the science teacher said they were one of civilization's great inventions, but what the hell good were they if you didn't have somebody at the other end listening to what you were saying? Even today this odd phobia persists, and when the damned thing rings, a recluse like me has to brace himself to keep his knees from buckling.

There were also wonderful sides to that early life. A boy could walk or roller-skate all over Manhattan, an endless treasure trove for the impoverished young sightseer. There was Central Park—Evangeline's forest primeval, though somewhat hemmed in by skyscrapers—at that

time safe for a youngster to wander alone even after dark, where, as a
citified Huck Finn, I taught myself to fish in the lake using a bent pin,
thread and doughballs for bait. The cops were terribly decent with
tenement kids and would often stop and say, "Having any luck,
youngfellermelad?" I'd proudly display a few spiny sunfish.

Central Park Zoo was an endless delight, with its diving seals
and the cat house that stunk mightily of lion and tiger piss. In the
educational monkey house you could dodge chimp turds flung
with surprising velocity or watch the macaques dreamily blowing
themselves—"As good a way as any for the poor creechurs to pass
the time," the keeper remarked.

There were the museums, free, like the Metropolitan on Fifth
where, prowling galleries silent as crypts, I first discovered true
beauty, and where I learned in the medieval armor exhibit that
oldtime knights weren't much taller than I was then and that ancient
matchlock arquebuses fired round slugs to shoot Christians and
square ones to kill Turks and other nasty infidels. A boy never
knew when such information might come in handy. There was the
American Museum of Natural History with its lifelike dioramas
filled with wild animals, where I discovered that a whole world
existed somewhere out there beyond the slums, if only I could
survive long enough to find it.

And in our kitchen there was a cheap plywood-veneered Philco
radio that brought in still another world: classical music on WQXR,
whose announcer claimed that a week of listening to the station
would expose you to more fine music than a wealthy 18th-century
Viennese could hear in a lifetime. Wolfgang Amadeus right there in
the apartment!

Best of all, for me anyway, was a branch of the public library nearby. There, at least in my feverish imagination, I escaped the tenements forever, tagging along with Marco Polo, farting around Africa with Livingston, sledding Jack London's Klondike with my team of beloved malamutes, signing up for a voyage on Melville's *Pequot* or Darwin's *Beagle* or suffering an Antarctic winter with gutsy Shackleton. Of books, yes, there was no end.

Children are, by and large, as fragile as granite boulders. They survive. I survived, became a novelist and have had a wonderful life. Even so, I'd just as soon not make the trip again.

Hitler versus the 1932 Buick

—————◇—————

Gordon Wagenet,
now a lumber manufacturer
in Willits, California, took his
first drive behind the wheel
of the family car.

In 1936, my father had
just been appointed to an
administrative job with Social
Security, and they sent him to
Europe for three months to study
similar programs in France and
Germany. That left our old family home in Connecticut vacant.
I was put in charge to watch the house for the summer.

The family car, a 1932 Buick seldom driven but kept polished,
was on blocks in the garage. With a 15-year-old's concern for this
family treasure, I decided it should be lowered off the blocks and
driven a few miles for the good of the battery. In backing it out,
I took the garage door off its hinges, smashed a taillight and put
a big dent in the side.

In Europe, my parents heard Hitler speak, openly threatening
war. On their return, my father tried unsuccessfully to sound the
alarm in Washington, then returned to Connecticut and told us about
the dangerous situation. When he finished I said, "That doesn't
sound good, but I've got some really bad news. The Buick…"

Bil Keane is a cartoonist, well known for "The Family Circus," now read by 100 million people daily in 1500 newspapers.

"*For me 1936 was a very good year.*"

———————◇———————

1936, as a high school freshman in Philadelphia, PA, (where I sat beside Benjamin Franklin) I taught myself to draw by copying the weekly cartoons by my idols in The New Yorker. It was the beginning of a career that had me cartooning through three years in the army in WWII, on to the Philadelphia Bulletin and eventually to create "The Family Circus." For me 1936 was a very good year.

Rabbi Leonard Beerman, a member of the executive committee of the Human Rights Watch organization, is founding rabbi of Leo Baeck Temple in Los Angeles.

"...we had no Hebrew school or Sunday school. At home I learned about the Jews."

———————◇———————

When I was 7, our family moved from my birthplace in Altoona, Pennsylvania, to Owosso, Michigan, population 14,000, with a Jewish population of seven families. My parents tried to bring in a *melamed* from Detroit 80 miles away for the three or four children of school age. This didn't work. So we had no Hebrew school or Sunday school. At home I learned about the Jews. About how they were always good and always persecuted. My parents welcomed the Shabbos (sabbath), I knew all the *berochos* (prayers). We had a Seder and brought matza in from Detroit. My mother made marvelous dill pickles in a crock that stood in our screened-in back porch. For the holy days my father rounded up a Jew here and there from neighboring towns. To conduct services (in the Odd-Fellows Hall), we brought in a student from the Hebrew Union College in Cincinnati. He stayed in our home.

Owosso was struck hard by the Depression. We had a few wealthy people, but there was no evidence that their wealth trickled down to the rest of us. The only factory in town was closed down. Its workers, the Slovaks and the Hungarians, enticed from their homes in Europe to work there, sat around on street corners or in the pool hall on Washington Street. In nearby cities, Pontiac, Detroit and Flint, there were sit-down strikes and the uprising of the labor unions.

I was confused and somewhat frightened by all of this, especially by the deepening impoverishment of our family. And yet a certain fabric of ideals and feelings was beginning to take form in my developing mind. The strands of it were poor people, the men in the factories working for low wages or standing outside of them unemployed and the powerful forces that cut them down. Cut my father down, cut us all down together and me, as well, a little Jewish boy trying to be big and strong and good.

That experience, linked to the values already imparted to me by my parents, served as a ground for what I eventually came to believe was the central facet of being a Jew: to have compassion for all people in their vulnerability and to be among those who would try to extend the domain of justice and love and simple decency in the world. This would become my song, my sermon.

A WPA writer talked
to housewife **Lucille
Keller Billman** of
Raleigh, North Carolina.

*"At the age of 14 I got
married, and I want to say
that's another thing I don't
believe in: child marriages."*

———————◇———————

I'm a victim of a large family, and I don't believe in them. I helped work for my father's family when I should have been in school. It was this way with all my brothers and sisters: they all had to help support the family. We were denied the advantages children should have because of that large family, and we had to exercise the greatest care in spending and see that not a penny was spent foolishly. So you see why I'm so disgusted with large families for poor folks. They have got no business with them.

I began work in the cotton mill at the age of 13. I did manage to finish the ninth grade in school before I quit entirely to go to work. My father was sick, and I was the oldest child. Week after week I brought my pay home and turned it over to them, and about all I ever got out of it was what I ate. At the age of 14 I got married, and I want to say that's another thing I don't believe in: child marriages. When I was married I didn't realize what I was doing. I knew very little about sex or what was required of a wife. I had never given a minute's thought to what it meant to be with child for nine months. I knew that childbirth was painful, but I had never realized the seriousness of it or what it meant to be a mother.

My husband was 19 at the time of our marriage. He was of a small family, having only one brother. At the time of our marriage my husband was construction foreman for a local concern. His salary was $25 a week, and if we had been older we could have lived well on that; but our inexperience made it difficult for us to get along. At 15 I found myself pregnant. We were living with my folks and they did all they could to help us out. He got along all right with my folks, but he wanted to move over to his mother's. I refused and we began to quarrel; we were both stubborn. My condition took a lot of the romance out of me, but I still loved my husband in a way. At last, however, I told him to go live with his folks and I would live with mine. He left. My baby came. I worked in the mill while Mother looked after it. It was a boy and she taught him Christianity, unselfishness, love and respect for all.

We separated four times by the time I was 22. During the times we were separated I went with other men, but I never loved anyone but him. Then we decided to quit our foolish ways.

We got an apartment and set up a home of our own. That was six years ago, and I find that I have never before been so happy in my life. My husband has a good job now with an express company. I keep his books for him and have his meals prepared on time. We own a car and he takes me with him on trips, or we go out riding most every day. Our son is well, healthy and strong. He is about all a real boy can be and we are both proud of him. Being raised in a large family and allowed to associate with the neighborhood children, he is unselfish and broad-minded. He can give and take.

I believe in birth control, especially among poor folks, but a child raised by himself is generally selfish. If people are going to

have any they should have at least two so one would be company and playmate for the other. I would have another child if I could, but I have had an operation for female trouble that has made me barren. It's the only time I ever was confined to a hospital and the only time I ever had a doctor except when my baby was born.

I feel everyone should have at least a high school education because this is required by most businesses employing help now, and then it helps a person in trading and keeping what they possess. Most every child of the middle class can get a high school education now with the improvement in the present school system, while I think the schools could be improved more. There is too much time given over to play in the schools now—too many socials, entertainments and societies.

I believe in using home remedies as much as possible and calling a doctor as the last resort. Our medical bills for the last six years have not been over $5 a year average. Our family is small, and it does not take so much for us to live on anyway. Three people can live comfortably on $15 a week and have plenty to eat and decent clothes. They can live well on $25 a week. We spend $25 a week most of the time, while we could live comfortably on much less. We give about $25 a year to the church. Everyone should attend church. The way the masses are losing interest in this is alarming. In regard to politics, I am a Democrat and so is my husband. I think we have better business conditions under Democratic rule, especially the Roosevelt administration. Of course, all my ancestors were Democrats, but I am not influenced by this fact.

Our amusements are few but adequate for recreation. We go to ride most every evening, and my husband goes hunting and fishing

during the season. We attend shows now and then, while we are not so interested in them. We do not attend dances anymore, but when we were younger we danced. My husband and I attend ball games often. He is somewhat of a fan. I do not care so much for foot-, base- or softball games, but he is very much interested and I enjoy going to the games with him.

This is the happiest period of my life. My husband and I have always loved each other. We're older now and understand each other better. Our son is a great pleasure. We have both vowed never to separate again, and we're looking forward to the happiness we now enjoy to continue. We are both striving to make our present situation a condition that will last until death shall separate us.

Above all, we are trying to live Christian lives so that when death, the necessary end, shall come, we will find still more happiness in eternity.

Al Hirschfeld is famed for his illustrations and caricatures of theatrical personalities. His fine eye for the telling detail also pilloried political posturing.

Then, as now, the distinction between theater and politics was often a hard line to draw; politicians as actors, politics as farce verging on tragedy.

Mussolini and Britain's Neville Chamberlain dig a grave for peace—a savage political cartoon in contrast to the genial celebrations of Broadway Hirschfeld still produces, 65 years on.

Tamara Geva, Ray Bolger in *On Your Toes.*

THE OLYMPICS

Albert Hague is an actor (he played Professor Shorofsky on *Fame* and appeared in myriad other TV programs) and the composer of many Broadway shows, including *Plain and Fancy* and *Redhead* (for which he won the coveted Tony Award). He is the composer of the perennial CBS special *How the Grinch Stole Christmas* in collaboration with Dr. Seuss. He lives in California with his actress-writer wife, Renee Orin. In 1936 he lived with his widowed mother in Germany and, like his friends and schoolmates, celebrated the coming Olympic Games.

"Learn to play the piano well and you'll always get a bowl of soup," my mother said.

———————◇———————

I t was 1933, the evening of the first day that Hitler came to power. Our household was in an uproar because Edith, my older sister, and her boyfriend Horace, who were both extremely active in an anti-Nazi movement, had to get the hell out of Germany before midnight. The borders were to be closed—one of the first edicts declared by Hitler! Frantically, they destroyed all documents that might implicate them. The irony of the situation was that during this frightening time, all my sweet mother—Mamachen, as we called

her—could think about was that her daughter would be traveling with a man who was not her husband. Edith and Horace managed to get to England and to safety. In my 12-year-old innocence, I didn't comprehend what was happening. A few years later my oldest sister, Gretl, fled to America, leaving Mamachen and me alone in Berlin. I announced to my widowed mother with all the decisiveness of a precocious 15½-year-old that I was going to become a professional musician, a composer, in fact. My pragmatic mother replied, "So you're going to be a bum for the rest of your life. You'll be an

educated bum. You'll go to college! Learn to play the piano well and you'll always get a bowl of soup." I'm sure she never read the Benjamin Franklin quote, "It's tough for an empty bag to stand upright. Since being poor is undesirable, train yourself in the qualities that make money." But she was certainly on the right track. I've eaten a lot of soup in my day.

Like many German Jews, my parents firmly believed in assimilation, so I was not brought up in the Jewish faith. We attended the Lutheran church. It was different from the American version. You listened to a lecture about the politics of the day, sang a few songs, put money in the basket and went home. If I would have stayed in Germany until I became of draft age, I'm sure that my real heritage would have been discovered, and I would have been dealt with in the infamous Hitler fashion.

During preparation for the 1936 Olympics I was a student at the Kaiser Friedrich Gymnasium. As the games approached, the students were asked to help—we were ecstatic. I was to be a French interpreter; luckily no one ever put me to the test. I don't think I would have been able to guide someone to the knockwurst stand, let alone have a proper conversation. I still have some programs from this incredible experience. I was there the day Hitler refused to shake Jesse Owens' hand. We were so naive. Obviously, Hitler was a madman, but he had been so selective in his devious "hate crimes" against the Jews up until then that we really couldn't anticipate what was about to take place. The Jesse Owens incident should have tipped us off.

One night in 1932, the principal of **Lou Zamperini's** school, his brother and the chief of police got together because Lou was in trouble all the time, running away from home. They said, "How about sports? Get him out for track. Running in the right direction might change his life."

"The Olympian athletes in those days were a mostly shy lot. Today they hold up a track meet by walking around slowly and bowing every 50 yards."

———————◇———————

In 1936, my brother said, "Take it easy, the Olympics are coming," but there were five great milers in the nation. I'm talking about college graduates, mature men, and here I'm a high school record holder, but I figured I couldn't get within the first three places so I just gave up. But then there was an article in the paper that the second best 5000-meter runner, Norman Bright, was coming to Los Angeles to run, and this guy would no doubt make the Olympics. My brother was into coaching and he said, "I want you to run against this guy just to see how close you can get to somebody who will make the Olympics. You got two weeks to train." So I ran my guts out for two weeks, got in the race in Compton. My brother said, "There's a lot of laps in the 5000 meter so I'll let you know when the last lap comes and you can move out to do the best you can."

I always had a good kick, and I figured I'd gain on the guy, but my brother miscounted the laps. He had me move out in the last half mile and that's a long stretch, so I passed this guy and he couldn't stand it so he passed me, I passed him, he passed me, and people were going crazy, the place was a sellout and the officials were so

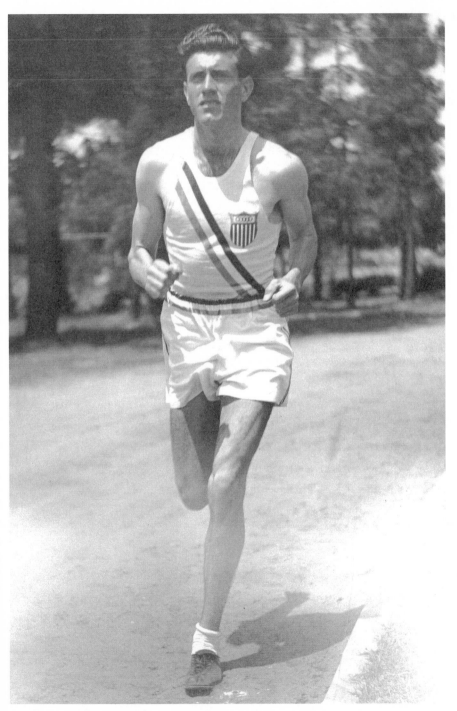

Lou Zamperini between meals.

excited they didn't do their duty—so we were coming around the last 200 yards and I finally pulled away from him permanently—5 yards, 10 yards, 15 yards—and I'm coming down the home stretch, a kid from San Pedro, and I'm about to lap him. The officials—all of a sudden they noticed what was going on—but instead of having him step off the track on the inside, they motioned him outside. I'd already started to pass him so I was forced into the grandstand, which was eight lanes out and now my opponent was ahead of me. I had 50 more yards to catch him and I caught him at the tape, and he beat me by about an inch. So I knew I could beat him.

On the strength of that performance I got an invitation to the Olympic tryouts in New York. It was unbelievable. My dad, fortunately, worked for the Big Red Car *[The famous local railway system that once linked Los Angeles together, dismantled in the 1950s—Ed.]*, which gave us a round trip on a Southern Pacific railway anywhere in America. In those days you had to find your own way to the Olympic trials or you didn't get to the Olympics. So anyway, I got on this train and the city dads in Torrance gave me a suitcase and shaving gear, and the merchants took a collection around town so I'd have money to buy food and have a place to stay in New York. So now I'm on the train with all these great athletes. The city of Torrance got a little overanxious and on the side of my suitcase they had painted "The Torrance Tornado." I about died. I got a roll of tape and covered it. I was 18.

So I got to New York and I'm running against Don Lash, who was the world record holder for two miles. Well, that was so far beyond me, there was no way I was gonna beat him. I just had to get second or third. On the last laps—he and his teammate were ahead of me—I puffed up behind him but psychologically I couldn't

pass a world record holder, so I just stayed there. Then on the last lap—same thing—I just stayed there like a dumbbell. Then when I realized the race was almost over—we had 200 yards to go and we're already on the curve—then I tried to pass them—I'm in the third lane—but we came in a dead heat and that was a shocker. I just ran into the shower room—in those days you didn't parade around, wave your hands and so forth—athletes were a shy bunch. Usually they just finished racing and disappeared. And they couldn't find me. They said, "Well, we're not sure who won, and then they showed the films that night and at first they said I won, then they said it was a dead heat. Anyway they gave me a first-place certificate. So I made the team.

Everyone in Torrance was excited. See, the city of Torrance never had an athlete. On the boat, the SS *Manhattan*, my first time away from home, and I'm sitting with these big athletes around big round tables and I couldn't believe the food. I'm an Italian boy. I'm used to eating spaghetti, lasagna, chicken cacciatore and here there's all these sweet rolls and they kept bringing food and food. So I started to eat. I ate and I ate and I ate, and nine days later I gained about 10 to 12 pounds and I didn't lose the weight.

The Olympic Village was the greatest ever, and it will never be exceeded. Of course they built it and used it eventually for officer's training. They had lakes in there for the Finns for when they take their steam bath and they dive in the water. The dining room had all these doors, each one was a different country, so each day I went into a different country to eat. Like an idiot. I was having so much fun and eating so much food that the Olympics were secondary. And I kept gaining weight and I kept training and I couldn't keep up the pace because of the extra weight I had gained but I always had a

great kick, nobody ever passed me from behind. There's something my brother taught me when I used to complain about the third lap in the mile. He'd say, "The other runners are tired too—but look at it this way, you've got one lap to go—about a minute—isn't one minute of pain worth a lifetime of glory?"

So I'm behind 50 yards—I'm in the second pack of runners—up ahead there are seven runners and so the last lap I open up and I go from one pack to the other, and that's quite a sight to see a guy gaining 50 yards in one lap—I'm up in the first pack now—but I still got eighth place, so we're all within the distance of the length of this room. Coach Robinson and Coach Dean Cromwell said, "Do you know you ran that last lap in 5.6 seconds?"

When I got showered up and got in my box, there's a buffer zone between us and Hitler and if you want a picture taken you have to give your camera to one of the officers. So I gave my camera to the officer— I think it was the skinny guy, Goebbels—and he said, "What's your name?" And I said, "Well, I didn't win anything." And he said, "Hitler wants to know the name of every athlete who takes his picture."

In the village they had storm troopers each day to protect us and they were a jolly bunch. They'd come by two at a time marching by with their rifles and we'd go "Heil Hitler" and they'd go "Heil Adolf" and they'd laugh, and then if we said "Heil Adolf" they'd say "Heil Hitler." It was humorous and they just laughed and knew that we were kidding with them.

Goebbels came back and said, "Hitler wants to see you." It didn't mean anything. Hitler didn't mean much to anybody, you know, especially me, the youngest runner on the team. So I went

over and he shook my hand and said through the interpreter, "Ah, the boy with the fast finish." And that was it. I went back and forgot all about it. Hitler shook hands with three athletes. Myself for sure, Helen Stevens for sure—she was the greatest woman sprinter in the world. I think the third guy was probably Glenn Morris, the decathlon winner—voted the handsomest guy on the boat. Then he played Tarzan and had Eleanor Holm as Jane.

This is a puzzle. They say Jesse Owens was the one ostracized by Hitler, but what actually happened was this: the first black guy to win a gold medal would be ostracized and it wasn't Jesse Owens—it was Cornelius Johnson, the high jumper. We come home telling that story, but Jesse Owens was telling a different story and that's because of the war. Propaganda, right? Hitler in '39 starts to take over Europe so America used Owens' life as propaganda, showing he was the famous one—the one that was ostracized but he wasn't. Yes, Hitler left, but Jesse Owens got four medals. Our president came for one day—opening day and gone. Hitler was there every day, all day long, and he had to leave abruptly at times because of the affairs of state or rain.

I am sure Hitler wasn't delighted with Jesse winning four golds, but he certainly couldn't deny it. And then also you got to look at it this way. Hitler financed the games. He had all the say-so and yet when the games were over they immediately had Jesse Owens and all of his records engraved permanently on the wall of the stadium. Now if Hitler had any resentments toward Jesse Owens he probably wouldn't have allowed that. No other name—Jesse Owens and all of his gold medals, still there.

The Olympics were different then. You were part of a world elite group—Olympians. Today it's not like that. Today they see each

other every day—they're fighting for the gold, for the million—and so they resent each other sometimes. The Olympian athletes in those days were a mostly shy lot. Today they hold up a track meet by walking around slowly and bowing every 50 yards.

Before I went home, the relay thing. The Jesse Owens thing. Well, there was Stoller and Marty Glickman. I think it was probably a combination of two or three things, but they had to win the relay. We would have won it anyway but they had to get another gold medal.

There was Stoller, Glickman, Floyd Draper and Ralph Metcalfe. I think that was it. I roomed with Jesse. And the coach told him to keep his eye on me. I was picking up souvenirs, drinking beer.

See, when you qualify for the Olympics in a relay, you're not the fastest guys on the team. Metcalfe, Whicoff were the fastest, and Jesse Owens. So they took the two Jewish boys off and put on Jesse Owens and Whicoff so we'd be sure to break a record and win another gold. And when Coach Robinson told Jesse Owens that, Jesse refused. Jesse was a real sweet guy. He knew what was right and what was wrong and refused, and Dean Cromwell as I remember it said, "You'll do as you're told." And he did it. And then he got really upset because the officials at the Olympics in '36 were treating the athletes like children. They were getting everything for themselves first class and they just looked down on the athletes.

The American Olympic committee was under Brundage, Avery Brundage, when Eleanor Holm was thrown off of the team, No. 1 backstroke swimmer in the world. The officials had first class with all the movie people and Hearst on the boat and we're in second class. They had the only deck that went completely around, where

we needed to go to work out. We'd go up there and run around the decks and they had a little opening in the wall where they were selling beer. We never got drunk but we liked a glass of beer when we got through sweating and so we'd always stop and have a glass of beer. Brundage knew that. A lot of the athletes were doing it. Then Hearst invited Eleanor Holm up for an evening dinner and a dance. Nothing wrong with that, and she had a glass of champagne. And because she had a glass of champagne and was up there, Brundage, without any vote, threw her off the team. Brundage was the dictator of the Olympics in those days. Avery Brundage was it. He was the big authority in the Olympics or in amateur athletics for that matter. And he was just absolutely zero tolerance.

We asked for a vote. Let the athletes vote to see if she stays on the team or not. So then what Hearst did—Hearst hired her as a correspondent and then in the paper she's sitting there in a cartoon sketch looking around the office at the newspaper and it says, "Do they fire you here for having a glass of champagne?" And it was really against Brundage. And that gives you a picture of the Olympic committee.

Then it was back to America on the SS *Roosevelt*. The mayor of New York, Fiorello LaGuardia, and Jack Dempsey took several of us out to dinner for a little celebration, and then I was bound to Los Angeles on the Southern Pacific. I was met at Union Station by a committee from Torrance and driven to my hometown. The car stopped two miles from town and I was transferred to a flatbed truck with a throne on it. I was embarrassed. We drove onto the town square and the entire city of 2,500 turned out, including a woman who was the grandmother of a friend of mine I went to school with, and she had been in a wheelchair for years. Paraplegic. I brought

her back a pair of argyle socks to keep her feet warm. So then that's over and I go home to my parents and they throw me a banquet, and before they could even open the banquet officially, the chief of police got up and said, "Well, I've been chasing Louie up and down every street in this town. He had to be in shape for something." So he took credit for having been my first coach and trainer. And he was right.

John Weitz is an American fashion and industrial clothing designer.

"My father (Third Prussian Guards Regiment, Iron Cross, war wounded) was not convinced of the durability of the Nazi plague, and so our house and summer place were still open."

———————◇———————

I was a 13-year-old poised with one foot on the gun'l of the boat and the other on the dock, hoping that no one would let go of the docking lines. I was a boarder at London's St. Paul's School (1509–Henry VIII) while my parents were still in Berlin. My father (Third Prussian Guards Regiment, Iron Cross, war wounded) was not convinced of the durability of the Nazi plague, and so our house and summer place were still open.

Back in Berlin for my summer school vacation, our old family chauffeur assured me that "the brown shirts would soon be gone." There were no anti-Jewish posters to be seen. Goebbels did not want to offend the thousands of foreign visitors to the Olympiad. I attended the games and saw Mr. Owens win his four gold medals. Many years later, Martha Dodd, whose father was American ambassador in Berlin, told about an Olympics party given by the von Ribbentrops at their Dahlem home. She asked the young SS officer who was her escort why Hitler had not shaken hands with Owens. "Oh," said the SS officer, "the Führer has nothing against

Jesse Owens, personally. It's just that blacks are really more animal than human and that it is unfair to match a white athlete against blacks. It's like asking them to run against a leopard or a gazelle."

Anyway, in 1936 during that visit to Berlin I watched as my father, usually my tower of strength, virtually faded away. He had suddenly become tenuous and insecure. My mother, despite Chanel and cocktail party superficialities, took charge.

Returning to England and school, I was relieved to be away from all the problems. School became my home. I crawled back into my own little fake P.G. Wodehouse world. Did I lack feeling and compassion? Indeed. Fortunately St. Paul's School was quite aware of the dilemma of its foreign (meaning politically exiled) boys and supported us, and at the same time treated us like all its other pupils.

The reckoning came a year later when my parents moved to Paris. Father was a better man than I. He insisted that no matter how he would re-budget his expenses, my school fees were to be paid until graduation, which came in 1939 when I was arrested as... an enemy alien.

Beatrice Abbott was
married to Dr. Abbott
Kaplan, social worker,
screenwriter, educator,
co-founder of the Theater
Group and founder of
Purchase College, a liberal
arts college in New York.

"He told me he had decided at the demonstration that he was going to marry me."

———————◇———————

The Olympics were being held in Germany and Hitler had invited a number of American universities to attend. Most universities declined except for Columbia University, and so the students held a demonstration in the quadrangle, critical of the president, Nicholas Murray Butler. I walked over from Barnard College.

Somewhere in the middle of a speech, a young man approached and asked me to sign a petition. I did not notice his face but I remember thinking as he walked away that his coat was more suitable to an old man—not a student. It was black, worn and serious.

That evening when the phone rang on our floor in the dormitory, it was for me. Would I come down to the lobby to discuss making a poster for further demonstrations?

It was the young man in the old man's coat. He suggested we walk along Riverside Drive Park. He told me he had decided at the demonstration that he was going to marry me. He did not ask me to make a poster.

We did marry that year, however. His name was Abbott Kaplan. He was the youngest of eight children, which probably explains the

coat. I have wondered and failed to ask him whether that was a legitimate protest form he had me sign and now, of course, it is too late to ask.

That year I was a sophomore at Barnard College. I came from a small town, less than 3,000 people: no high school, no movie house, no library. My father liked the fact that I read his copy of the *New Republic*, or was it *The Nation*, and discussed it with him.

When I arrived at Barnard, the special friend I made was very exciting. She talked about strikes, modern dance, Martha Graham, the *Daily Worker* and Michael Gold. And she believed in "free love," as it was called. I worked at Macy's all day Saturday and Thursday evenings. I sold blouses and earned $4.25 for the week, most of which I saved in a Vicks VapoRub box on the upper shelf of my closet and spent it all on clothes after meeting the man of the poster.

The elevator operators' strike was on—we marched, and I was asked to carry the flag in the parade. We were photographed by one of the newspapers. I clipped the photo and sent it home. My mother wrote back; her sole comment: "You look thin."

Meanwhile Abbott was working toward a doctorate in history and I, a major in literature. And Abbott taught Hebrew to support us

And then suddenly in the late '30s, the Spanish Civil War began and young American men were volunteering and some did not return

From the WPA, here are the background and words of **a packinghouse worker.**

"The boss comes around lunch time and we make him eat with us. He likes our gang. Some of the old Polish women get sore as heck because he treats us better than them."

———————◇———————

Description of room, house, surroundings, etc.: YWCA Center, West Side. Family owns home on North Side, in good condition. Good, quiet neighborhood.

Ancestry: German, American born. Twenty-two years old. Excels in athletic sports of all kinds, has won sweaters, cups, etc., in volleyball, softball, basketball, swimming. Enjoys horseback riding. Amateur, of course. Used to play on factory teams.

Member of the Industrial Girls Department of the YWCA, West Side. Joined club for its athletic program, swimming, etc. Likes and shares social activity of club. Witty, strong and stubborn. Well liked by the girls. Lots of pep and always wanting to be engaging in physical activity. Goes to German Lutheran church. Father a skilled, steadily employed craftsman. AFL union member.

"I've worked in Reliable Packing Co. for the last six years, mostly in sliced bacon. I just wrap up the bacon as it comes out of the slicing machine, in those cellophane wrappers, and stack them. I have lots of fun at work, we kid around with the guys all the time. Sometimes

we fry bacon on a little electric plate that we plug up to one of the machines. A bunch of us always eat together. We even make coffee. It's against rules to cook anything, really. You're supposed to use the cafeteria. But the boss don't care, he comes around lunch time and we make him eat with us. He likes our gang. Some of the old Polish women get sore as heck because he treats us better than them.

"They don't like to see young girls and fellows have a good time, but we don't do anything. We just monkey around a little bit, that's all. They're just jealous 'cause they can't.

"I get paid by the hour. It's pretty nice where I work. It gets cold, but I don't mind. I got two weeks' vacation with pay this winter, I took another week off without pay, the boss let me off and I went to Florida. Did I have fun! I was flat broke when I came back.

"We have a union in our place. It's the Employees Mutual Benefit Association. We have dances and socials, parties, things like that. We have our grievance committee, all that. Of course, the CIO had to come butting in where they weren't wanted and lots of people joined, but my gang didn't and I'm glad. I'm satisfied with my job and I got no kick with the company. Why should I worry about somebody else's troubles on the job?

"I pay my dues to the Employees Association and always will. They're just jealous of anybody with a good job, and they join the CIO and try to get the company to give them all the easy work. Some of them in the CIO union won't even talk to us anymore; can you imagine that?! We get along at work better than any of them, so we don't pay any attention to them."

"We decided to do what we had sworn to our families we never would do: take to the freights."

Sidney Shapiro has lived in Beijing since 1949 and became a Chinese citizen in 1963. With his Chinese wife, an intellectual, he experienced all of China's tumultuous changes over the past 50 years. A famed translator of Chinese literature into English, Shapiro has published a number of books on ancient and modern Chinese history, including his recent autobiography, *I Chose China.* He is a member of the Chinese People's Political Consultative Conference, China's national advisory board.

St. John's Law School in 1936 was in a 15-story office building on Schermerhorn Street in the Boro Park section of downtown Brooklyn. I was a second-year student taking the three-year course. The attraction was that tuition was relatively cheap, and you could attend classes from seven to ten in the evening after working all day.

I had to work if I wanted to go to college. I worked in a division of the U.S. Treasury Department, which handled the payrolls of the huge numbers of new employees under the Works Progress Administration. FDR's New Deal invented the WPA to provide jobs for thousands of desperately idle people— from manual laborers to writers and artists. It not only succeeded in blunting the edge of a dangerous unemployment situation, it gave us artistic creations like Diego Rivera's murals in Rockefeller Center.

I took the subway through the tunnel under the East River to the lower half of Brooklyn, scanning a law text while holding on to a

strap in the swaying car. A quick bite in a Greek diner, a cigarette and more hurried reading, then a rush to the office elevator that whisked me to class. It was not the kind of routine to groom one for a clerkship with a Supreme Court judge. Still, it got me, and many more "subway scholars" like me, through college.

Pop worked his way up from the poverty of the Lower East Side, survived TB (the poor man's disease) and became a lawyer. His clients were other struggling aspirants to "the good life," speculating in real estate and shaky fledgling companies. They brought Pop enough income to move us from Boro Park to the Jewish nirvana of Flatbush, a place of trees and flowers. Never mind that the street was unpaved and had only temporary sewers that flooded our basement every time it rained. We now resided in a one-family frame house with a terraced lawn covered by a tiled roof and a large mortgage.

We had to scramble to meet installments due on life and health insurance, on the car, on the home mortgage. But then, so did all our friends and neighbors. Pop even prospered from a brief flurry of representing clients going down in bankruptcy and mortgage foreclosures.

But I was starting to become aware of the dangers growing all around us. In Spain, Franco and his fascist hordes were taking over, aided by Germany and Italy, honing their tanks and bombers for the coming World War II. Washington declared "neutrality," leaving the Democrats to their fate. The Nazis were rounding up German Jews, robbing them of their possessions and sending them to their deaths in concentration camps. Men peddled apples and pencils on the streets. Homeless people lived in shanties they built on empty lots in communities called "Hoovervilles." There were strikes and hunger

marches. Fanatics boldly preached racial and religious hatred in radio broadcasts and on street corners. A gang of homegrown Nazis set up a platform in front of the East 17th Street library in Flatbush and harangued the crowd, trying to convince them that the butchers in Germany were being maligned. Several off-duty Jewish policemen in plainclothes who happened to be in the audience beat them to a pulp.

I had a vague, unformulated desire to do something. Get involved in politics? I didn't like either the Democratic or Republican parties. What I had seen of them on the ward and street levels convinced me they were both machines of crude politicians out to make a dishonest dollar in whatever way they could. The Communist Party I found equally unappealing. Its blind worship of anything and everything the Soviet Union did, including the neutrality pact with Hitler, seemed illogical and unprincipled. I went to a cocktail party in a penthouse on Central Park West, where the dilettante "progressive" host dispensed application forms. All you had to do was fill one out and you were a member of the American Communist Party. It was just too glib and superficial.

While in the pre-law division of St. John's I had become friends with a classmate named Jerry Mann. Jerry was more advanced than I and had a rudimentary concept of class struggle. I saw it simplistically as a division between the haves and the have-nots, with the first callously trampling upon the second. My aim was to get to where no one could ever trample on me. I had no higher aspirations than that. Jerry, whose father was a cutter in the garment industry, was also restless. A tough boy, handy with his fists, he too was seeking a more exciting future than life as a lawyer. We decided to go out together and look, to hitchhike across the country to California during our summer vacation.

We set out one morning in late June 1934, heading for Chicago. We arrived four days later, feeling ourselves already veterans in thumbing rides and cadging meals. Pop had bet me ten dollars we would never get there. I immediately sent him a telegram asking him to promptly remit. He did.

Reaching our next stop, Kansas City, proved more difficult. People seemed reluctant to give us rides. Was it our sprouting beards and increasingly unkempt appearance? We found the reason one afternoon when, after waiting hours in vain for a lift on the outskirts of a city, we glanced at the telephone pole behind us. On it was a poster that said: WANTED, DEAD OR ALIVE, JOHN DILLINGER…and went on to give a detailed description of the killer for whom the police of seven states were searching. No wonder drivers wouldn't pick up rough-looking characters like us!

Because we had only about $50 apiece we tried to stretch our money by sleeping out in the open, weather permitting, and working for our meals. The well-to-do home owners and restaurant keepers we approached usually made us sweat for our suppers. But in the run-down dwellings our host or hostess would usually say, "Eat first, then we'll see." And when we'd finished, they'd laugh and say, "Forget it. We don't have enough to do around here ourselves."

Early one day we were on U.S. Route 1, the Lincoln Highway, an asphalt swath over rolling plains that should have been covered with corn and wheat. Instead, only parched shoots stubbled the cracked soil, for there had been a terrible drought. Homesteads were few and far between.

We walked up to the nearest one and found the family at
breakfast. They invited us to join them and plied us with eggs, milk,
butter, homemade bread and deep-dish cherry pie. They told us they
were having a disastrous year, even as they kept urging us to eat
more. So strong is the tradition of American farm folk hospitality
that it never occurred to them to let their hardships influence the
treatment of guests at their table.

As the population thinned out, and with Dillinger on the loose,
rides grew scarcer. At last we reached Kansas City, then a poverty-
stricken town half in Kansas and half in Missouri. We decided to
do what we had sworn to our families we never would do: take to
the freights.

We had thought originally that freight trains were used mainly
by hoboes. We met some of them, as well as gamblers, pimps,
hustlers and con men. But in this year of depression and drought,
the bulk of the nonpaying passengers of the railroads of America
were migratory workers, men traveling from state to state harvesting
crops, picking fruit.

Freight trains haul few empty cars, and they rode on top, sitting
on the long, three-plank catwalk as the cars jerked and rattled along.
Sometimes they were so thick up there it was hard to find a place to
sit down. These men were very different from the slovenly hoboes.
Lean, dignified, most of them carried a small cheap suitcase. On
arriving at their destination they would remove their smoke-grimed
travel clothes, wash thoroughly at a water pump, shave, change into
clean overalls, put their dirty garments in the case and set out for
their prospective jobs.

There was an art to catching freights. While most towns didn't care, some were patrolled by nasty "yard bulls" who enjoyed arresting and beating up men they caught. You had to hide in the outskirts and wait until the freight was already gathering up speed, then race for it, grab a ladder and climb to the top. It had to be a ladder at the front of the car. If you lost your footing the momentum would swing you against the side, and your feet could regain the rungs. If you were on the short rear ladder you might be flung between your car and the one behind it. Many a man lost a limb, or perhaps his life, that way.

You also had to avoid open gondola cars carrying pipes or other loose freight. These could shift suddenly with the rocking of the train and cause severe injuries if you were resting on them.

Jerry and I hit a "red ball" express freight out of Kansas City that brought us into Colorado Springs almost nonstop. We traveled right through the night, riding, as usual, on top. We could rest only by turns in short naps, the one staying awake holding on to the sleeper with one hand and clutching the catwalk with the other.

A nice elderly couple gave us food and shelter for tending the garden and doing odd jobs around the house. They were from another state but had been living in Colorado Springs for years "because of our lungs."

When Jerry and I resumed our freight car travel a few days later, we once again were guests of the Atchison, Topeka and Santa Fe. The line ran southwest through New Mexico, then south. Another few hundred miles and it would turn west, cross Arizona and take us to California.

But for me, that was not to be. Familiar with the rules by then, we hopped off as the train slowed to enter San Antonio, Texas. We walked through to the southern outskirts and waited for it to emerge. About two hours later, after having discharged some cargo and taken on other, and adding more coal and water, the freight came puffing slowly along the gleaming rails.

We dashed out of our hiding place and ran alongside. Jerry grasped a front ladder of a car and climbed to the top. I stumbled over a switch, breaking my stride. I recovered only in time to grab the rear ladder of the car behind. The train gathered speed. We were rolling across flat desert land. Rear ladders had only four rungs on the lower ends of the cars, where brakemen could signal with swinging lanterns before the trains left the freight yards. The ladders were not intended to reach any higher. I couldn't climb up and I couldn't get off.

The sun burned my neck and my bare arms and legs. I was wearing a short-sleeved polo shirt and a heavy knapsack. The straps were eating into my shoulders with each jolt of the train. I could feel the grip of my hands on the rough rungs of the iron ladder weakening. "Well, goodbye, Shapiro," I said to myself. "This is a stupid way to die."

Fortunately, the rails rose in a slight incline and the train slowed. I made up my mind and jumped in the same forward direction the train was going, a method we had been taught by fellow travelers for leaving moving freights. I landed on my feet, and then on my hands, lacerating them on the roadbed cinders. The train quickly picked up speed again. Jerry was waving his arms and yelling something I couldn't hear. With bleeding palms, I watched the freight roll across the desert and disappear into the distance.

Now what? There was no chance I could find Jerry again, even assuming I could catch another freight, a feat I was not likely to accomplish with my torn hands. I wasn't very keen on going to California anymore. By the time I walked for two hours under the burning desert sun and got back to San Antonio, I was sure about it. With my remaining few dollars I bought a ticket on a Greyhound bus. Two days later I was back in Brooklyn.

Jerry went on and reached the West Coast. He also returned a few weeks later and entered St. John's Law School with me. (So enchanted was he by California that he and his parents subsequently moved to Los Angeles, where Jerry became a wealthy manufacturer of women's sportswear.)

Born and raised in New York, we settled in big cities at opposite ends of the continent. Looking back, it seems to me it was those few weeks in rural America that gave me a sense of what grassroots Americans are really like. I have never forgotten that, even today, more than half a century later, in China.

J.P.S. Brown is a Tucson novelist, rancher, horseman, Hollywood stuntman and author of more than 12 novels about real cowboys. This story is excerpted from his forthcoming novel, *The World in Pancho's Eye.*

"His eyes were the ones the world used to watch what went on outside its heart."

────────◇────────

About 1936, as soon as Mildred, my mother, could leave me in the car when she went shopping, she would dress me up, part my hair in the middle, slick it back against my skull the way my handsome uncles did, and take me to Nogales. She always parked the car on Morley Avenue in front of the stores. She rolled down the windows to give me air, told me to stay put and watch the people go by, but not to stare, and went off to do her shopping.

I was born in Nogales, Arizona, and I thought I knew everybody and everybody knew me, so I looked for a friend in each face that passed. I made ready to smile when I looked into a face in case I found that I knew the person. If I liked the face, I smiled whether I knew the person or not. People said that my father, Paul Summers, and I were alike that way.

The first friend I made on that street on my own was an old black man named Joe. He came by, puffing his pipe with his eyes downcast the first day, and I liked his face so much I had to stare. His face passed within a foot of mine. The man walked slowly, so I was given a long, close look. Black Joe wore a brown hat and seemed to be powdered all over with ashes. His face was deeply lined, and the lines looked as though they were full of light gray ash that also lay in the

lines of his hands. He wore a dark suit vest and his tobacco can, a
gold watch, another pipe to smoke, matches and a clean handkerchief,
all of which showed above the rims of the four pockets. His walk was
a poised and graceful amble.

That was the day I began to study the way men walked. I began
to realize that a real man's walk must always have a special style that
suited him. Black Joe's walk was unconsciously dignified, stately,
and I was sure it had taken grace with the way he lived. He did
not drag his feet and he did not limp. He coasted at 1 mph, maybe
even down as slow as $^{1}/_{2}$ mph. His feet never seemed to leave the
pavement, yet did not touch down between steps in the same way
that heavyweight boxer Joe Louis' feet imperceptibly cleared the
floor when he skipped rope for us on the newsreel.

One day Black Joe raised his eyes to me and I saw that they were as
feral as those of my horse, Pancho. I never forgot what I saw in those
eyes and years later I became aware of what it was. They looked at the
world as though they had been doing it since long before 2,000 B.C.
and were still not tired enough to quit. They were the world's eyes, the
ones the world used to watch what went on outside its heart. They had
been much used but would never tire of what they saw, or be surprised.

One day Black Joe came by and I murmured hello. He looked
at me and gave out a rumble so deep that I could not understand
the word for the sound. After that he always looked into my eyes
from farther down the street as he approached, then rumbled
something to me as he went by. Mildred told me that Black Joe had
been a good friend and comrade in arms of my granddaddy Bert.
He owned the indoor shoeshine stand on the town plaza. Paul, my
dad, and Buster Sorrells, my mother's brother, liked to stop and sit

under a shade tree on the plaza and share a bottle of whiskey with him from time to time. He had been decorated for bravery as a Fort Huachuca cavalryman against Geronimo. He had been a horse soldier in the 10th Cavalry when my granddaddy Bert Sorrells was their scout. I told my granny about him and she said he was Old Black Joe, her and Granddaddy Bert's best friend of all time. He cowboyed for them on the Vaca Ranch, the first place my granddaddy took my granny to live right after they married.

I asked why he was called Black Joe. I felt a kinship with him because of that. My name is Joseph and the grownups in my family called me "Black Man" because my hair was so black and I burned so black in the sun. Black Joe did not look very black to me. He was not as black as little Chapo Valenzuela, Granny's gardener, who walked over from Nogales, Sonora, to tend to her lawn and flowers every Saturday. I was a little kid, so I understood Granny to say that he was called Old Black Joe because a song was named after him. She sang the song to me and then taught it to me.

The next time I was on the street in the car and Black Joe came by, I said, "Hi, Joe."

He looked at me with the world's eyes and said, "Hi, Joe," and started on by.

I said, "How did you know my name was Joe, too?"

He stopped and said, "What do you call yourself?"

"Joe."

"What else?"

"Joseph Paul Summers."

"You say Paul Summers?"

"Yes."

"Mildred's your mama and Paul is your daddy?"

Mildred returned to the car at that moment and shook his hand and said she was glad her boy had stopped him so she could visit with him. He owned great, burnished-gold teeth and some of his color had come off on them and his tongue was pink as a flower. He told Mildred that he and I had been friends a long time, even though we had not spoken until that day. He was glad to know that I was Bert Sorrells' grandson.

After that, Black Joe stopped to visit with me every time he came by. He would pat my hand, rumble for me awhile and go on. He had been 30 years a Buffalo soldier, and he told me my granddaddy was the best man he ever knew.

Warren Adler is the author of 24 books, including *The War of the Roses, Random Hearts* and *Mourning Glory.* He has also been a newspaperman, playwright, screenwriter and businessman. Living among the gangsters of Murder, Inc., under the elevated railroad, during the hardships of the time, he recalls feeling utterly secure, regretting only that it lasted such a short time.

"Relief was for the goyim. *To accept a relief stipend was shameful and degrading to Jews."*

————————◇————————

There were 11 of us living in my maternal grandparents' row house on Strauss Street in the Brownsville section of Brooklyn during the Great Depression. My parents had been dispossessed from their apartment in Crown Heights. My father, a gentle, handsome man, was a bookkeeper, and a good career start was detonated by the Depression. He had come to America from the East End of London when he was 10 years old. He never recovered his economic footing for the rest of his life, and although he lived on the generosity of my mother's brothers, he was never made to feel inadequate or lesser in their eyes. In the period I am writing about I was, as near as I can figure, between 6 and 12, from 1934 to 1939. Living in my grandparents' house were my mother and father, myself and my baby brother, Cyrus, Uncle Chic and Aunt Rose and Cousin Joyce, Aunt Ida and Uncle Sunny.

I slept in the same bed with my little brother as soon as he was out of the crib. My parents slept in what was called a daybed in the downstairs dining room, my grandparents had the master bedroom and one aunt and uncle slept in one room with my little cousin. My

single aunt had her own little bedroom and my single uncle slept in the back kitchen. There was one bathroom. The address on Strauss was 2108 and was practically under the IRT. Elevated. Trains clamored past every few minutes, making a big racket that would make it impossible to hear the radio as they rattled past. After a while no one noticed.

In those days the old world of the *shtetl* and its rituals had not completely disappeared from the lifestyle of my grandparents' generation. Despite an adjacent bathroom with modern plumbing, my grandparents continued to place a *pishtepple* under their bed for nocturnal emergencies. Many signs were in Yiddish. There was a thriving Yiddish culture, a number of Yiddish newspapers graced the newsstands, a theater showing Yiddish plays and movies, the Hopkinson, was nearby.

Fish and poultry were bought live. In the fish store a woman would sit on a cutting board on a high platform overlooking a pool in which live fish were swimming. My grandmother would point to the fish of her choice, which was quickly netted and brought upward to the cutting board, and after a few skillful chops and the removal of innards it was passed along, wrapped in paper, to my grandmother. She would then proceed to the live chicken market, study the noisy birds, then point to the chicken of her choice. The vendor would lift it by its feet and my grandmother would test its plumpness with her hands and, if it suited her, nod her agreement. The chicken was then directed to a *shoiket*, an official religious slaughterer, who cut its throat in a blood-draining koshering ritual. It would then go to the chicken flicker, who would pluck its feathers, singe off the remainder and present it to her. The process emitted a rather unsavory smell that lingers in olfactory memory as I write.

Religious rituals were strictly observed. Keeping kosher was essential. Two sets of dishes were there for the separation of meat and dairy meals. Under my grandparents' roof, one was expected to conform on the Sabbath; no cooking was allowed and yesterday's food simmered on a metal sheet placed over the stove, which stayed lit from Friday sundown to Saturday sundown.

To my grandmother, sundown must have meant sundown in Smolensk, since it was always pitch dark when she officially declared the Sabbath over and allowed us to turn on the lights. In her zeal, she would neatly prepare cut strips of toilet paper for use during the Sabbath holidays. No tearing of paper was allowed on Shabbos, nothing was allowed. No smoking, no driving, no working, no cooking and no riding on public transportation; nothing, except reading, walking or going to the Synagogue.

My successful uncles never left the house without putting paper money in a china closet dish for their parents' support. Although the use of money on the Jewish Sabbath was also forbidden, my grandfather's joke was that he did not want to hear the sound of money as it was passed into the china closet dish. This was interpreted to mean that only paper money was to be expected.

All my uncles who could afford it contributed to the support of their parents and siblings. It was the unwritten rule of the times. Jewish families took care of its members. If that failed, Jewish charitable organizations filled the gap. Relief, which was what welfare was called in the Depression days, was for the *goyim*. To accept a relief stipend was shameful and degrading to Jews. We were, in fact, impoverished, although I never thought of us as poor. Other people were poor, not us.

Pitkin Avenue, the great white way of Brownsville, was as crowded as Broadway. In front of Hoffman's cafeteria, men argued into the night about the joys of socialism and the heartlessness of the bosses. Social ferment was everywhere. Candy stores were everywhere, along with delicatessens and Chinese restaurants. Young men hung out with their buddies in front of the corner candy store. The candy store on Saratoga and Livonia, owned by a shadowy woman dubbed "Midnight Rose Gold," was the headquarters of Murder, Inc., that band of Jewish gangsters who serviced the Mob's killing machine. Pay phones in the back of the store were used to assign hit men to their jobs. But in the vicinity of Saratoga and Livonia no one considered street crime a problem.

My mother was a housewife, devoted to her children and her parents. Indeed, it was the tradition of the time that there was an element of shame for a woman to work, implying that her husband was unable to support her. While today's women might think housewifery a demeaning occupation, from my perspective I attribute my own inner security to her being there for me always. She was there when I came home from school for lunch. She was there when I returned from school in the afternoon. She was there at mealtimes, including breakfast, and there when I awoke and went to bed.

It was an essential ingredient of the Brownsville culture in my day, especially for boys, to learn the rudiments of Hebrew and the history and rituals of the Jews. It was a hard time for boys who, like myself, would rather go out and play, and the poor, harried Hebrew schoolteachers suffered the brunt of our repression and scorn. Somehow we did learn Hebrew, never to the point of fluency, but we were able to read the various prayers and bask in the admiration of

our parents and grandparents, especially at Passover, when we had to recite the four questions in both Hebrew and Yiddish.

Saturdays were reserved for movies. There were two theaters within walking distance, the Blue Bird and the Ambassador. A typical offering on a Saturday was two features, two or three cartoons, Movietone News, coming attractions, a school supply giveaway and often a drawing for prizes, all for 10 cents.

Most of the kids my age loved action movies. When any love scenes came on we would scream and yell and throw spitballs at each other. The imprint the movies made on others and me in the '30s never ceases to amaze me and baffles my children and grandchildren.

My father worked sporadically at jobs he hated, run by bosses he despised. He was often out of work. Yet the family went away every summer to the beach to escape the stifling heat of the city. Our resort of choice was the Rockaways, where the family rented rooms in big old houses converted to what was referred to as *coochalains,* a Yiddish word that meant a kitchen shared with other families.

In those days, the Rockaway beaches were pristine, the boardwalk wonderful and the summers a cornucopia of excitement, recreation and new friends. Usually we shared a tiny room with my parents on an upper floor and my grandparents had a slightly larger room on a lower floor.

When my father was working, he would usually come home after a long hot ride on the railroad and he and I would take off for a before-dinner swim in the surf. Was this poverty? A few pennies from my mother for the penny arcade were tangible riches in those

glorious summer days. Intangible riches were far more valuable. In those terms, we were billionaires.

Whatever the devastating Great Depression meant to others, I can say with deep honesty that the period of the early and middle '30s was for me a time of great joy and happiness. I had no doubts about being loved by my parents and everyone else in my extended family. I never felt deprived by lack of money, never observed despair or pain in the world around me, never felt the tensions of economic hardship. There were no bitter arguments among family members and an angry word was rarely heard.

I have thought about this period of my life often and always with tears of regret that it lasted such a brief time. I still revisit it in memory and enjoy the recall with much emotion.

Adrienne Fontana Henoch retired in the 1970s from a career as a popular singer to become a writer and nurse. She recalls the mid-Depression as a time of hope and opportunity.

"Time seemed extremely rosy and satisfying."

———————◇———————

I was 22 years old and the world was my oyster. I was appearing in nightclubs and shows as a singer. I dropped my last name, Matzenauer (after my famous mother, Margaret Matzenauer, the opera star), as it proved to be too long to put up in lights! I was known in clubs, on stage and in early TV only as Adrienne.

Leopold Stokowski, a close and dear friend, was still with the Philadelphia orchestra that he had made famous, weaving his magic both musically and physically with his gorgeous women. One of these was my mother! I was one of the few he never propositioned. I was too much like a daughter to him.

Time seemed extremely rosy and satisfying. I think I paid little attention to the storms that were whirling around me. A looming Second World War—poverty—Hitler rising to power—Roosevelt's second term. I was very much wrapped up in myself, my talent, my beauty.

Neil Elliott knew Jack Ruby, who shot Lee Harvey Oswald, the assassin of President Kennedy. He spent 40 years as an advertising executive.

"...a very good year for small-town girls and soft summer nights."

———————◇———————

Ruby and I had adjacent territories, selling cheap beer glasses, perfumed urinal cakes, cards and dice to the roadhouses that ringed Chicago. I was marking time, waiting to go to work in the steel mill. Jack Ruby—then in his 30s—had no excuse for taking a $16-a-week job, considering his claim to be "connected" with powerful underworld figures.

We met one evening, my date bringing an older friend for Jack. At 17, I expected only an evening in a very good year for small town girls and soft Summer nights. A couple of beers, a few nickels in the juke box, and pair up for the drive home.

Jack showed up in a chalk-striped suit, Borsalino felt hat and spats—really spats! The girls, merely puzzled by his mumbled references to Big Al and Frank Nitti, and his impersonations of James Cagney and Edward G. Robinson, agreed with me that it was getting late, and I took both girls home in sullen silence.

Jack Ruby went on to shoot Lee Harvey Oswald, capping his career as wanna-be gangster but still owing me a buck eighty for the beer and music.

Tom Wicker is an author and was a columnist for the *New York Times* from 1966 through 1997. He grew up in a small Southern town, the son of a railroad man.

"The folks who lived next door were known to be Republicans. My mother thought that drove down property values..."

————◇————

At 10 years old I was quite sure of three indisputable facts: (a) we didn't have much money, (b) neither did anyone else and (c) the greatest living human being was Franklin Delano Roosevelt.

In my young life, these three indisputable facts were of inverse importance. FDR was positively revered in my household and by everyone I knew—except the folks who lived next door, who were known to be Republicans. My mother thought that drove down property values in our neighborhood, but after long reflection I believe the croaking bullfrogs our neighbors kept in their garden fishpond were more detrimental.

It was not just that President Roosevelt's cheerful voice on our old upright Philco radio or his beaming face and jaunty cigarette holder in the moviehouse newsreels reassured us that hard times somehow would come out right. Primarily, Franklin D. Roosevelt was an object of our veneration because my mother taught my sister and me to believe what she held as an article of faith—that the president, once upon a time, personally and on purpose had signed a piece of paper that permitted D.D. and Esta Wicker to keep their little house at 414 Hamlet Avenue, Hamlet, North Carolina. I never

doubted it then, and I still believe that when Mr. Roosevelt devised the New Deal (a phrase that to me still has biblical resonance) he had in mind good, hardworking people like my parents.

Also of considerable importance to a reasonably observant child was the fact that my family was not alone in suffering hard times. The only people I knew in Hamlet who seemed to be well off were the Gibsons, who owned (or controlled, or something) the local Coca-Cola Bottling Company, and the Cornings and the Monroes, who had some kind of dual command of the Buttercup Ice Cream Company. And even Joe Monroe, who was later in my class at the old red-brick Hamlet High School, had to wait like everyone else when we chose up sides for sandlot baseball or football.

Virtually all other families, including mine, were headed by a father who worked for and earned his slender living from the Seaboard Air Line Railroad, even though the Seaboard was in bankruptcy, a status that baffled my 10-year-old understanding—how could a bankrupt company still be operating? Now, "the road"—as in those days it was always called—is several mergers in the past, recalled only by progeny like me and by collectors of railroad memorabilia. Railroad men like my father were protected, however, by a strong union—known as "the Brotherhood"—and he was never "laid off" during those hard years.

Sometimes, however, because the Brotherhood saw to it that all its members got a share of what little work there was, my father would go weeks at a time without being summoned by Cary Hodges, the Seaboard's call boy. (Actually he was a grown man.) When my father was called, my sister and I would proudly watch him trudge off to work, lantern in hand, brakestick over his shoulder—a real railroad man (which in those days was about like

being an airline pilot today, at least in the eyes of 10-year-old sons). He wasn't called often enough to suit him, but I don't remember my father indulging in self-pity during his frequent idle periods.

There were, of course, better and lesser areas in which people lived, since economic differences can never be totally erased. Class distinctions scarcely existed, but racial ones did. Hamlet, after all, was in the segregated South. The kids who were bussed in from the countryside (all white, I regret to say) seemed happy to have the chance to attend a town school.

So leveling were the economic conditions of my youth that when the federal Works Progress Administration built the sidewalks in my hometown, all the men I knew, including my father, turned out to work on the job. I well remember bringing him his favorite lunch, a fried egg sandwich, while he shoveled and leveled cement on Spring Street, a few blocks from our house. He and his fellow workers seemed cheerful enough while going about their hard physical labor, although all were proud railroad men. I could not realize then how thankful those men were to have honest and useful work, and to be paid for doing it; but that memory is at the root of my belief that most people really want to earn their own way and will turn to what we used to call "Relief" only with somewhat shamed reluctance.

When the WPA later got around to laying down sidewalks in front of our house on Hamlet Avenue, my father had been called to one of his periodic jobs on "the road" and could not take part. My mother, however, was prominently on hand, standing with her arms folded and her back to the trunk of a huge oak tree planted right in the line of the proposed sidewalk. She refused to move to allow the WPA to cut down that tree to make room for modern "improvement," and she did not

budge until the WPA (in that case, her friends and neighbors) finally gave in. To this day, not far from our old house, that tree stands uncut, casting down its copious shade and dropping its acorns on a sidewalk that bends awkwardly around its massive trunk.

One morning, after a particularly long wait for a call from the road, I accompanied my father on a journey I didn't understand. We set off in the old secondhand Dodge my parents had been driving for years, a square and solid vehicle that a friend of ours once described this way: "If you stood that car on its rear end with its wheels against a brick wall, it could climb right up that wall."

We didn't have to climb a brick wall that morning. We drove, instead, to a nearby textile mill village—the kind that was common in those days, in which the textile company provided its workers with poor housing at exorbitant rents and the only place to buy groceries was the company store—where, in some cases, a buyer could pay only with company scrip (issued in lieu of real cash wages) that could be spent nowhere else.

The Seaboard operated a company store in Hamlet, where railroad families could buy groceries, but could not pay either cash or scrip. The cost—much higher than in other local stores—could only be charged against, to be ultimately deducted from, the family head's wages. So hated was this facility in Hamlet that it was known as "The Grab." My father had forbidden me, on pain of a trip to the woodshed, to buy so much as a penny candy at The Grab.

I don't remember whether the first store where we stopped that morning was a company store. I do recall that my father took a box of cheap cigars from several on the backseat and went in, not

allowing me to follow. I was puzzled because I knew he was a pipe smoker. Soon he returned, carrying the cigar box, a drawn and haunted look on his face. We drove to another store in another mill village and again my father went in, carrying a box of cigars. This time, he stayed a little longer but eventually came out carrying the box, the same strange look on his face.

At a third store, I waited in the front seat of the old Dodge until he came out with the little box, appearing white-faced and somewhat smaller than I had always thought of him. Then the unthinkable dawned on me. My father, a railroad man, a freight conductor, an independent soul who through years of hard times had clung to his house and his car and managed to keep his family together—my father was going store to store in the mill villages, peddling cigars.

Eventually, I suppose, my father made a sale, pocketing a few coins or even dollars to help hold his family together. I don't remember. I only recall how glad I was when we reached home, to find that Cary Hodges had stopped by the house at last to summon a railroad man to his real work.

Gregory Peck, movie star and former president of the Academy of Motion Picture Arts and Sciences, enjoyed the year.

"It was a very good year for college boys without independent means."

———————◇———————

A ll I did at Cal was study, row, wait tables in the co-op, and you know what else. It was a very good year for college boys without independent means.

Stanley Marcus built his family's luxury department store, Neiman-Marcus, with high-quality and attention-getting sales, such as "His and Her" gift items—his and her windmills, camels, airplanes and arks with live animals.

"...America and the world discovered Texas."

———————◇———————

The year 1936 left a bright spot in my memory because that was the year Texas celebrated the 100th anniversary of its admission to statehood, including a centennial celebrated in Dallas. It was the year America and the world discovered Texas, which was an unknown land to them. It was pictured as being filled with Indians and cowboys. Instead, when visitors came to Texas for the celebration, they found a sophisticated fashion store, Neiman-Marcus. The impact of this discovery affected us a great deal; ever since that time we've never had a quiet weekend.

A WPA writer interviewed **Chris Thorsten**, an ironworker in New York City, in his union hall where the men waited to be called for work.

"On Friday they walk a narrow little plank away up in the air and on Saturday, the sidewalk ain't wide enough for them. They drink like hell."

————————————◇————————————

This union is housed in the Labor Temple building at 84th Street. The Union Hall where men sit around is a bare loft some 30 by 50 feet. Three huge windows. Stacks of wooden folding chairs in a corner. Three long plain board tables on which men are playing cards. A few wooden benches along the wall. A small bulletin board with a few yellowed notices near the entrance. No other written or graphic material around the place. Thirty or thirty-five men sit around, some playing cards, others sitting alone. There is a remarkable lack of talk. The men, when they do talk, speak low and their mouths hardly open. Their voices seem to be pitched to the same note. Even the men playing rummy and pinochle on the tables do not talk any more than the game demands. They are dressed for the most part in black or dark gray work pants, same color shirt, leather windbreaker and a cap. The faces are solid, hard and set in straight deep lines. All have the same firm and taut quality about them. You got a different reaction here than you usually got from a group of unemployed men. There is no sullenness, no resentment, no nervous tension, no moaning, easy confession talk, no plaint. There is a quiet, hard waiting, a methodical sitting alone or with other men and looking at the floor or the ceiling and waiting. There are no postures of defeat or helplessness.

Thorsten is 200 pounds, 6 foot 2, flat, hard muscle. Back is bent
in a long curve, no hips, long thin legs, hands are twice the size of
an ordinary man's hand, fingers abnormally thick and straight. Face
set like iron but immensely amiable. Clear gray eyes, fine, well-
proportioned features solid and sharp. Reddish tan complexion,
deep-set eyes, graying blond hair.

"I been in this racket 32 years. You wouldn't believe I wuz 51
years old. Take a good look. You wouldn't believe it, would you?
It's a hell of a racket. Now take that Sixth Avenue job. They're
rushin' that job. Plenty of men get killed there. The first man gets
killed standin' on the railroad tracks. Friday, another man gets killed.
Down by Canal Street the first man was killed. They dropped a
whole load of steel. I was on a job once and my friend George
Morgan got killed. We're just sittin' there jokin', you see. He was
tyin' on a safety railin' on the scaffold and a beam rolled. The next
mornin' we had to go over and work where he fell down. I had him
in mind, and I got stuck between a beam and I landed in the Good
Samaritan Hospital. Three vertebrae broken and the collarbone.
Here, you can feel the bump where the back was broke. Go on, feel
it. You ain't an ironworker unless you get killed. Everybody knows
Lehman [governor of New York—Ed.] is behind this Sixth Avenue El job.
They can't get men from the Union to go down there. Well, they're
rushin' it. A man don't have time to watch out for himself. There'll
be plenty of men killed before this job is over. Men hurt on all jobs.
Take the Washington Bridge, the Triboro Bridge. Plenty of men hurt
on those jobs. Two men killed on the Hotel New Yorker. I drove
rivets all the way on that job.

"Once down in Maiden Lane we wuz workin' and we wuz singin'
dirty songs. You know, 'It ain't gonna rain no more, no more.' You

know, I can't tell ya. Ya know, 'Mary went to the grocer to buy herself a duck,' that kind of stuff, and they had to send the cops up to stop us from singing because they could hear us. That place is like a canyon. Once down in Georgia two colored ladies wuz walkin' along the street. They see some of the boys comin' out of the saloon. You know. Foolin' around. One colored lady says to the one, 'Ya see dem guys. On Friday they walk a narrow little plank away up in the air and on Saturday, the sidewalk ain't wide enough for them. They drink like hell.'

"If they'd give the damn work back to the contractors, we'd all be workin'. I don't get this WPA setup at all. You take Sam here. They fired him on the WPA for drinkin' once or twice. That ain't no way for them to act. We ain't got any stories around here. All we got is hard luck."

THE HOLOCAUST

John Slade was born in Frankfurt, Germany. He is honorary chairman of the executive committee at Bear, Stearns and Company. Here is his reaction to the early signs of the approaching Holocaust.

"There was a new law: any Jew caught kissing a Christian girl would go to jail. I left Germany in a hurry..."

———————◇———————

I n Hamburg for two years I played on the First Field hockey team. I suddenly was thrown out of the club because I am Jewish—my ambition to be a member of the German Olympic team in Berlin in 1936 was made impossible. There was a new law: any Jew caught kissing a Christian girl would go to jail. I left Germany in a hurry for the United States, where I did not know anybody. I arrived on March 25 in New York with $1,000—that was the maximum you were permitted to take out of Germany.

On the first day of my arrival I received an affidavit to immigrate from another gentleman. He warned me not to start a career on Wall Street—"There is no future," he said. I got a job with Bear, Stearns making $15 a week. The volume on the stock exchange was 1 million shares—today the volume on the stock exchange for 1 day is twice as much than for the whole year in 1936.

I am still with Bear, Stearns after 64 years—the firm had 50 employees when I joined—today we have 10,300 employees.

Leah Rabin is the widow of assassinated Israeli leader Yitzhak Rabin.

"...we in Palestine continued more or less with our daily routine."

———————◇———————

I grew up in Tel Aviv, and we watched the rise of the Nazis through Europe with great trepidation. Rumors were beginning to reach us of the horrors that were being perpetrated against the Jews of Europe, as Hitler proceeded with his demonic Final Solution.

We could not conceive of such things actually happening, and while this genocide was taking place, we in Palestine continued more or less with our daily routine. This is something of great concern to me today, as I believe that somehow or other all of us in the free Western world are equally responsible, at least in terms of our subjective feelings—could we or could we not have done something? This remains an eternal question, but did we do enough to alert the world's attention to what was going on? It is a chapter that has not been, and never will be, closed in terms of our collective conscience. I believe the young Germans of today are no less burdened and disturbed by this sense of guilt. More and more books are being written nowadays on this issue (I have just finished reading *The Reader* by Bernhard Schlink) and this does not surprise me at all. It is a manifestation and acknowledgment of what I have said above. There is still a deep sense of collective guilt about the failure to really grasp the horrible reality of this inconceivably dark chapter in mankind's history—and where were we all and how could it have happened.

In 1936 **Dr. Ruth Westheimer**, the popular sex therapist of television, was trapped in Germany with her mother, waiting for a U.S. immigration visa.

"...a more careful reading of Hitler's volume, Mein Kampf, could have prevented me from becoming an orphan at such an early age."

————————◇————————

I remember in 1936 walking with my mother to a local schoolhouse to vote. I could not say for sure that she might not have voted for Hitler's party because my parents probably did not believe that anything bad could happen to assimilated German Jews. As we all now know, some foresight or a more careful reading of Hitler's volume, *Mein Kampf,* could have prevented me from becoming an orphan at such an early age.

I left Germany on January 5, 1939, on a *kindertransport* bound for Switzerland. I was put into a children's home that soon turned into an orphanage, where I stayed for six years.

Hans Werner Henze is one of the world's leading composers. This is his heartbreaking account of the subtle but devastating erosion of trust and social bonds in Germany as the Nazis consolidated control.

"I feel only immense impatience and contempt for the age in which I live and the conditions that now prevail. I find everything inadequate and live only from day to day, waiting for better times that will come when I am bigger. Then I'll do only the things that I want to do."

———————◇———————

M y parents and I left Gutersloh in the spring of 1930 and moved to the nearby town of Bielefeld, where my father had gotten a job teaching, first at an ordinary school and later in a more progressive type of comprehensive. The school was closed down by ministerial decree and on the orders of the local NSDAP on the grounds that it was disseminating Marxist ideas. The Social Democrat headmaster of the school, Artur Ladebeck, was incarcerated in a concentration camp. My father and the other young teachers from the disbanded comprehensive were exiled to the tiniest villages. It was at this time that my father became more and more of a Nazi sympathizer, a change of heart undoubtedly due as much to fear for his livelihood as it was to intimidation.

I still remember 23 March 1934. My brother Jochen had just been born in the local hospital, and my mother had asked my father to go into town and buy some baby's nappies. He was photographed

leaving the local haberdashery, and the photograph appeared in the daily paper the next morning with the caption "This man buys from Jews." I suppose he then had no choice but to try to rehabilitate himself in whatever way he could.

He was given a job at the primary school at Dunne, a village at the northwestern edge of the vale of Ravensburg, in the foothills of the Wiehengebirge, not far from the old Roman frontier. Life was not easy for him or for the other four members of his family. (The latest addition was my sister Elisabeth, who was now 3 years old.)

My father was unable to continue playing the viola in the Bielefeld Chamber Orchestra. Our social lives came to an end, as did membership in the local Teetotalers' Association and the town's Brass Band and Choral Society, to say nothing of cabinet making, modern ideas and our beautiful ground-floor flat in the Azstrowstrasse. Here, in a room with a bay window, with the ceiling that my father had painted in an art deco design, had stood a grand piano. It was unplayable—it had no strings and the keys merely clattered emptily—but Franz Henze was a craftsman (a gift that I have unfortunately not inherited) and had planned to restore the instrument himself.

I remember walking one Sunday in the Teutoburger Wald with my parents, who were still deeply in love at that time. The oak trees were all bare, and the dry November leaves crackled noisily beneath our feet. Gerhard and I collected acorns, which we took back home with us, feeling a warm glow not only from so much walking and running, but also from our sense of inner harmony and love, so it was a matter of total indifference that our apartment was unheated. We had no money to pay for coal. Our parents made us a veritable

menagerie of the most delightful bipeds and quadrupeds out of matchsticks and acorns.

Now we were in Dunne and everything had changed, both at home and at school. I no longer had to bow stiffly when greeting grownups, no longer had to say hello to people. We now had to do as the children of Father's new colleagues did, clicking the heels of our clogs together and saluting the unspeakable Führer. We joined the Hitler Youth, and Gerhard and I only narrowly avoided having to obey the written injunction of its leader, Baldur von Schirach, that hung framed on the wall in our room and that invited all young Germans to get down on their knees every morning and thank God for giving them the Führer.

I noticed books by Jewish and Christian writers disappearing from Father's bookcase and being replaced by *Mein Kampf*, Rosenberg's *Myth of the 20th Century*, Karl Schenzinger's novel *Hitlerjunge Quex*, and other anti-Semitic, anti-Communist and National Socialist literature. Grandma Pericolosa was furious. The Ministry of Education's guidelines were now regularly to be found on Father's desk. We were no longer taught religion and no longer attended confirmation classes. It was not until much later that I got to know the Bible—or parts of it—through Bach's *Passions*, but all that I know of the Ten Commandments is that they are forever being broken, at least by the present writer.

My mother, a miner's daughter, regarded all this with the critical eyes of her class but behaved as befitted a German wife and mother—obediently and with only the gentlest of sighs. After all, she had sworn, in the eyes of God and the law, to obey her husband in all things. My father, too, seemed initially embarrassed by his change

of attitude, especially toward his genteel mother, who was now living under our roof in the country, where she died in 1941, never having believed in the final victory. A Pietist and a supporter of the antifascist pastor Martin Niemoeller, she regarded developments within our household with feelings of deep dismay, shaking her head and expressing her concern and disapproval even in our presence. With the passing years, we children came to regard these developments, including our parents' estrangement, like a daily dose of poison. In the end we forgot what it was like to laugh.

Yet I cannot claim that we knew only sorrow and worry. Once a week a certain Herr Albrecht Hiling would shut his cigar shop in the nearby town of Bünde and cycle over to Dunne to give piano lessons to me and the children of some of the other teachers. It was Herr Hiling who gave me my first insights into harmony, and every Wednesday evening I was allowed to turn the pages for this sullen and taciturn man when he played classical trios at Dr. Butenuth's house in one of the neighboring villages. The doctor himself played the violin and a baroness from a nearby castle played the cello. Were they any good? I remember only that Herr Hiling used a good deal of pedal. But they always got through the piece and never had to stop or rehearse or correct what they had played. Oddly enough, they never discussed the piece in question.

And a dark secret shrouded the whole affair: as a non-Aryan, Frau Butenuth was in constant danger, protected perhaps only by the fact that her husband was an important and well-respected local doctor. The beautiful music that I was privileged to hear, year in, year out, in this cultured middle-class household that was threatened by sinister forces undoubtedly taught me a very great deal and confirmed my belief that the true home of art is in the world of

those who are persecuted, among people whose feelings and exceptional qualities are bound to cut them off forever from the vast majority of so-called normal people.

As children, we were unable to form a clear picture of our father, since we knew nothing at all about him. He told us nothing, so we did not know whether he had had a happy childhood in and around Hannover at the turn of the century or whether it had been a terrible time for him. He had been born in 1898. Had he screamed as a baby? When did he have his first girlfriend? Or was our mother, nine years younger than he, his first, just as Father was probably her first boyfriend? They were decent, God-fearing folk then. For Franz and Grete, life could have gone on as normal, quietly and agreeably, but the little happiness and peace that they might so easily have been allowed was not, in fact, to be granted them, at least not in the longer term.

My father must have followed my literary and musical activities with a certain pedagogical interest and may even have helped to guide them in a particular direction, even though, to my regret, we never spoke about books or music or, indeed, about anything else. I never discovered the reason for this lack of understanding and coldness between us, but I remember that another of the presents he gave me one Christmas—the time of year when, as a rule, something like a truce breaks out in families in general—was a copy of Anna Magdalena Bach's *Clavierbuchlein* in a particularly fine edition. Once I could play all the pieces in it and had memorized them all, the road to Bach lay open. Whenever I heard the sounds of organ music issuing from any of the churches in Bunde Bielefeld or Herford, I would slip inside and listen to the organist practicing. Even composers such as Buxtehude and Pachelbel I came to admire

for their severe and searing austerity, but it was Bach's music above all that was like a light that filled the gloom of my life at that time with a feeling of great solemnity but a very real optimism: it was an expression of righteousness and truth, of rightness and consolation. It was the voice, in short, of salvation.

Some 20 years ago I wrote a piece on a school outing to the Roman frontier. It runs as follows:

> "School trips were something to be feared, although we were grateful to them for the fact that there were no lessons on such days. They recalled nothing so much as forced marches, making it impossible to stop for even a moment, still less to lie down in the grass or have a good look round. On one such excursion–in my memory they all took place in the autumn–I came across a genuine salamander. It was the only time in my life I had ever seen one. He would have made a delightful companion, and I only wish I could have taken him home, but I expect that he preferred it here in the wood, living a life of freedom, under the moss and close to a grotto with its rivulets of water. Also, I had to run to catch up with the rest of the class, which, implacable in its progress, had marched on ahead without me. The whole of Germany was marching at that time, increasingly implacably, beneath the whip hand of the capital's high-ranking slave-drivers.

> "Panting. My heart beats loudly, I've a stitch in my side, and my feet are hurting. I'd like to sink to the ground and never get up again. My clothes, which won't be changed again until next Saturday, are soaked with sweat. My sandwiches have all been eaten, and there's no more raspberry juice in

my canteen. We're on our way to the northernmost frontier of the Roman Empire. We've already been given a detailed account of the arch-enemy's cowardly and degenerate characteristics and even sung a song on the subject. And we've seen a performance of Hermann, Prince of the Cherusci at the open-air theatre in Nettelstedt, a play in which the emperor Varus and his mistresses and legionaries cut sorry figures indeed. They didn't stand a chance against the decorous Hermann and his loyal supporters—our own forebears—who always appeared on horseback and whose cause was clearly just. All this had in fact served only to diminish our interest in the Roman frontier, although we still expected to feel a certain sense of awe and emotion as, flaxen- and ginger-haired, we pressed on through the rustling leaves, often sinking in to our knees. It would, we felt, be a great moment—it could not be otherwise after all that effort, all the sufferings and complaints! Such a long walk to see only a bump in the ground?

"We could not believe it when we finally stood there. It was just like any other bump in the ground, indistinguishable from all the rest, except that it may perhaps have extended further on either side. I think how boring it must have been here for the olive-skinned youths from Rome and North Africa, and also how cold it must have been for them (I would later learn that Virgil had expressed similar concerns in his eclogue: 'Alpinas, al Dura nives et frigora Rhem'), but it is difficult to imagine anything in the face of this bleak bump in the ground, covered by autumn leaves that have accumulated over the years. Were there once any fortifications here? Shelters? Trenches? Hot food, swimming

baths? Was it dangerous to keep watch here? Did the Roman soldiers have to be on their guard day and night against the barbarian hordes? Did they have passwords? Were those who were sent to this desolate outpost felons? Ugly, unpopular, recalcitrant, unwanted, fit only to stare into space at the Empire's northernmost boundary, at the back of the beyond? No hares, no deer or squirrels to play with, but only an embarrassed silence weighing on this scene of desolation. Even the trees would like to leave.

"I am thinking of the way home and of the math lesson tomorrow morning. I have nothing to look forward to. I feel only immense impatience and contempt for the age in which I live and the conditions that now prevail. I find everything inadequate and live only from day to day, waiting for better times that will come when I am bigger. Then I'll do only the things that I want to do.

"My brother and I had to cycle 10 kilometres to school every day, a journey we had to make even in winter when it was often insanely cold—as low as minus 25°C. There was something quite wretched about it all. Since then I have always hated having to get up and leave the house in the dark. It did not start to grow light until we arrived in Bunde. One day, as we were approaching the town, I saw the pale sky lit up by fires and blackened by smoke. It was 9 November 1938—Reichskristallnacht in Bunde as in Gutersloh and every other German town and city, Jewish houses and synagogues had all been set on fire. From our schoolroom window we could look down into the small Jewish cemetery and see where the trees had been cut down

and the tombstones knocked over and daubed with anti-Semitic slogans and swastikas. No one said a word about it, not even our teacher, who was there to teach us German. We all pretended that nothing had happened. And no one asked after the taciturn, dark-haired boy who never returned to the school from that day onward. Not even I myself asked what had become of him—at least not in so many words. It had become clear to me by now that not even this terrible and fateful event would ever be mentioned in our parents' house. Our world had grown cold and tightlipped."

Tad Szulc is a former UPI correspondent, *New York Times* foreign and diplomatic correspondent and the author of 19 books, including biographies of Fidel Castro, Pope John Paul II and Frédéric Chopin. The growing storm of World War II was a dark but distant shadow on his childhood horizon.

"I remember skipping over black squares on a black-and-white mosaic sidewalk outside the Zurich station, convinced that there would be a world war if I missed and landed on a black square, and peace if I made it from white to white."

——————————◇——————————

My life was quite pleasant, if a bit boring, as I grew up a sickly child in my grandparents' elegant Warsaw midtown apartment. I lived with my grandparents, my mother, my governess, the cook and the maid. We were an upper-class bourgeois, assimilated Jewish family. My paternal grandfather, an international businessman, was an amateur pianist and he would listen on his crystal radio in his den to the Friday evening concerts of the Warsaw Philharmonic, and I was encouraged to listen on my own set of earphones. My mother was deep in the social swirl of the capital. Her beau, much later to be my stepfather, drove a blue Bugatti sports car and rode a Thoroughbred saddle horse at the manage of the elite cavalry regiment. Her sister, Irena, a painter and member of the Polish artistic community, presently married a United States diplomat stationed in Warsaw. My parents were divorced and my father lived in Brazil as a Polish government trade representative.

Sheltered from all sides, I was only dimly aware of the existence of anti-Semitism in Poland, certainly not murderous and quite subtle compared with Germany, and of the fact that a world war was fast approaching. In fact, even most intelligent Polish grownups did not sense the danger. My parents, who had remained close friends, had the imagination to export me in 1937, when I was 11, to Le Rosey, a prep school in Switzerland.

The company at school was quite acceptable: Reza Pahlavi, the future Shah of Iran, and his brothers; Prince Rainier of Monaco; the princely Hohenloe twins; a stray Prince Radziwill from a Polish royal family; Jacques Cartier of the jewelry dynasty; and sons of British and American diplomats and transatlantic millionaires, among them Alistair Horne, who grew up to be a distinguished British historian. (Le Rosey is still called the "School of Kings.") The old Shah-in-Shah picked his sons up in a black Rolls-Royce.

Le Rosey provided tough European education conducted in French and English. There was no favoritism for the highborn or dementedly wealthy. Everybody was called by their last names and everybody was subject to fines for the slightest infraction. I suppose democracy was better taught there than in most other places. In the spring and autumn, in addition to education, we had soccer, tennis, fencing and shell rowing on the Lake of Geneva in competition with other Swiss international schools. We also learned to smoke in the dark basement of Le Rosey castle. In the winter the school moved to chalets in Gstaad, in the Oberland Bernois, where we skied and played ice hockey. Down the road from the school in Rolle, the girls' international school, La Combe, was occasionally invaded at night by our guys. Much as we, the children of affluent and world-conscious families, took considerable interest in events around the

globe—Abyssinia, Spain and so on—we were oddly disconnected,
I think, from events around us, let alone from any sense of history.

My family, to be sure, was highly sensitized to politics, if not to
history. I was at school in Switzerland in March 1938 when Hitler
annexed Austria and triumphantly entered Vienna. It affected me
personally, not because of the fate of Austria and Austrian Jews (the
world hadn't comprehended yet what the Nazis were doing to Jews
and at 11, I couldn't have absorbed all the horror even if I knew it),
but because of my aunt Irena and my uncle, John C. Wiley, who
served at the time as the American minister plenipotentiary to
Austria. Uncle John, who had started his foreign service career in
1919 carrying President Wilson's briefcase at the Versailles Peace
Conference, devoted much of his time between Vienna and Anschluss
and the closing down of his Legation to helping Jews flee Austria.
His friend, the minister plenipotentiary of Belgium, supplied all the
necessary Belgian transit visas on instant notice. Aunt Irena persuaded
the State Department to ship over to Vienna telephone directories
for all the main U.S. cities so that Austrian Jews applying for
American visas could search for relatives who could serve as
sponsors (as required by law).

My final departure from Warsaw to Switzerland in the autumn
of 1938 was by train. My father was taking me back to school after
our respective summer vacations in Poland and Brazil. Possibly
because there were no other railway schedule alternatives, we went
through Berlin. We knew then almost nothing about Nazi
concentration camps, but I sharply remember my paralyzing fear
when two tall jackbooted SS officers in black uniforms with swastika
armbands entered our train compartment right after we crossed into
Germany to check our passports. They said nothing, returned our

passports and left. My father, as I recall, was cool and unconcerned or, at least, he made that impression on me. I am certain Father knew better than to feel really relaxed at that moment.

We had no problems in Berlin, which made a very good impression on me as a great city. Our two cousins drove us around Berlin, showing us the sights and chatting relaxedly with my father in German, which I did not understand. Tens of thousands of German Jews must have already been in camps or had managed to flee abroad, but I don't believe we, the visitors from Poland, were aware of it. What I remember best from the trip was a mechanical doggie-in-the-window in an expensive shop on chic Friedrichstrasse, tapping gently on the pane with his paws. Father did not offer to buy it for me; he clearly did not think it would make a favorable impression on my Rosey schoolmates.

As it happened, that was the week when Britain's Prime Minister Neville Chamberlain (as in "Peace in our Time") and French Premier Edouard Daladier had flown to Munich to meet with Hitler, a conference that resulted in Czechoslovakia's loss of the Sudeten region. It was occurring as our train rolled from Berlin to Zurich, where we were to change trains to continue to Lausanne and Rolle, where Le Rosey is located. I must have been conscious of it. I must have heard it discussed by my father and his current girlfriend, the wife of a Polish newspaper publisher, traveling with us in our compartment, because I remember skipping over black squares on a black-and-white mosaic sidewalk outside the Zurich station, convinced that there would be a world war if I missed and landed on a black square, and peace if I made it from white to white. When I think of that day, I have the undeserved feeling that I was the tiniest participant in history.

Lucian Heichler was a U.S. foreign service officer for 35 years, now retired and living in Frederick, Maryland.

"My family decided that I should continue my education at home, under the watchful eye of my father...this effort required calmer, stronger nerves than anyone had under the circumstances, and we all soon gave up on it."

───────◇───────

When I started school in Vienna, the Austrian school system was very different from that in America, and presumably it still is. Grammar or elementary school had only four grades—ages 6 to 10. At that young age, children, or rather their parents, then had to decide whether to continue on to Hauptschule or normal school for four more years and then learn a trade, or to enter one of three different types of gymnasium or university preparatory school. These were: (1) the Humanistisches Gymnasium (classical high school) for children who intended to study medicine or law or obtain a Ph.D. in one of the social sciences or humanities; (2) the Realschule, a more practical school, with emphasis on mathematics and the sciences but no classical languages, for those who wanted to become scientists or engineers; (3) the Realgymnasium, a hybrid where children were taught Latin (but no Greek) and given more math than in the humanist gymnasium.

My father was a physician, and from the day of my birth it was a foregone conclusion that I should follow in his footsteps. At the age of

10, I had to sit through the entrance examination for the Humanistisches Gymnasium. On passing, I attended the school in and for my district, the Piaristengymnasium, housed in a very old monastery established by the Piarist Order. The school occupied one of two long wings flanking a basilica. The monks lived in the wing opposite us, across the square in front of the church. Not long before my time, monks had taught in the gymnasium, but now my teachers were lay employees of the state. Over a period of eight years, until my Matura, or graduation, I was to have eight years of Latin, five years of classical Greek, three years of either English or French, as well as all the math, physics, chemistry, history and geography provided for in the curriculum.

It was a tough, rigid school, but I was a good student, as I had been in grade school, and enjoyed my classes. My teachers–all men– were very strict, but not as strict as my father, who insisted on reviewing my homework with me every night and lost patience with me at the drop of a hat. My friends were of necessity limited to the four or five other Jewish boys in my class, but we did not get along especially well; there was much rivalry and quarreling among us.

All in all, I had a reasonably normal school experience–until the Anschluss (Germany's invasion of Austria). There was no school for one or two weeks following the German occupation, ostensibly to celebrate this joyous event–Austria's "return home to the Reich." When I went back to my class, I was somewhat surprised and intimidated by the suddenly cold and hostile attitude of my teachers, all of whom suddenly sported the Nazi Party emblem in their button holes, and I sensed that the gulf between my Gentile classmates and myself had widened considerably. We Jewish boys were summoned to the principal's office. He informed us that we were no longer citizens but rather tolerated "guests" of the state, with limited rights;

for instance, we were strictly enjoined from "polemicizing" (as though we had any idea what that meant). After another week or two we were sent home; there was to be no more mixed education, with Jewish children polluting their Aryan classmates.

Then the authorities established a special high school for the city's Jewish children. A ramshackle, dirty old school building in Vienna's Second District Leopoldstadt—historically and traditionally the city's Jewish quarter—was chosen to serve as our new school. Classes were extremely crowded, and teachers made it a point to be impatient and hostile. We learned nothing in the weeks remaining to the end of the school year. After that, the experiment was abandoned; Jewish children were no longer permitted access to public education.

My family decided at first that I should continue my education at home, under the watchful eye of my father and his sister Ernestine, who had taught Latin once upon a time. However, this effort required calmer, stronger nerves than anyone had under the circumstances, and we all soon gave up on it. I simply did not go to school for two years; instead, I read voraciously—not as a conscious substitute for school, but simply because I was of an age when I wanted to devour books, escape into them, disappear in them and shut out the ugly reality of my life.

Those were strange years for a boy of 13 and 14. I became even more of a dreamer and introvert than, as an only child with much-older parents, I had already been. I walked around Vienna and the nearby Wienerwald hills, carefully avoiding trouble—places where I was not wanted, where I might be recognized as a Jew and run into trouble, quickly crossing the street when I spied gangs of adolescent

boys in the uniform of the Hitler Youth who might be looking for a Jew-boy to beat up. At home I read voraciously and kept a secret, highly emotional diary.

The Gestapo visited us. Four young men in plainclothes knocked on the door of our apartment, with orders, they said, to search the house for weapons. My mother and I were paralyzed with fear, certain that they would take my father with them and that we would never see him again. We stood around and watched as they ransacked the house, searching closets and bureau drawers for pistols we knew they would not find, because of course we had none. But in a drawer of my father's desk they came across his World War I decorations for valor. I can still see the young man seated behind my father's desk as he looked at the medals and then barked at his companions, "*Frontkämpfer* [combat veteran]...let's get out of here." And at that they turned and walked out, leaving us standing open-mouthed with astonishment and relief. A few years later, my father's wartime service would have counted for nothing.

As Nazi restrictions grew tighter and tighter, Jews were given only half the rations allotted to others. Certain items were forbidden us altogether, such as any and all fresh produce, including potatoes and other root vegetables. We were no longer allowed in the greengrocer's shop on the comer. This account would be incomplete and unbalanced without at least one vignette of unsung heroism. Our landlady, an upper-class Austrian Catholic in her late 70s, looked with disdain and disgust upon the Nazi regime and all its works. Once or twice she knocked on our third-floor apartment door in the middle of the night (having first made sure that her Nazi concierge was not spying on her, for that woman would have liked nothing better than to denounce her employer to the Gestapo) and dragged a

heavy sack of potatoes into our front hall. How the frail old lady got that heavy sack up the stairs is a mystery to me. Frau Preleitner has been dead for many decades, but her act of love and courage has continued to live on in my memory for more than half a century.

When we were finally able to complete the maze of U.S. State Department visa requirements, German laws had stripped us of all our assets, including my father's medical instruments and my mother's jewelry. Our last money went for steamship tickets at vastly inflated exchange rates. We arrived in America with $12 for the three of us.

Frances Nunnally, a teenager as we would call her now, kept a diary, and from the news full of terror and darkness, her daily record turned to romantic dreams, as so many did.

"This particular year proved to be a treasure trove for a youngster trying to shut out the harshness of daily life by dreaming of kings, queens and real-life princesses."

⸻◇⸻

I was fresh out of school at 13 and looking for a job. I lived in Vienna, Austria, and recovery from the First World War had been slow and painful. Men, now middle-aged, missing an arm or a leg or both, were everywhere to be seen on the streets, some begging for coins from passersby.

The shop where I worked sold fine leather ware—belts, purses and such, but I was rarely permitted to get close to the customers. Rather, my duties included sweeping and waxing the floors, washing crockery in the back room and, on occasion, taking care of the proprietors' children. For this I was paid the princely sum of 18 shillings a month. (Perhaps $10 in today's currency?) But to me this paltry wage was a fortune indeed. On my first payday I stopped by a fruit seller's on the way home and bought a pound of cherries for my mom.

As a wanna-be scholar, but—alas—a school-less child, I'd always had a burning interest in history. And this particular year proved to be a treasure trove for a youngster trying to shut out the harshness of daily life by dreaming of kings, queens and real-life princesses.

My diary entry on January 21, 1936, reads: King George V of England died today. Edward, Prince of Wales, is now King Edward VIII. He is 42 years old.

December 10: The young king of England fights for his love. She is not a royal princess but a commoner, Mrs. Wally Simpson, an American divorcee. The whole world is holding its breath.

The world didn't hold its breath for long, for the following diary entry notes:

When I saw the newspaper this morning, I felt as if I had been hit by an electric jolt. King Edward VIII has abdicated! Will he marry Mrs. Simpson? I am so sad that this has happened...

As the year drew to a close, signs of economic recovery began to appear. My parents saw their own little business grow. There was even talk of my being able to enroll in a trade school the following year.

Within five years my parents, brother and most of my relatives would be gone—murdered in the Holocaust.

The Reverend Trudy Jarno, painter, founder of the Church of Inner Light in Los Angeles, metaphysical teacher, medium, psychic healer and author, remembers her flight from Vienna when the Gestapo came to arrest her family.

"I looked back at them from Swiss soil and knew my life had been given back to me."

◇

This was the worst part of my life that I can remember. I had to send my 9-month-old baby away and out of danger, so we sent her to family in Prague. I didn't know if I would ever see her again. For two weeks I had no idea where my husband was. He left Vienna the same night I did, although I didn't know it. I left in the day and he left in the evening to Prague, and I didn't know where he was. You could not go into a hotel because you had to register. I couldn't just take a plane and leave because I had an expired passport. All the pages were filled. So I took the train to Nuremberg to my cousins' and stayed for two weeks. They had a little chocolate manufacturing business in their home, and faced with frustration, anxiety and fear, I sampled them all and gained quite a few pounds. I didn't understand why nobody came, because I was told someone was coming to get me. It was one day two weeks later, a man and a woman came from Switzerland and asked me to leave with them. They came with a German car and a Nazi chauffeur. Their Swiss car had broken down on the German side and they had to hire other transportation. They told the driver that I was an actress who was badly needed the following day on a movie set under a certain name. This Swiss couple told me what my name was, where I came from and to rehearse that quickly. "She" had entered on a pass that entitled her to take a trip around Lake Bodensee. The Swiss woman handed me the pass and

then used her Swiss passport to exit Germany. The luggage was divided between us, not to arouse suspicion.

That five-hour trip to Switzerland is something that is very hard to think about because that was having the guns behind you. On a sudden impulse, the decision was made to drive to a small and closer frontier crossing. It was then 10 minutes to midnight. This remote place had not yet heard of the change of the new regulation effective at midnight. The pass I had became invalid then and it was my only exit paper. The retrieval of the broken-down Swiss car became the topic of conversation between my Swiss guides and the German border guards. Nobody talked to me so they didn't see I didn't have the Swiss accent or the German accent. They stamped our papers blindly without checking me over and I waited in the car, totally ignored. When all formalities were completed, the couple joined me to ride the few feet to the Swiss side.

To see the German soldiers behind a simple gate a few yards away with rifles, ready to use them and take your life, cannot be described. The gratitude that swept over me when I looked back at them from Swiss soil and knew my life had been given back to me changed my outlook on life.

I was reunited with my mother early that morning and my husband came from Prague the next day with our daughter. I had left my wedding ring in Nuremberg to hide my real identity. When in Switzerland I received a box of homemade candies from my cousins in Nuremberg. We indulged in these sweet delicacies and I gave the last three candies in the box to the maid in the house. The next day she came to me and handed me what she had found. My wedding ring was embedded in one of the chocolates with the inscription "Seppl and Trudy."

Dr. Jacob Jupiter, at age 85, is retired from a 40-year career as a psychoanalyst. He does volunteer psychotherapy for his Temple in Delray Beach, Florida.

"....we are on a vacation from death."

The shot that killed Chancellor Engelbert Dollfuss in Vienna, Austria, started World War II. The Final Solution was born and six million Jews were murdered including my dear, dear mother.

Those of us who are scattered around the world today are alive, but are we really alive? No...we are on a vacation from death. My soul died that year, in 1936. My thinking is convoluted, fear is always present at my fingertips–every night of my life nightmares roam in my brain. I am a neurotic being. I smile, I love, I eat, I travel. I'm a successful psychotherapist ensconced in a warm, wonderful, caring family, surrounded by many friends, a worker and worshiper in my Synagogue.

The hole in my heart has never healed, and that is the sadness of the reality...my love for Vienna has never left me.

Ed Guthman is a Pulitzer Prize-winning journalist who served as press secretary to Robert Kennedy. He led infantry reconnaissance patrols in North Africa and Italy during World War II, receiving a Silver Star and a Purple Heart. He teaches at the USC School of Journalism. His mother's family came early from Germany to America; his father as a teenager in 1889.

"Some came three, four or five years later. Others died in the camps."

◇

I was 16 in 1936, living in the same house in a middle-class Seattle neighborhood where my three older sisters and I were born. My dad was sales manager of a wholesale grocery firm, and while the Depression cut fairly deeply into our lifestyle, we—as our father reminded us—were fortunate in always having enough to eat. I worked that summer in a retail grocery chain's warehouse, loading trucks after giving my first week's pay—$35—to get a temporary work permit from the Teamsters Union.

The day that Hitler came into power in 1933, Dad got visas for every member of his family in Germany—an older brother, two sisters and five or six nieces and nephews and their children. Only one, a young doctor recently graduated from Heidelberg, came at once. Some came three, four or five years later. Others died in the camps. By 1936 my parents were part of a group that met every train and every boat that had German refugees and assisted them in getting shelter and employment. Our home was open to them.

My sisters and I did what we could to help, and while my mother and dad had always spoken German when they didn't want us to

catch what they were saying, we had picked up a fair understanding anyway. We were forbidden from studying German in high school.

"It's a dead language," Dad said.

POLITICS

A WPA researcher talked to **Mr. Dunnell**, a hay, feed and grain merchant in Northfield, Massachusetts. Former House Speaker Tip O'Neill once said, "All politics is local." It was also intensely personal in small towns.

"Him and Stearns was so friendly that I guess they used to keep their teeth in the same glass of water."

––––––––––––––––◇––––––––––––––––

Charlie Stearns thought he owned the town clerk's job, because his father had it, or somethin'. An' some of us thought it was about time for a change. Stearns had been clerk for years, and he didn't need the money. He is one of the kind that think they are getting ahead if they are piling up money in the bank, 'stead of making some use of it themselves—goin' to Florida once in a while, or doing something, by God, instead of buying books with figures in 'em from banks. First thing he knows, a president or somebody will come along and say that as the rich people had won all the money and the rest of us had to keep playing the game, whether we liked it or not, that hereafter we wouldn't use money no more. That we'd use poker chips, or pins, or buttons. And if anyone was caught selling anything for money they'd be shot! If that happened where would Charlie Stearns be?

Anyway, we figured that Charlie Stearns had money enough without the town helping him out. And there was a nice woman here that was having a tough time. She used to keep books in a whip factory over at Hoosick Falls, and after that she was a stenog'pher or something at the Seminary, and all the women knew her. We got more women voters than we have men voters, you know. Stearns used to run a dry goods store in the center of town. And he didn't

have too many customers. He spent most of his time peeking out the winder to see what folks was doing. You'd see somebody go in his store on town clerk's business or yer could see that easy from the drug store steps, 'cause Stearns always went to his desk—he'd 'tend to 'em nice and polite. Then he'd watch them out of sight. And when they'd gone he'd make tracks for old Warner's house. Warner used to be in the legislature, you know, and was the boss politician of this town. Him and Stearns was so friendly that I guess they used to keep their teeth in the same glass of water.

Well, our town hall was burnt up, so we had to hold our town meetings and the elections in the church. Frank Williams burnt it up—the feller that was town treasurer and put our money in a hole in the ground out west. He'd told the janitor to build a fire in the furnace for some meeting or other that he had. The janitor wouldn't do it for he said the insurance people said it warnt safe til the flue had been fixed. But Frank he knew better'n the insurance people, so he fired up himself. The town didn't get no insurance though. For among other things, it seems that it had slipped Frank's mind as treasurer to keep the policy in force. God! but that fire was funny, though us taxpayers had to pay for the fun we had. First, they could a-put the fire out if they'd had a fire extinguisher. There was supposed to be plenty of extinguishers around the hall. But it seems one of the selectmen had taken 'em down to his garage to recharge 'em. The gang rushed down there hellety-whoop. Nobody knew anything about 'em. He'd gone off somewhere with the key. And they hadn't been charged yet anyway.

When the gang got back to the fire, it had got to the part where the town kept its fire apparatus. But they managed to save the hose cart and a few lengths of hose. They rushed this around to a

hydrant, and a feller took a wrench to turn on the hydrant. But he didn't know which way to turn. So another feller grabbed hold with him, and between 'em, they twisted the damn thing clean off. Guess it must a-been rusted a bit. Well, anyway they had a nice little fountain going as a kind of additional attraction. And they had to run their hose clean from another hydrant somewheres down on the Warwick road. When the water finally come it ran out of the hose, but that was about all—oh maybe 10 or 12 feet—but it kinder died, you know, just gradually sub-sub-subsided, 'cause the busted hydrant reduced the pressure.

So we lost the town hall and had to hold the elections in the church. The first election come out a tie, so for the second we scraped up every voter there was in this town. Gosh! It was a cold day, too. There was snow on the ground—plenty of it—but it had melted some so the sidewalks and the roads were just covered with ice. I got out good and early and bought a box of cigars to take to church. When I got there, greasy little Charlie Stearns was greeting the voters as they come in with that oily smile of his and a handshake for anyone who would come near him. It felt nice and warm in there after the cold outside, so I took on the job of greeting the voters, too, and Charlie didn't like it a bit. But we kept smirking at the voters, him on one side and me on the other. An' I kept track well as I could in my head of who'd come and who hadn't.

Along in the afternoon I made up my mind that I'd better get outside, cold or no cold, and dig out some voters I thought would be for us. First place I went was right across the street. "You voted?" I asked the old feller who lived there alone. "No," said he, "too cold. Sit down, Dunnell, and have a glass of cider."

"No," I says, "much as I'd like to. But I'm over at the church and it wouldn't be right to have 'em smell liquor on my breath. But I know you don't like Charlie Stearns. And here you have a chance to beat him, and you won't walk across the street. Now, I'll tell you what. I've got to go other places, but when I get back to the church, you'd better let me find out you've voted. For if you haven't, honest to God I'll be back over here. And I'll get in, even if I have to kick in the door. And I'll take you, just as you are 'without no overcoat right over there and make you vote.'" Well, he said he'd come.

Then I went up to a woman that runs a boarding house. "No," she said, she couldn't come, it was too cold. I told her how the wimmen ought to stick together, but I didn't get nowheres with that. She said a couple of my boys had stopped and asked her to ride down, but she had refused to go, and if she went with me they'd think she didn't like 'em. Look, I says, you remember the time I was delivering coal here, and I saw those weeny, scrawny potatoes you was cooking? I says, An' how I brought you up a bag of good ones, and never charged you nothing. I says, just a neighborly act to help you out when you needed it. And now you won't even come and vote for me, I says. Well, she guessed she would go, after all. And on the way down in the rig she asked me how she should vote. Oh, I can't tell you that! I says, 'twouldn't be proper. You vote just as you've a mind to. But I'm not ashamed to tell you how I voted, I says. Well, 't was just like that all the afternoon. Only thing a little out of the ordinary was in the store when I went to look for a clerk. "Fred around, Miss Leavis?" I asked the bookkeeper. She said, "Yes," but the way she kinder colored up, I thought I knew where he was so I went down to the cellar and then out back. "Come out o' that," I yells, "come on out and vote!" "Go away," he says. "I ain't got no time to vote." "By God, mister," I yells, "promise me that you'll come over and vote just as

173

quick as you can, or I'll bust in the door and take you just as you are!" He promised alright after I'd shook the door a bit.

When I got back to the church I was pretty much all in. I hadn't had nothing to eat all day, and my box of cigars hadn't helped my stummick any. I figured we was licked. I couldn't see that we'd skipped anybody. Charlie Stearns had a sagging puss on him as though he was already to cry, so I figured it wasn't going to be no walkover for their side, and started shooting off my mouth about how much the town was going to benefit by a new town clerk. The Stearns fellers didn't like it, of course. One of 'em, Will Merriman, says, I see you coming up by the cemetery, he says, a-getting 'em out of there you was? I knew he'd seen me when I stopped for the Mattoon sisters, who live down that way, and who I had to help over the ice to get into the rig. They was pretty old. Oh no, I says. We didn't get near all the voters we could have out of the cemetery. All we bothered was in the new part. We didn't get around to tackle the old part, I says. After that, I begun to feel better. And I swaggered around confident as you please. But I damn near died when the time come to announce the vote. Seems if I couldn't stan' it. When I heard that we'd won by one vote, I let out a yell that Stearns' ancestors coulda heard. I started out on a run to spread the glad tidings—an' I forgot all about the ice. What is it the Bible says? Somethin' about "Pride going before destruction and a haughty spirit before a fall." I guess so. Anyway, I had a fall alright. I slid about 40 miles. And I busted my box of cigars—what they was left of 'em. But it didn't hurt me none, 'cause we'd licked that pore, little, miserable runt of a Stearns. If we hadn't I'd had to have gone to the hospital, I expect.

S. Charles Straus is a retired machine tool manufacturer and licensed security analyst who works pro bono as a financial adviser. He has been married 53 years.

"The Nazis, Fascists and Communists each had enthusiasts in the Dartmouth student body, but no one seemed to believe that they were as evil as described."

I was a senior at Dartmouth College awaiting graduation with a surprising lack of apprehension, no definite ideas about the future and little ambition. The realities were obvious. We were in a serious economic depression with a mad bigot in control of Germany, a self-styled emperor in Italy, plus an ambitious despot in Russia. There was a seldom discussed but popular belief that the future was not going to be pleasant.

My reaction to the couple of people I knew who quit Dartmouth to join the Abraham Lincoln Brigade to fight in Spain was ambivalent. I admired their dedication to a cause but questioned their judgment. The Russians didn't read like they were effective or realistic, and I couldn't understand how fighting for or with them would solve any problems for Spain or Europe. Nor did I subscribe to many of the president's newly started alphabet agencies, most of which sounded dramatic but pointless.

The Nazis, Fascists and Communists each had enthusiasts in the Dartmouth student body, but no one seemed to believe that they were as evil as described. At least that was the stated belief of most of us who were probably pretending that the future would not be as bad as it really was going to be.

My father was a bright, conservative businessman who did not become as overextended as many others had in the late '20s. Consequently he survived the '29 stock crash and Depression with little changes in our family's lifestyle.

He often told my older brother, who graduated from Yale in 1936, and me that he would continue to finance our education as long as we attended postgraduate school. He made it clear that when this stopped we would be on our own. Neither of us was interested in more academics, so we made the decision to go to work.

I was an economics major. In senior year I was required to take a coordinating course. The professor to whom I was assigned was Bruce Knight. He had recently published a book titled *How to Run a War*, which he used as a text for the meetings held at his home.

He had been a soldier of fortune in the Philippines as well as an economist before becoming a professor. This combination made what he said very convincing. Mr. Knight believed that war in Europe was inevitable, and that the U.S. would be involved a couple of years after it started.

He stated that an officer was more productive in any army than a private and that the living quarters were correspondingly better. According to Mr. Knight, anyone who could become an officer and didn't was a fool, so I listened carefully when he explained how easy it would be to become an officer by taking a correspondence course.

Also, before graduating I took a required statistics course from a professor named Rice, who had been gassed and shell-shocked in World War I. It was as dull as its name, but memorable because of

his afflictions and the textbook he used, a new book by Graham and Dodd called *Security Analysis*.

The author was *the* Benjamin Graham, the legend of Wall Street who is considered the father of modern investing, and I still feel fortunate to have been exposed to his brilliance so long ago.

In 1938, after working for a year, I phoned Mr. Knight to ask if his views on the future had changed. He said that they had not except that the estimated dates had been advanced, and war was inevitable.

So I took the correspondence course he had suggested and later served in World War II as an FBI agent.

Harry Miles Muheim

is a screenwriter and narrator. Here, he tells of his father, a passionate Democrat, who with a devoted Republican friend listened to Roosevelt making a speech. For Muheim it was a defining moment, a lesson in democracy.

"FDR could put his arms around you with his voice!"

———————◇———————

In the summer of 1980, I sat in a dim screening room at the Twentieth Century Fox offices in New York, looking at footage of four former presidents as they spoke. I had written the half-hour film that would introduce President Jimmy Carter to the Democratic Convention later that year, and I was now searching for sound bites from these earlier speeches that would give a glimpse of the continuing ideas that ran through the long and often fractious story of the party. That great voice from the past took me back to when I had first heard the speech.

It was a beautiful California Sunday. We had left San Francisco early in the morning to drive to a family reunion in the little town of Oakdale, in the Central Valley of the state—about a hundred miles east of the City. We rode in our aging 1929 green Ford Tudor sedan. Our father and mother, Emile and Anna, sat in the front seat, my sister and I in the back. An American Family on the American Road.

Emile Muheim, a civil engineer, was the most avid New Dealer in the nation. I had become a New Dealer myself on the night back in 1932 that Roosevelt had defeated Governor Ritchie of Maryland for the Democratic nomination, and Emile—who was usually undemonstrative—had danced a victory dance around the Spartan radio. Twelve years old at the time, I was swept up into his intense

political enthusiasm. Though I did not understand all the political details of the first Roosevelt administration, I soon came to enjoy the fact that the president was funny. (I was 26 when FDR died, and he had made such a powerful impression on me that even today I am still, at heart, a New Dealer.)

We had a fine time at the family reunion, but Emile did not lose sight of the fact that Roosevelt's campaign speech would be broadcast at 6 p.m. The party began to break up around five, and since our Ford did not have a radio, he suddenly found a solution. Bob Turlen, a distant relative, would be driving with his wife back to the City.

President Roosevelt at a whistle-stop in the 1936 campaign. His wheelchair was carefully hidden when he stood for these speeches, to deflect attention from his paralysis. A Republican whispering campaign spread that infantile paralysis affected the brain.

Turlen, a quiet man in a necktie and camel-hair sport jacket, had just bought a brand-new Plymouth coupe. It had a radio. Emile wondered if we could follow the Turlens and then stop by the side of the road when the speech came on at six. Turlen, a Republican, was clearly not too enthusiastic, but he agreed to do it anyway.

An hour later, we were following the Plymouth along a two-lane blacktop road atop a levee. This was the delta country of the Sacramento River—with fields stretching far off to the south and one of the quiet branches of the tidal Sacramento on the north side of the road. The shoulder of the road was narrow here, but Turlen found a place where he could pull over to park.

My mother and sister stayed in the Ford; Dad and I got out and walked ahead to the parked Plymouth. The setting sun—straight ahead to the west—was casting a yellow-gold light across the delta country. There was no wind at all. It was a glorious moment—the beginning of twilight. Dad came up to stand on the driver's side of the car. I stood on the other side, where the levee ran down in a sharp slope to the water. And then Roosevelt's voice boomed out across the quiet landscape. In later years, someone would say of FDR, "He could put his arms around you with his voice!"

There was my father, standing outside the open window, listening intently, nodding, agreeing. And there was Bob Turlen, shifting around uncomfortably in his expensive coat saying nothing, but clearly disagreeing. (And probably wondering why he had agreed to stop at all!) The president's amiable tirade pointed out that the Republicans seemed to be blind in this election—that they were purposefully unable to see that many of his New Deal programs had actually begun to lead the nation out of the slough of the Great

Depression. "And yet," he added, "the members of the Grand Old Party are now in such good shape—in such fine fettle—that they are ready to throw the crutches at the doctor!"

Emile Muheim laughed with gusto, and so did I. Bob Turlen managed only a thin smile. I have always held in memory those two faces and that late-in-the-day time of listening there on the vast delta flatland. There was a kind of wordless confrontation between the two men—and for me it was a defining confrontation. The hopeful Democrat in the chambray shirt, ready to embrace some new scheme, not sure of exactly how it might come out. And the slightly disdainful Republican with the necktie, confident that the Democratic scheme will surely lead to disaster. That continuing argument has been at the heart of our history. It continues today. And a generation of adversaries has created a complex democracy that has endured for more than two centuries. It is a balancing act that is the political wonder of the world.

Stanley Rubin is a writer and producer of feature films and television movies. At UCLA in 1936 he was the rabble-rousing liberal editor of the *Daily Bruin*, the campus newspaper.

"What an arrogant, opinionated, unbearable horse's ass I was."

———————◇———————

I was in my third year at the University of California at Los Angeles. Those were exciting days politically. Roosevelt was running for a second term against Alf Landon; I was running for editor in chief of the UCLA *Daily Bruin* against Louis Banks.

Louie and I had been working on the *Daily Bruin* since our freshman year. He was also campus stringer for the Hearst paper, the *Los Angeles Examiner,* and there was no doubt in my mind that he was the better newspaperman.

The retiring editor of the *Bruin* was a tall, serene, gifted young man named Gilbert Harrison. We, the staffers, were all in awe of him. I was extremely nervous when he called me into his office on May 19, 1936. He had reached a decision, he told me. He was recommending me for editor in chief, Louie Banks for managing editor.

I was thrilled—stunned, actually—and barely managed not to question why. Two days later the Bruin carried a four-column headline: STUDENT COUNCIL NAMES RUBIN, BANKS TO HEAD 1936–37 DAILY BRUIN.

It was really a big moment for me. I was 18 and I was going to run a daily newspaper for 6,500 students—and the town of Westwood.

I could see fireworks spelling out "1936" in the sky. I may have thought Louie was the better newspaperman, but it was I who was going to write the brilliant, society-altering editorials. Now at last I would have at my disposal a daily column in which I could tell the campus, Westwood and even the city of Los Angeles exactly what was wrong with them and how to fix things.

In early September I took over the *Daily Bruin* and started repairing the university. In welcoming the incoming freshmen I wrote, "Uncover faults in this University's set-up. There are many already uncovered. There are far more still to be uncovered."

Later that month a prominent professor in UCLA's education department—popular for his joke-filled lectures—suggested that he would be the right choice for state superintendent of public instruction. In the next day's *Bruin* editorial I wrote, "Governor Merriam might look over a few copies of Professor Woellner's speeches in town and attend a few of his classes on campus, and then remember that the critical post of State Head of Public Instruction is crying for…a progressive leader…a man with a few new ideas, not old jokes."

Next came a blast at a chief of police in the Midwest. Nine hundred of the thousand students enrolled at Memorial High in Campbell, Ohio, picketed the school, protesting the removal of a favorite teacher. The students were dispersed when the Campbell police chief ordered his men to use tear gas bombs.

"High school students today are experiencing a liberal education," I wrote in the *Daily Bruin*. "They are learning civics outside the classroom. Formerly they were taught that the American system… gave them certain rights and liberties. However, they were driven

from their campus by the men ostensibly employed to safeguard those rights. Actually the students were rather lucky–lucky they weren't beaten by the police or suspended from school and deprived of the opportunity to continue their liberal education."

I followed this with an open letter to Ernest Hopkins, then president of Dartmouth College in New Hampshire. It seems Dr. Hopkins roused my ire with an article in the October 1936 issue of the *Atlantic Monthly*.

Upon his return from a lengthy tour of Europe, he wrote, "It appalled me to see the artificial political forces of the Roosevelt regime devoted to breaking down and making soft the whole structure of life among us...that all the forces of democracy dedicated to hardening the self-reliance and personal responsibility of every citizen were now being utilized to belittle and undermine the very qualities of individualism which made this country strong and through which its future lay."

In my editorial I replied, "I wonder what you mean, Dr. Hopkins. Perhaps it's the relief agencies, and the WPA, and the other Rooseveltian structures? If it is these things you think are breaking down self-reliance, I want to explain to you that these have only arisen as the effects of a breakdown in our economic structure.... Do you think a man thrown out of work and kept out of work, not because he is unfit but because the system cannot absorb him with a profit, is apt to develop more self-reliance sitting at home than by working on roads or even standing on relief lines?"

Hopkins went on in his *Atlantic Monthly* piece decrying "the extent to which the New Deal has felt obliged to go on soliciting for its program by reiterating to the public the misfortunes to which they are pictured as being subject.... We are being made a people sorrowing in self-pity."

And in the *Daily Bruin* I replied to the distinguished president of Dartmouth, "I knew 1931 and 1932 and 1933 and their breadlines and evictions and foreclosures would be forgotten, but I never suspected they could be forgotten so soon.

"By the way, Dr. Hopkins, you don't have to answer this letter. You probably are a very busy man what with running Dartmouth College and everything. But I will take the privilege of writing to you again. I've only covered half your article."

A few weeks later, in spite of Dr. Hopkins, FDR won a second term. And in spite of his landslide victory over Landon, there were muttered curses around the country about "that sonofabitch in the White House." As the president who brought us, among other things, unemployment insurance and Social Security, he did not deserve those curses.

There was also muttering in the microcosm of the UCLA campus, but I was too self-absorbed to be aware of it. One of my pre-election editorials—this one about Earl Browder, the Communist candidate for the presidency—may have been the legendary straw.

Browder was tossed in jail in Terre Haute, Indiana, just to keep him from making a campaign speech. My Daily Bruin editorial cried, "Either there is free speech and democracy, or there is no free speech and there is no democracy.

"A couple of days before Browder," I went on, "a man named Father Coughlin did speak, just a few miles from where Comrade Browder was supposed to, and Father Coughlin was not put in jail. Father Coughlin will continue to advocate many quaint things like

violent repression and lynching and he will say Roosevelt is strangling our Constitution… and he will not be put in jail. It is not that we think he should be. An asylum would be better."

Somewhere about this point in time I finally became aware of a group on campus that called themselves the UCLA Americans. And it seems they had begun cursing "that sonofabitch in the *Daily Bruin* office." There was a member of the Bruin football team. His name, I learned later, was Max Rafferty.

And abruptly one day Mr. Rafferty marched the UCLA Americans into the *Daily Bruin* quarters, intent on running "that red sonofabitch Rubin out of there!"

Well, I don't know how the Bruin staffers actually felt about my editorials, but they lined up shoulder to shoulder in front of the door to my office—and challenged Rafferty and his Americans to remove their bodies first.

The incident reverberated in downtown Los Angeles, and the *Examiner* called their stringer, Louie Banks. Like the good one he was, my managing editor, Banks, gave them their story— just the facts. But the next morning the *Examiner* headlined Louie's objective account something like: "UCLA Americans Demand Ouster of Red Bruin Editor."

Louie apologized for that headline, but I assured him the apology was unnecessary. I knew the *Examiner* very well.

As I look back, a few thoughts occur to me. First, what an arrogant, opinionated, unbearable horse's ass I was. Second, how desperately that

18-year-old editor needed to lighten up and also find a little humility. Third, though I hold no brief then or now for groups like the UCLA Americans, I can understand the extent of their frustration at the time. Fourth, while I would still stand by most of the thoughts I set down in the *Daily Bruin* editorials, I would sure as hell express them a little differently and open the column to other views.

As for Louie Banks, I was certainly right in thinking he was the better newspaperman. He went on to become an editor of *Time* magazine and eventually managing editor of *Fortune* magazine.

As for Max Rafferty of the UCLA Americans, I learned later that he had been particularly infuriated by my editorial dissing of Professor Woellner. How could the editor of the *Daily Bruin* be so disloyal as to attack one of UCLA's own professors?

Well, in one of life's endless ironies, years later Mr. Rafferty wound up getting the job my editorial set out to deny to Professor Woellner. Max Rafferty became California's state superintendent of public instruction.

Alvin Josephy is an author, past editor of *American Heritage* magazine and the founding chairman of the board of trustees of the Smithsonian's National Museum of the American Indian. For him the California political campaign of '36 was a war of dirty tricks and mass deception, as excerpted from his book *A Walk Toward Oregon*.

"Fake newsreels [depicted] Sinclair as an unwashed, bearded, bomb-throwing anarchist...enemy of religion, a crazed vegetarian, and a supporter of free love."

───────◇───────

U pton Sinclair, a mild-mannered 56-year-old socialist and muckraking author of the early part of the century, whose book *The Jungle*, published in 1906, had been largely responsible for the passage of the Pure Food and Drug Act, announced that he would seek the Democratic nomination for governor. He had written a smash-hit book titled *I, Governor of California, and How I Ended Poverty*. The book had pointed out that while millions of unemployed in the cities were going hungry and losing their homes, the goods and produce that they needed but were unable to buy were lying idle in stores and rotting in fields and orchards. Containing a program that Sinclair claimed would end poverty, the publication had made an immediate impact on masses of angry, demoralized California families. Almost a thousand EPIC (End Poverty in California) clubs had sprung up to help Sinclair launch a crusade to gain the governorship and carry out his program.

In August, to the surprise and consternation of the political and business leaders of California, Sinclair won the Democratic primary by a landslide over eight opponents. As it began to look like he would

go on to win the governorship in November, the Republicans and the monied interests of the state—fearful that Sinclair's schemes would ruin them—set out to destroy him through a massive, all-out public-relations campaign by the media empire of William Randolph Hearst and the head of MGM, Louis B. Mayer, who could commandeer and direct the creative talent necessary for a smear campaign.

Mayer helped mobilize publicity and advertising experts, directors, writers, actors and extras to produce false and scurrilous newspaper and billboard ads, radio spots, fake newsreels and anti-Sinclair posters and flyers, depicting Sinclair as a dangerous imbecile, an unwashed, bearded, bomb-throwing anarchist, an atheistic Communist, an enemy of religion, a crazed vegetarian, and a supporter of free love.

One night, I accompanied my uncle Eddie and aunt Mildred to a dinner at the home of their friend Herman Mankiewicz, a hard-drinking former New York newspaperman and one of Hollywood's best-known screenwriters who years later would incur Hearst's wrath by writing the script for Citizen Kane, the unflattering movie based on Hearst's life. Mankiewicz, a cynic and wit who had nothing but scorn for Sinclair as a "crackpot idealist," told us that Mr. Mayer had his younger brother, Joe Mankiewicz, a talented writer at MGM, busy writing spots for radio that would frighten people "out of their minds" and turn them against Sinclair.

At the same time, Felix Feist, a director of screen tests at MGM and a friend of some of us junior writers, was turning out phony newsreels on the MGM back lot, which theaters all over the state included in their programs. Many of them showed hordes of horrible-looking alleged bums played by hired film extras who supposedly were pictured on their way to California from other

parts of the country, announcing happily to the camera that Sinclair had promised to take care of them if they helped him get elected.

To help finance the smear campaign, Mr. Mayer pressured every MGM actor and employee making over $100 a week to contribute one day's salary, putting out word that if Sinclair won, the studios would move out of California. As a junior writer making only $30 a week, I was spared at first, but one week I found in my pay envelope a pledge form volunteering a donation to the Merriam campaign. All I had to do was sign it and hand it in. I held the form for a day or two, then tore it up and threw the pieces away angrily when I saw my first shocking example of the anti-Sinclair forces' obscene handiwork on a towering billboard that loomed above an intersection on Wilshire Boulevard. Depicting Sinclair as a hairy apelike monster with blood dripping from his fangs, it showed him advancing with a bomb and a gory knife in his hands toward a heroic Governor Merriam, who was posed defiantly like a modern-day Horatio at the bridge, protecting a frightened, cowering mother and her children from this oncoming ogre.

The vicious campaign of deliberate lies and distortions, orchestrated by so many, upset my sense of decency and justice. I wrote to Sinclair, offering to help his campaign in any way that I could. He replied on October 10, inviting me to "come and join our EPIC movement." Despite my feeling that he was too idealistic and impractical to make a good governor, I thought he would be better and more honest than Merriam, and I joined up and for a couple of weeks found time to write some campaign news articles for Sinclair's newspaper, the *Epic News*.

Sinclair lost the primary, and the hysteria evaporated.

I was getting nowhere at the studio, and it appeared increasingly evident that sooner or later I would have nothing to do and would be dropped. I wrote my parents that I would be coming back with an old friend, Lester Hofheimer. I was stone-broke, my parents were just getting by and a return to college was out of the question. These were to become the darkest days of frustration and gloom in my life. *[Josephy moved to New York, where he resumed his liberal political activities while working for a Wall Street brokerage.—Ed.]*

Like almost every firm doing business in Wall Street, Maloney, Anderson and Block was overtly dedicated 100 percent to the defeat of Roosevelt. Everyone, from the partners to the board boys, wore prominent, extra large yellow Alf Landon sunflower buttons on their lapels, proclaiming their support for the Republican candidate, Kansas' governor, who had been nominated largely because he had managed to balance that state's budget. All the employees got the word that if Roosevelt won, we would all find pink slips in our next pay envelope and the firm would go out of business. No one knew of my organizing work for Roosevelt, and somehow it was after the election before anyone learned what I had been up to, despite the fact that on a number of occasions I had spoken along with others at street corners and from the back of trucks at different places on the East Side. Generally, however, our meetings were in private apartments and school buildings. With original lists of potential members supplied by the Democratic National Committee, the few of us who had begun the chapter enrolled increasing numbers of young people who would vote for the first time and, equally important, would work enthusiastically for the Democratic ticket as volunteers on Election Day, getting other Roosevelt voters to the polls.

As Election Day approached, everything seemed solemn and hushed on Wall Street, as if the fate of everyone and every firm hung in the balance. On the eve of the election, Roosevelt planned to drive up Broadway from the Battery to midtown in a dramatic last-minute campaign appearance. Toward noon of that day, crowds of Wall Street workers, all wearing their bright Landon buttons, lined the curbs of lower Broadway or filled the windows of the buildings overlooking the president's route, everybody ostensibly ready to boo and jeer FDR as he rode by in his open car. Standing with friends in the crowd, I felt terrible. Surrounded by a sea of Landon buttons, I, too, wore mine, though I had pinned a Roosevelt button underneath the lapel of my jacket. On schedule, the motorcade began south of us, and as it headed north, we began to hear a roar that got louder and more frenzied as the president's car approached us. Everyone assumed it was the sound of massive booing and jeering, until suddenly, straining to see what was happening, we saw the air south of us filled with ticker tape coming down from every office building. We realized with a start that the roar, now engulfing us like a storm in the Broadway canyon, was from people along the sidewalks and in the office buildings cheering at the top of their lungs as the president rode by, waving happily at them from his car.

In a moment, he was gone, on his way up Broadway, accompanied by the huge roar that rolled along with him like an ocean wave. But behind him, where we were standing, and up and down Broadway as far as I could see, Wall Streeters were pulling off their Landon buttons and throwing them with defiance and glee into the middle of Broadway, where they littered the pavement until street cleaners swept them up. That afternoon, I, and a startling number of other people, including leading brokers and traders, returned to work wearing red-

white-and-blue Roosevelt buttons, and nothing happened. In the election, Roosevelt won every state but Maine and Vermont, and no firm on Wall Street went out of business.

My departure from Wall Street was painless. Horace Block and all the friends I left at Maloney, Anderson and Block had finally come to accept me good-naturedly as a fish out of water, knowing I was more bent on becoming a professional writer than a customer's man, and our office Christmas party, ringing with good-luck toasts to my future, doubled as a cheerful end to my career in New York's hustling financial district.

At the same time, in view of all the frustrations and rejections I had experienced during 1936, I could scarcely believe that I was going to be working full-time—and for one of New York's two greatest newspapers, one with the eminence of the *Herald Tribune*.

Movie star **Marsha Hunt** made seven pictures in 1936, including *Arizona Raiders* and *Hollywood Boulevard*. On FDR's birthday she was invited to lunch at the White House.

"Mrs. Roosevelt said, 'The president's so disappointed to miss being with you. I know he would appreciate it if you would just pop your heads in at his office upstairs and say hello. Down the hall from the top of the stairs, third door on the right.'"

───────◇───────

President Franklin Delano Roosevelt's 55th birthday was a lulu, at least for me. In his honor 5,000 Birthday Balls were held in cities all across the country and in seven major hotel ballrooms in Washington. The proceeds from all of them went to treat victims of polio (infantile paralysis) and intensify research to combat the disease, which attacked so many children and adults (300,000 in '37) and had crippled our popular president. In 1938, the annual drive was given its catch name, the March of Dimes, which flourishes still, although now widened to include various birth defects.

For the festivities in the Capitol, Hollywood sent three emissaries. I don't know who picked them or how, but they were Jean Harlow, Robert Taylor and Marsha Hunt! There must have been 50 or more stars then with far greater fame and box office than I had, but who was I to argue with such an invitation? And such company! What might have brought it about was the tendency of the Washington, D.C., press to refer to me as a "local girl" and "Washington's own,"

194

since my paternal grandmother, twin aunts and uncle all lived there and I often visited them.

"Platinum Blonde" Jean Harlow was at the peak of her popularity as a tough-talking sex symbol, and Robert Taylor had overwhelmed female America with his romantic handsomeness. They were currently making a film together, *Personal Property*, which had halted production–"at great cost: $100,000," so MGM said–just to free them for this junket. Jean was subdued and uncomfortable, suffering from the flu but gamely attended the countless appearances scheduled. There was a manly niceness about Bob Taylor, a total lack of conceit or arrogance. He'd been kept too busy in Hollywood making movies to realize the effect they had on the matrons who saw them, until this public exposure in Washington. He had suddenly become the biggest matinee idol since Rudolph Valentino. Seeing him in person, girls, matrons and dowagers en masse were reduced to sighing, swooning, shoving and shrieking. A modest, private man, all this startled and embarrassed him, but he kept his dignity and good nature throughout, the more remarkable in that he, too, had a touch of flu.

Nearby Baltimore, not to be denied, gave him an hour's motorcade, which totally snarled traffic. As his open car crawled cautiously through the seething mob, one crazed fan grabbed his tie and hung on while the car's progress so tightened the slipknot

that Bob nearly strangled. Rendered voiceless and literally turning blue, he could only pound on the driver's back to stop the car and get someone to pry the fan's grip from the souvenir trophy that almost murdered her idol. He returned to Washington hoarse, shaken, and minus any buttons left on his ripped coat, but game for the next trial by fan-fire.

D.C. Commissioner George Allen, chairman of the Birthday Ball Committee, gave us visitors a splendid formal dinner on Friday evening, attended by government officials and much of the diplomatic corps, after which, close to midnight(!), we paid a visit to Chief G-man, FBI Director J. Edgar Hoover, and his staff at the Department of Justice, which he'd kept open just to give us a personally conducted tour of the whole Bureau, complete with weapons and clothing mementos of the shooting of Public Enemy No. 1, John Dillinger. I wore a long-fitted pearl-gray satin gown and Jean Harlow a black velvet formal, deeply hemmed with white ermine fur, which had swept along so many dusty corridors that the ermine wound up a dismal gray. Jean told J. Edgar, "Your cleaning woman can take the day off tomorrow. I've saved her the trouble!"

Lunch at the White House loomed in our minds the next day— the president's birthday. There we were, gathered on the portico of the Executive Mansion, posing for pictures with First Lady Eleanor Roosevelt. That stalwart stood in the biting January cold for a quarter hour, hatless and coatless among her well-bundled-up guests and the entire Roosevelt family except for the president, assembled for his birthday celebration: James, Elliott, FDR Jr., John and their one sister, Anna, and a host of their children. They clustered around us, as delighted to meet us as we were to meet them. They were so hearty and informal that they made the great mansion seem like a

family home, and they made us comfortable and welcome. Especially Mrs. Roosevelt. Once inside, she told us that the disastrous flooding of the Ohio River, causing widespread suffering, had forced her husband to rewrite his birthday broadcast speech for that evening, preventing his joining us at lunch. "He's so disappointed to miss being with you. I know he would appreciate it if you would just pop your heads in at his office upstairs and say hello. Down the hall from the top of the stairs, third door on the right."

What followed was an afternoon of picture posing at all the famous Washington landmarks, and I suppose, a hasty bite of dinner somewhere. Then at 9:30, all of us, dressed to kill in our caravan of limousines and trail-blazed by those siren-wailing police motorcycles, began weaving in and out of horrendous traffic snarls, as all Washington seemed to be hotel hopping, just as we were, from ball to ball. Each hotel's sidewalk, entrance and lobby were a crush of fans and celebrants, the crowds so dense that our uniformed stalwarts were unable to protect us as we tried to dash from car to elevator. We were clutched and patted, pulled and pushed as part of a surging mass of excited, yelling people. The District's 1,500 police, unable to control the seething city's crowds and traffic, summoned the District National Guard, the Marines and Naval Reserves to help out.

We learned caution and tried evasive tactics. Sirens were silenced as we neared each next hotel stop, and we drove around the corner from the main entrance and into a dark alley, alighting at the service entrance. No crowds there, we slipped into service elevators, slunk down back corridors, sometimes dashing through hotel kitchens before their busy staffs could notice and recognize us and would emerge suddenly through waiters' swinging doors into the ballrooms, sawdust from the kitchen floors still clinging to our formal finery.

I'm ashamed not to recall what Jean Harlow wore that night—probably white, to match her hair and milky skin. I'm sure both it and she were gorgeous. I wore the pale yellow confection of tulle ruffs, punctuated by a gold sequin belt and scattered stars, from my *College Holiday* wardrobe designed by Edith Head. It barely lasted the rigors of the night and never recovered from its wounds.

This went on for five hotel appearances. There would be two more ahead of us to visit, besides the Capitol and Earle Theaters, well past midnight, and finally a 2 to 5 a.m. gala gold plate breakfast dance at the Carlton. But just before 11:00, we were driven back to the White House—the second time in one day!—and guided to a room below the main floor, where, once inside, we were suddenly in a quite different world from the noisy bedlam we'd just left.

Behind a desk sat the president, facing a battery of microphones, lights and newsreel cameras and their operators making last-minute adjustments in their equipment.

The president looked up from his notes as we came in, gave us a cheery wave and then with a wicked grin asked us, "Is my toupee on straight?" and tugged at his own very real hair. A discreet titter rippled around the room, followed by breathless silence as the earphoned radio network men signaled only seconds to airtime. Then one of them gave him the downward-slicing pointed finger, the go-ahead, and Franklin Roosevelt began his birthday message to the nation, simultaneously carried over all three radio networks and filmed by several newsreel cameras. When he finished and was off the air, he asked the newsreel men if they wanted to reshoot any part of it. They replied no, it had been perfect the first time. Then thinking of that coveted nickname the studio film crews give to an

198

actor who is known for getting a scene right on the very first take, I was astonished to hear my own voice softly muttering: "One-take Frank!" Jimmy Roosevelt heard me and to my horror, he sang out, "Hey, Pop! Did you hear what Miss Hunt just called you? She said you were One-take Frank."

A great gasp went around the room, followed by a more intense hush, as we all awaited his reaction, and I wondered to which part of the world I might be banished for my brashness. Then FDR threw that great head back and howled with laughter, followed, now that it was safe, by everyone else. And on that jolly note, we parted.

The next day, four wire services told the world's press what a funny and daring name Jean Harlow had called the president of the United States.

Apparently the Paramount publicity man escorting me for the evening hadn't been able to squeeze into that crowded room, but the MGM man had.

Arthur Naftalin is the former mayor of Minneapolis (1961–1969).

"The owners of rooming houses...were realizing much-prized income by renting rooms to students and they regarded university dormitories as unfair competition."

———————◇———————

By 1936 I knew it was time to leave Fargo. I was increasingly unhappy with my overloaded routine as copy editor on the *Fargo Forum* and with the social isolation caused by my job.

Minnesota state politics in 1936 was dominated by the Farmer Labor Party, which had won a great victory that year with the election of Governor Elmer Benson. From the moment of his election the party was divided between left and right wings. The influence of Communists became a point of contention and in the years that followed, Minnesota politics were wracked by violent clashes that reflected the conflicting ideologies of world politics.

Stalinists and Trotskyites were relentless in their attacks on each other. Members of the Communist Party were influential in the Benson administration and were very successful in organizing fellow-traveling front groups. ("Communism Is Twentieth Century Americanism" was now their slogan.)

Soon after my arrival at the University of Minnesota I became aware of the ideological turmoil. Mostly my new acquaintances were not drawn to politics but the ones I found most interesting knew about the Soviet Union and the struggles within the Farmer Labor Party. There was a small Marxist Club that propagated the Stalinist position. There were fewer Trotskyites but enough to keep up an assault on the Stalinists. On arriving at the university in September 1936, I lost no time in making contact with the School of Journalism and the *Minnesota Daily*. I was soon on the rim of the *Daily*'s copydesk, alive with excitement over meeting other young aspiring journalists. Socializing with others on the *Daily* came rather easily, but it was soon apparent that Jewish students were not part of the larger campus social flow. They had their own fraternities and sororities and formed, in the main, their own social circles. I did not want to join a fraternity, mostly for reasons of money, but I was also put off by the idea of their separateness.

In the fall quarter of 1936, I roomed with a friend from Fargo, Jerome Salzberger, who was in his second rather uncertain year at the university. Our room was in a run-down older house, typical of the housing supply offered students. Some nights I would awaken to find Jerry pounding a wall in an effort to scare off some animal—either a squirrel or a rat—that was loudly scampering through it.

The owners of rooming houses were a strong political force. In this time of Depression they were realizing much-prized income by renting rooms to students and they regarded university dormitories as unfair competition. Their lobbying efforts with the regents and the legislature made them a prime target of *Daily* editorial criticism.

At the end of the fall quarter my Fargo friend decided to quit the university, and in the winter quarter I had a new roommate, Sam Keil, chief of the *Daily*'s copydesk. Sam was from a Duluth family with Stalinist connections. He was knowledgeable about the ideological conflict but had become disenchanted. He had gone on to a wider intellectual pursuit; he was working his way through all the books published by the Modern Library.

Sam taught his innocent friend from Fargo about Stalin and Trotsky and explained how one didn't need to be a Communist to have serious reservations about capitalism. He inflamed my mind to the point that I got a copy of *Das Kapital* from the library and made my first foray into Marxism. Sam and I were devoted friends until he answered the draft and was killed in the Second World War.

Anti-Semitism was a constant concern. I soon learned that the men's honorary societies—the rival Grey Friars and Iron Wedge—never elected Jews and that the board of publications would never appoint a Jew to the editorship of the *Daily*. While there were Jewish medical students, the medical school faculty was notorious for its discriminatory policies. There were, in fact, very few Jewish faculty members and it was widely understood that appointment of Jews was a no-no in most departments.

One day in an economics class I was startled and extremely upset to hear a professor launch into an attack on Jews, citing some spurious theory. I hurried to report the offense to another economics professor, Arthur Marget, one of the few Jews on the faculty. He listened sympathetically, indicating that he shared my outrage, but he said there was nothing he could do about it. To insert himself in the matter, he said, would be counterproductive. The offending

202

professor, a short while later, resigned to become an executive vice president of the U.S. Chamber of Commerce.

In a few years the attitude toward Jews would change. Faculties would be opened to Jewish appointment. In 1939 the *Daily* would have a Jewish editor. In my senior year a Jewish friend would be elected to Iron Wedge and I to Grey Friars. In June of 1939, when few in our graduating class were getting jobs, the journalism faculty recommended me for a new hire inquiry from the *Minneapolis Tribune*, probably the only, certainly the best, job inquiry it received that Depression year.

If Jewish students were held apart by the general campus community, black students were simply nonpeople. Their number was small and we knew a few of them, but they had no presence in campus life. I remember a controversy over whether they were being admitted to the university dormitories and—incredible to fathom now—they were excluded from varsity sports. The consciousness of the university community with regard to racial discrimination was in 1936 not yet awakened, even among *Daily* staffers who generally thought of themselves as having a tolerant, liberal outlook.

I look back upon that time with some pleasure and much bittersweet nostalgia. Writing about it now reminds me, so poignantly, how the world looked in the springtime of my life and it makes me wonder about the ambitions of my youth, especially those not realized.

Roy Huggins' career as a writer and producer in television spans 40 years, including the popular series *Maverick* and *The Fugitive*. Like many in the 1930s, he saw communism as a viable answer to the disaster of economic collapse in America and Fascism in Europe.

"I joined under a Party name, Y.C. London, a sophomoric jest that suggests my state of mind..."

————————◇————————

When Martin Heidegger, one of the most influential philosophers of the 20th century, proclaimed to the students of Germany that "no dogmas and ideas will any longer be the laws of your being, the Führer himself, and he alone, is the present and future reality for Germany and its law," I junked my major in English literature and switched to political theory, my first substantial departure from the *coeur* of my much-loved surrogate father, Jack.

I also registered to vote.

By 1936 an entire generation, mine, had been shocked into recognition that our destiny was Armageddon. Germany had brought its unemployment of six million down to zero by a combination of rearmament and the establishment of universal military service. Hitler boasted that he had created a great air force in violation of the Versailles Treaty. A year later he violated the treaty again by remilitarizing the Rhineland and gloating about it:

> "The 48 hours after the march into the Rhineland were the most nerve-racking in my life. If the French had then

marched into the Rhineland we would have had to withdraw with our tails between our legs, for the military forces at our disposal would have been wholly inadequate for even a moderate resistance."

American conservatives had a number of objections to Roosevelt's anti-Nazi stand, but their primary and seldom admitted one was that anti-Nazi intervention was "playing Stalin's game" and might trigger the collapse of Hitler's dictatorship and open the door to German communism.

Conservatives may have been right on that last point, but most of my generation, proclaimed by Roosevelt to have a "rendezvous with destiny," thought the difference between the Soviet dictatorship and the one in Germany was simply that the Nazis intended to launch a second world war and the Soviets appeared to be trying to avoid one.

When my two years at Pasadena Junior College ended, the school still had no buildings but their graduates were well regarded and I was accepted at UCLA. I soon became an anti-fascist activist on campus, making speeches in student-packed Royce Hall for the Associated Students' Peace Council, calling for intervention in German aggression while there was still time to stop a second world war. (The Orwellian significance of "Peace Council," when we were advocating militant action against Germany, never occurred to us.)

The Communist Party had two "organizers" on the UCLA campus: Celeste Strack and Bernadette Doyle, engaging young women who were members of the student body. Celeste was an "open" Communist, Bernadette was not. On many occasions I was

approached by one or both to join "the only party uncompromisingly dedicated to anti-fascism and stopping the coming war." My refrain was that I was committed to democracy, and the Soviet slogan, the "dictatorship of the proletariat," sounded a bit too blithe on the subject of dictatorship.

In May 1939, the war in Europe was only four months away and I was about to graduate summa cum laude, a record I cite because of what followed when I applied for a graduate fellowship. I was told by a friend, Bud Nielson, a graduate student in the department, that I was about to be passed over on the grounds that I did not meet the department's academic standards. It was Nielson's opinion that I was being dumped because the department believed I was a Communist. (I later received a postcard stating that I did not meet the department's academic standards.)

I met with J.A.C. Grant, the department chairman, told him I had heard the rumor and asked him if it was true. He looked uneasy and referred me to another member of the department, Charles H. Titus, who loathed the Soviet Union. A gaunt man with close-cropped hair, he was a veteran of the First World War and had seen action in several major offensives. He greeted me coolly in his cramped office and immediately got to the point:

"A lot of factors are considered when fellowships are granted, and a grade point average is only one of them—and not the most important one."

I waited for him to tell me more about those other factors but he asked if I'd read the recent press speculations that a pact was in the making between the Soviet Union and Nazi Germany. I said I

was aware of the rumors, but I had been told by Dr. Graham (a department authority on international relations) that Britain and the USSR were at that moment negotiating a mutual assistance treaty.

"I don't think so," Titus answered. "A treaty with Britain would commit the Soviets to war. A deal with Hitler would let them sit out the war. Which deal do you think Joe Stalin is most likely to take?"

I said I thought speculation like that was pointless, that opposition to fascism was a basic principle of Soviet policy, just as destruction of Soviet communism was a basic principle of Nazi policy.

"I only know of one 'basic principle' in Soviet policy," Titus said, "and anti-fascism isn't it. I think there is a deal in the works, but no one, especially the members of the American Communist Party, will know about it till it's signed."

I wanted to tell him he was talking reactionary bullshit, but I was there to plead for a re-evaluation of my qualifications for fellowships so I said nothing.

"You don't think there's any chance of a rapprochement between the Soviets and the Nazis," he said. It was a statement, not a question. "I'm afraid I don't," I said, as neutrally as I could manage.

He was silent a moment before he said, "I didn't think you would." A few days later the "news" got around that I had been denied a fellowship because I was a "member of the Communist Party." Celeste Strack, knowing it wasn't true, saw this as the opportune time to try me again. I said I'd think it over, and Celeste responded with a warm kiss right there on the steps of Royce Hall.

I thought it over and told her the department's action was unjustified by fact, policy or constitutional probity, but I didn't think that was any reason for me to make them look justified.

The single compelling political text of the Left at that time was written by John Strachey, not Marx or Lenin. It was called *The Coming Struggle for Power*, published in Britain in November 1932. American economist John Kenneth Galbraith said of Strachey's opus: "As an exercise in persuasion…it was probably the most influential book of its kind in the century."

I reread Strachey and told Celeste I was ready to become a member of the Communist Party.

I joined under a Party name, Y.C. London, a sophomoric jest that suggests my state of mind, and I was attending meetings 10 days later. On August 23, 1939, the "obscene notion," as I had thought of it when Titus predicted the Nazi-Soviet pact, became an unthinkable reality. On September 1 the Nazis invaded Poland and World War II was under way. On September 17 the Soviet Union invaded Poland and occupied the territory the Nazis had dealt them in the pact.

I resigned from the Communist Party USA.

Efrem Zimbalist Jr., a star of television *(The FBI)* and screen *(Airport)*, recalls his year in the Soviet Union and his father's triumphant tour as a concert violinist. It is a view of communism in action as opposed to communism as a political ideal, the view of those at home for whom capitalism had failed in 1929.

"I send you greetings from the Soviet Union by the hand of two dreadful children who have behaved disgracefully in our great fatherland."

◇

My father, once a celebrated Russian musician, was invited in 1935 to tour the Soviet Union as an American violinist, with none of the inculpating baggage borne by hapless Soviet artists who had succumbed to the blandishments of the West.

As this was a summer tour that coincided with school vacation, my sister, Maria, and I were brought along at considerable sacrifice, I'm sure, on our parents' part.

Never in my life have I seen such acclamation. My father was literally carried through the streets on the shoulders of singing, cheering throngs, and considering that these were, musically, the most highly educated audiences in the world, the impact of seeing my beloved father so honored and revered remains with me to this day undiminished. I am particularly haunted by memories of the Mendelssohn and of a mazurka of Chopin, plangent and intoxicating, offered up as an encore under the stars in Socchi, the jewel of the "Russian Riviera."

Maria and I were to be left behind in the Soviet Union for the coming academic year. Furthermore, to forestall our frittering away

the time, no doubt without even bothering to learn Russian, my sister was entered as a piano student in the Moscow Conservatory, while I was similarly installed in Kiev, judged to be a safe distance away. My father took me to the bank, where he deposited to our account his entire earnings from the tour. These were paper rubles to be sure, with no value whatever outside the country but within the Soviet Union a princely sum. "You might as well spend it before you leave," he advised, "because if you don't it will probably buy a bomb." My sister, at 19 and I at 16, products of unusually restrictive boarding schools, were ill equipped to handle this sudden freedom and wealth. Kiev was considered—with the possible exception of Leningrad/St. Petersburg—the most beautiful of Russian cities and, with Novgorod, one of the oldest. Founded by the mercantile Vikings, it was wiped out by the Nazis in their Ukraine campaign but rebuilt after World War II, I'm told, with expert and loving care. All arrangements had been made prior to my arrival, even to the engagement of a tutor, a young man named Volodya (a nickname for Vladimir). In those days any such person—guide, teacher, translator—working for a foreigner either belonged to the OGPU (then the acronym for the Soviet Secret Police) or reported to it. Volodya's primary interest in me was to learn American swear words—a daunting task since his native Ukrainian contains no hard G, that consonant being replaced by a breathy H reminiscent of a convulsive gnu. He was a pleasant enough chap, and I found my room comfortable and clean—my problem was with the conservatory. I had never had a piano lesson yet here I was, aged 16, in a piano class with superbly gifted little children including one wunderkind of 4 who sat on two telephone books and played like Horowitz.

To make matters worse, all classes were conducted in Ukrainian, the coinage of the realm, which bears no resemblance to Russian

and of which I understood not one word. Now in my final year at
school I was taking second-year German when I came down with
the mumps. Confined to the hospital and unable to attend classes,
I reasoned that since I had already learned the vagaries of German
syntax, including the cluster of verbs that swarm around the ends
of sentences like folds about the ankles in a pair of dropped trousers,
I merely needed to increase my vocabulary. Consequently I set about
memorizing the dictionary and had little trouble with the finals.

For a time I was sustained by the stimulation of life at the
conservatory and the unfolding of the beauty and tradition of the city.
I tried to validate the course I was launched upon, but with each
passing week the utter hopelessness of ever catching up with my class,
my inability to comprehend my teachers and an unremitting sense of
alienation combined to bring me at last to a decision. I called my sister
to say I was moving to Moscow.

Rail travel in the Soviet Union offered three types of
accommodation: international, or first class; *myakhi,* or "soft,"
second class, which provided an upholstered seat; and *tvyordi,*
or "hard," third class, in which the passenger sat on a plank. The
trip to Moscow was an overnight one and the only available space
was in third. The boards were stacked in series of three the length
and breadth of the car, mine, of course, being at the top. This
was my home for about eight or ten hours, and while I soon grew
to enjoy the Chekhovian flavor of my surroundings, I found it
somewhat of a challenge to avoid skittering off like a hockey puck
every time we made a turn or the engineer applied the brakes. For
sustenance we would contrive to extricate ourselves at station stops
and funnel out to the platform and the upholstered woman at the
potbellied stove who dispensed sandwiches and hot tea.

My sister was living *en pension* with a family of four and had procured for me a room directly across the hall. My hosts were a husband and wife with a daughter, Galia, who, the mother later informed me, had reported her parents to the school authorities for an "anti-Soviet" remark that had escaped their lips at the breakfast table, occasioning their arrest and incarceration. This kind of initiative on the girl's part was encouraged by the government and was rewarded by her being named scout of the Soviet Union or some such nonsense.

Maria continued at her conservatory for some time. She was an accomplished pianist, artist and singer, but eventually the malaise of my life infected hers as well with a congruent loss of purpose. One factor in all this is worth mentioning: we had come to the USSR for a summer vacation spent largely in a semitropical climate, and had, accordingly, brought only the lightest of clothes. Now we were facing a Moscow winter that, be it said, had done in Napoleon and was about to do the same to Hitler. In America's affluent society it is difficult to conceive that there were no warm clothes to be bought, but that was the case. A Russian with a ration card had to wait a minimum of five years for a pair of shoes, and we had no ration card! Visitors to the Soviet Union booked their tour in advance through Intourist, all expenses being paid in the country of origin. Any extra expenses, purchases, etc., were paid for in *valyuta*, or a goldbacked currency. For these travelers merchandise was available and they were treated quite differently than ordinary Russians by a gold-starved regime. As an example, if a diner who was paying in rubles ordered *shashlik*, a traditional Russian version of shish kebab, it was brought to him on a skewer by his waiter. If, on the other hand, the same dish was ordered by a client paying in *valyuta*, it was brandished by the maître d'hôtel on a flaming sword.

212

The only merchandise obtainable by those on rubles without
a ration card was luxuries, many from the *ancien régime*. Maria
bought a fur coat and some jewelry, I a hideously ugly fur coat and
a piano. Fortunately, we had both brought along evening clothes but
the laces to my patent leather shoes broke beyond repair early in
the first quarter of the game. Since there was not another pair to be
had the length and breadth of the Soviet Union, I had to depend,
perforce, on Maria's largesse to remove those from a pair of navy
blue shoes of hers and lend them to me for the evening.

Our days began—and one varied little from the next—about
2 p.m. with the arrival of our Russian teacher and a brunch
consisting mainly of tea, toast and a pound of caviar, which cost
the same as butter. Following this collation came the Russian lesson
which, as our aptitude increased, became more and more weighted
with Russian literature and art. About 5:00 the teacher, a most
accomplished woman, would depart and we would begin preparing
for the evening—bathing, shaving, etc. All curtains in Moscow were
at 7:00 sharp, so at 6:00 we would meet on the landing between our
apartments, Maria with the laces in hand. After I had performed the
necessary transfer we would be off in a taxi if the roads were clear,
or a sleigh when the snow was piled high. It might be the theater
or the ballet or the opera, but rare was the evening that we failed
to attend a performance of some kind. After the final curtain our
wont was to head for the Metropol bar, watering place for all the
diplomatic types and foreign correspondents among whom an
uneasy camaraderie prevailed; uneasy because one never knew,
in Stalin's Russia, who might overhear and report an unguarded
comment. Generally by 2:00 everyone had run out of conversation
or was no longer able to make it and the party would start breaking
up. We would head back to our respective abodes, pausing on the

landing while I removed, somewhat unsteadily, the laces from my shoes before planting a goodnight kiss on Maria's cheek; though I confess there were times when I missed her face altogether.

There were 30 or 40 theaters in Moscow, headed by the famed First Art, which, in addition to the great classics, actually had in its repertoire an anti-Communist play, *The Night of the Turbins*. This astonishing paradox owed its existence to the fact that the eccentric Stalin, the heavy-handed arbiter of Soviet artistic expression, had been charmed by the play and countermanded any and all efforts to have it removed from the repertoire. The presentations of this great theater, evoking the influence of Chekhov, Stanislavsky and others, were unsurpassed. Equally miraculous were the productions of the Bolshoi. For the great ballroom scene in *Eugene Onegin*, furniture, chandeliers, costumes and jewelry were lent by the Hermitage and the Catherine Palace. The effect, combined with Tchaikovsky's score, the majesty of the opera house, the great orchestra and magnificent performing artists was overwhelming. We must have seen it a score of times and could still, like Eliza Doolittle, have begged for more. The ballet, of course, for which Russia, if anything, is most renowned, was easily on a par.

So much for the cream. Alas, with the exception of the first-rate Kamerny, the vast majority of remaining theaters varied from mediocre to abysmal. These were the propaganda plays, their currency a kind of Soviet boosterism, their heroes Stakhanovites and the like. One final tableau, representative of most, I vividly recall: the hero and heroine were standing in front of a tractor as he announced, portentously, "Next year I'm going to exceed my norm by 20 percent!" To which she responded, "And I'm going to exceed mine by 27!" BLACKOUT. Enough said.

As our clothing problems multiplied, often forcing us to crouch, huddled before the radiator, we began writing home begging for warm things. Meanwhile, Christmas (totally ignored, of course, in Moscow) came and went. William Bullitt, friend of Roosevelt's and American ambassador to Moscow, who despised the USSR and communism to the point of disdaining to learn a word of Russian, gave a Christmas ball worthy of the tsars (or the commissars, for that matter). He had the entire ballroom floor of Spasso House removed. Soft lights were installed, on top of which were placed hundreds of hollow bathroom tile-sized glass cubes filled with water containing tropical fish, forming a smooth, vitreous surface for the guests to dance on. As an ironic touch, Santa Claus was represented by one of the babushkas employed by the trolley lines to sweep the tracks, complete with besom.

As our appeals for clothing grew in frequency and intensity the winter turned to slush, mud and, at last, reluctant spring. We were to learn, ultimately, that Mother had tried repeatedly to send packages to us but each time they were returned as undeliverable, the victims of Soviet red tape or suspicion. Then, suddenly one day when our spirits were at their lowest, an envelope arrived that left us stunned, incredulous and madly, insanely, deliriously happy. Enclosed were two Cunard steamship tickets from Le Havre to New York! When we managed at last to gain some measure of self-control, we set about determining what needed to be done in preparation for our journey.

On entering the Soviet Union one's cash was counted and duly recorded and that was the amount—not a penny more—that was permitted to be taken out upon departure. As we had entered with our parents, Maria brought nothing in, while I had a $5 bill in my wallet that was still in my possession. In addition I had a check on a

London bank for $20. We ascertained that the cheapest tickets from Warsaw to Paris would cost $75 and since what remained of our fortune in rubles—about half—was worthless beyond the frontier, fundraising suddenly became the order of the day.

The ruble had been floating comfortably on the black market at around 40 to the dollar when, out of the blue, word filtered down of the government's intention to peg it arbitrarily at 7. This news threw the foreign contingent into panic and Maria and me into orbit; they suddenly needed rubles as badly as we needed dollars! The Austrian correspondent was a friend of mine and one night at the Metropol, we agreed secretly to trade 3,000 rubles for $75. This was a high-risk undertaking with ominous overtones, since he couldn't really trust me any more than I could him. We could only hope we weren't walking into a trap. He gave me his address and the plan was that precisely at midnight I was to walk through the front door of his building, which would be ajar, and the exchange would be made inside. As I started off in a taxi for the assignation my feelings were mixed; half of me was scared to death while the other half was thrilled at the thought that I was not watching a Hitchcock movie—I was starring in it!

I stopped the cab two blocks away and told the driver to wait. I passed no one on the street approaching the building, which was on a corner and totally dark save for the faint glow of a street lamp. As I opened the door wide enough to enter I was able to make out a curtain ahead of me stretching from one side to the other. This was not uncommon to see in Moscow as a family was often confined to half a room with a curtain separating them from their neighbors. What happened next was almost instantaneous: as I approached the curtain a hand shot out through a slit and in it was a $50 bill, a 20

and a 5. These I seized, replacing them with the rubles and I was gone: not a word had been spoken.

Back in Maria's room we went to work. With the blinds drawn, she emptied out half the contents of a cold-cream jar while I wrapped the $50 bill in wax paper. This we placed in the jar, putting back the cold cream and completely concealing it. Next we removed the back of an alarm clock, inserted the 20 and put the clock back together. That left the 5, which I stuck in my wallet, not considering it important enough to worry about.

For our last night in Moscow we went to the Kamerny. The chief cook and bottle washer there was a man named Rubinstein. We knew him fairly well, so when, at our leavetaking, he asked us to deliver a letter to Katherine Cornell upon our return, we readily agreed.

A giddy feeling of ecstasy swept us along all the way to the Polish border and our last encounter with a Soviet bureaucrat. This inspector of custom quickly dismissed Maria, directing his full attention to me. At his request I opened my wallet and produced the two $5 bills and the check. After consulting his records and verifying that I had come in with $5, he returned one of the bills to me. The other one, however, he picked up, saying, "I take this." Fighting back the impulse to comment on the smallness of his soul, I awaited his next move.

"What this?" he asked, scanning the check. I told him what it was.

"I take this—" he started to say before I interrupted him, pointing out that that $20 was in England and had never been within a thousand miles of his country.

"I take this," he repeated.

"You do not!" I retorted, seizing the check and tearing it into little pieces. A Pyrrhic victory perhaps, but rather satisfying after a year of being on the other end of it.

At the Polish ticket office we learned to our dismay that there would be a six-hour delay during which all luggage would have to be unloaded. This meant hiring a porter, an unanticipated expense. As my $5 would barely suffice for a bite to eat, I raced back to the train, locked myself in the compartment, pulled down the shades and proceeded to take the alarm clock apart!

It was seven hours later when we got under way at last for our first glimpse of a capitalist society in a year; and while that term had never had any special significance for either of us before, it had come in those few hours to connote smartly dressed men and women with an ease of manner about them and an outgoing friendliness they felt no compunction to conceal. Little did we anticipate that their candle would be brutally snuffed out and trampled upon so pitiably soon, but for now it was burning bright.

We had a two-day journey ahead of us and the exchequer was totally depleted. This meant no food until we reached Paris, nor were there berths to be made up at night. The first morning without breakfast was a bit hard but we made it through the day by reminding ourselves that we were halfway there. It was the next morning that was the hardest of all, even though we were close to the end of our journey. We had been traveling by ourselves for some time and were now stopped at a town in Belgium. As we started up again we were joined by a peasant couple, elderly and stiff of joint from years of

bending down and never up. He had brought with him an old paper bag from which he extracted with gnarled fingers a fat loaf of heavily crusted bread which he broke, offering her a thick chunk. Next he brought forth a slab of ham and, reaching into his pocket for a penknife, proceeded to hack off pieces that they shared with alternating mouthfuls of bread. What made all this almost unendurable for us was not only that they never offered us any but that their arthritic ways cast the whole maddening performance into slow motion, doubling or tripling the term of our suffering; but time was on our side in this struggle and was about to play a trump, for before he had finished the last mouthful and was still wiping his greasy fingers on the bag, we were pulling into the Paris station. To our great relief we were met by an agent from Cook's who had been engaged by Mother to take care of all business, see to our luggage and escort us to our hotel, where we found a generous check to provide for our needs while we were in Paris. That night, after a bath and a fabulous dinner, we went to see *Top Hat.* If ever there was an antidote to the gray face of communism it was that film, and I am eternally grateful to have been given the privilege, years later, of thanking both Fred Astaire and Ginger Rogers for leading two bone-weary, bedraggled young wayfarers into sparkling sunlight with their magic.

On board the *Aquitania,* Maria and I had finished dinner and were taking a stroll on deck. As we paused to look out over the rail I drew Rubinstein's letter from my pocket. We exchanged a look; it was enough. Carefully opening the envelope I began to read:

"My dear Miss Cornell: I send you greetings from the Soviet Union by the hand of two dreadful children who have behaved disgracefully in our great fatherland…"

I did go to see Katherine Cornell in New York. She was appearing in Shaw's *Saint Joan* with a cast that included a young man named Tyrone Power, and dropping backstage afterward I delivered Rubinstein's greetings to her.

But on the deck of the *Aquitania*, with perhaps a touch of the ham, I slowly tore the letter into little pieces, which we watched long and lingeringly as the wind lifted and wafted them far, far out into the night. Our thoughts were not on the letter or the man who wrote it. They were thousands of miles to the east, raising a glass to an interpretation of life we would never share again; and to a kindly and generous people, warm and trusting, brilliantly creative and tortured of soul, who had never in their history tasted freedom, only the boot of one tyrant after another. All we could leave them with was a blessing; they had left us with so much more.

A WPA writer report on the stonecutting culture in Vermont.

"I've seen things happen in the quarries that God never would let happen, not a decent God."

———————◇———————

He was a slender man, but with a wiry nervous strength and quickness. In the lean face his blue eyes were alert and sharp with a whimsical light that matched the curve of his mouth. For a man of 45 he was very young, quite boyish at times. French himself, he had married a Swedish woman, sturdy, cheerful and dependable. They had four children, the oldest girl just out of high school. And they all enjoyed one another's company, their own good times, and life in general.

"No, I didn't come in with the strike-breakers from Canada in 1920, or was it '21, I was here long before that. I've worked beside Scotchmen, Italians, Spaniards, Swedes, and got along good with them, most all of them. Of course I had my share of fights when I was younger. I know they don't like the Frenchmen who came in to take their jobs. You can't blame them for that. They still won't have anything to do with some French families, and most of the French stick together. But it's different with us and they all know it, and we get along fine. My wife's folks were an old Swedish family here. I've tried just about everything. But I didn't like it much farming. We've had a funny life, Alice and me. She's always been a good sport about it. I'd make money in one thing and then lose it in another. Besides working in the shed [in

the granite quarries] we got a roller-skating place we run nights, and we get pretty good business. Alice helps me out. I come home from work, take a bath, change and eat. Then we drive down to the rink and we're there until midnight. Not every night, of course, but it makes a long day. Alice ran it when I was sick. She's always been a good wife, a good woman, and tried to help me all she could. Summer nights when there's no roller-skating I work around the house or in the garden. There's always things to be done. On weekends we take trips with the kids sometimes. But once a year Alice and I go away somewhere by ourselves. We have a good life together—we always did.

"I used to hang around in this blacksmith shop on the Hill because all the old characters hang out in there. Real characters, too, by God. And did they put the liquor into them! I never saw such drinking as those old-timers did. They drank enough to kill anything or anybody. And most of them lived to be old. They were men in those days. Tough old Scotchmen and Swedes and Irish. You couldn't hurt them with an ax. The Hill was some place in those days, wild and tough, booming wide open.

"I've seen things happen in the quarries that God never would let happen, not a decent God. I've seen accidents, in the sheds and quarries both. Just a year ago a young fellow was killed up on the Hill. A big strapping young fellow, not more than 20 or so. They were blasting in the spring—too early for blasting, everything damp and loose. A whole great ledge fell from the top rim. The men heard it coming like thunder and they ran. It carried almost across the bottom,

and this boy was caught under it. He must have tripped or
something. One end was on top of him, only his head,
shoulders and arms were out. For three hours they worked
to get him out, and he was alive and conscious all the time,
conscious with his body crushed under that rock. He spoke
to them while they worked. Gave them directions and
everything. Once he even helped pass a chain under for
them. Three hours he lay there... *Jesus Christ!* And he tried to
joke with the blood coming out his mouth. 'I got my stone
already,' he said. 'A good big one, too.' And he tried to grin.
Three hours that way, by God. Then after they got him out
he died.

"The next day there were hundreds of cars and people up
there to look at the place. That quarry is 300 feet deep.
They drove up there, whole families, men, women, even little
kids playing around the cars. Some of them took their
lunches, made a regular picnic out of it. There were drunks
with bottles and fellows with their arms around their girls....

"I tell you it turned my stomach, honest to God, to see those
people. I knew that boy and all his family. I thought how
they must feel. All those outsiders pointing and peering and
talking about it. Still, I don't suppose that really mattered.
And anyway I guess that's the way people are and the way
the world is."

Another WPA report from the same city and the other side of the bitter economic divide of the **Great Depression**.

"The country club ladies told stories, then, that would have made the Italian women of Granite Street blush with shame."

———————◇———————

Their forefathers had hewn from the solid granite of Millstone Hill the money they were so freely spending. The cool peace of the back veranda [of the Country Club in Barre, Vermont] was broken by many voices, where an older set had gathered with ice tinkling in tall frosted glasses. They spoke of many things, always with an attempt at witticism. They spoke vaguely of the war in Europe, and someone told a dirty story about Hitler. They talked about local golf tournaments; weekends at the cottage, the pond, the lake; recent drinking parties; dances, poker games, dice games. One woman spoke with undeniable relish of a particularly gruesome auto accident, and this precipitated a whole flood of bloody smash-ups and sudden deaths on the highway. They turned to gossip then: Jimmy was drinking himself to death since his wife left him…Phyllis had gone away on a vacation, but she was really going to have a baby…Bernard must be blind not to see that his wife was in love with Doc Goss…They say Helen lost her job because she kept running around with that married man, what's-his-name?…Did you hear the latest about Mary Jane?…Somebody saw them leaving a hotel together in Montreal…I don't see how that girl gets away with the things she does, honest to God…The Fairfields owe *everybody* in town…She was so drunk it was positively disgusting–stinko…She'll

go with anybody, do anything, there's nothing too low for her since she found out about her husband...They say that she *actually*...Just imagine a man of his age with that young Goddard girl...

The country club ladies told stories, then, that would have made the Italian women of Granite Street blush with shame. In one way or another their money had come from granite. There were granite manufacturers, quarry and shed owners, who had inherited all that their fathers, rough, strong men with steel-sharp minds and steel-sinewed hands, had sweated and died for. And if these people did not scorn the stonecutters, it was simply because they ignored them altogether.

Upstairs the swing music went on, but the young couples slouched and sprawled about, glasses in languid brown hands. On the porch the session continued and most of the women were showing their drinks. Laughter and voices were shriller and louder, jokes were coarser.... They mentioned John Steinbeck's *Grapes of Wrath*, and the fat woman said she found it unspeakably filthy and vile. A man proclaimed it nothing but propaganda. Another man announced feebly that he thought it a damn fine book. The subject was dropped.

The girl had thick blond hair, which the summer sun had bleached to several shades. She had a mild forehead, pale blue eyes set well apart, and a wide, generous mouth. Her face was rather square and plain, brightened by the smile. She had something of the attractive homeliness of Miriam Hopkins. Her figure was fine and strong, full-breasted and sturdy, with graceful legs and hands. She moved with the lithe ease of the trained athlete. In thought she frowned and bowed her golden head, the broad brow wrinkled.

"I was born here—up on the Hill, Graniteville. I've lived here most of my life, except for a few years we lived in northern New York State. And a couple of years in New York City. I *love* New York. I used to spend my summers in Detroit, that's where my father is now. I don't like Detroit at all. I hate the place. My mother—my mother died when I was very young. She was only 26—my age now. I can't remember her.

"My grandfather brought us up, my brother and I. He had eight children of his own, and then he had us besides. He was a wonderful man, one of the finest. He came over here from Sweden and settled in Graniteville. He started with nothing and before he was through he had raised and educated two families really—and he left my grandmother quite a bit of money and property. He was in the granite business, opened a quarry on the Hill after awhile. He worked his way up from the bottom all right. He was my mother's father and the grandest person I have ever known.

"In those days the Hill was quite a place. There were some fine old families and some nice homes. It's different since the French came in. Most of the old families are gone now. There's a different class of people there, and it shows in their houses, the way they live.

"I took a post-graduate year in high school because I couldn't make up my mind. I was simply crazy about basketball. I captained my team and made All-New England guard one year. Aren't I the immodest hussy, though? And now it's golf and skiing. But one has to do something after school is past. Then I went to a private finishing school in New York, and I

took up Nurses' Training for a time. After that I went to Katherine Gibbs! That was always my trouble. I could never make up my mind what I really wanted.

"Most of my girlfriends are about my age and work in the same sort of offices. Some are college graduates and some are not. It doesn't seem to make any difference. Quite a few of the girls have been married recently. The rest of us will no doubt drift on into the 30s, bachelor-girls still. Unless some Lochinvar looms suddenly and unexpectedly on the scene.

"Those people there, they talk about me the same way when I'm not around. I know it. And they talk about each other exactly the same.

"They're wondering now who you [the WPA Interviewer] are, where you come from, what college you went to, how much money you have, what you do for a living. They won't be satisfied until they find out. I didn't realize until lately how sick and tired I'm getting of them, of all this. It's so damned small and smug, so narrow and mean. And they're so completely satisfied with it.

"This money they fling around all came from granite, directly or indirectly. Everything that they have they owe to the granite. And you should see their nostrils twitch when some stonecutters come into the Venetian after work and take a table next to theirs. One thing I do enjoy is this—the stonecutters are as scornful of them as they are of the stonecutters. And they don't mind showing it either."

DAILY DIARY

Norman Corwin was 26 years old in 1936 and worked for the *Springfield Republican*. Reporter by day, he was a radio editor in the early evening and newscaster from 10:30 to 10:45 p.m. over WBZ. The following are excerpts from his loosely kept diary of that year.

"Had a long chat about women with Milt tonight. He says he is more interested in their minds than their bodies. I told him I'd make an exception in the case of Emily Dickinson..."

———————◇———————

January 8—Heard pianist Jose Iturbi in Greene Hall tonight. Concert was sold out, so several customers including myself had to be seated on the stage. After a Haydn sonata and some stormy Beethoven, he gave us whiffs of Debussy, Chopin and Poulenc. I was impressed by his seeming impassivity. He stared abstractedly at the ceiling while his hands were flying over the keys, as though detached from himself. At one point, after finishing the Poulenc, he forgot what came next, and asked those of us onstage. I answered, having a printed program in hand, and he thanked me and went on. I can now claim that I conversed with a musical great.

Feb. 16—Had a long chat about women with Milt tonight. He says he is more interested in their minds than their bodies. I told him I'd make an exception in the case of Emily Dickinson, but I generally find women's bodies much more interesting than, say, astronomical bodies, or busybodies. *Chacun a son aphrodisiac.*

Feb. 21—To see *Modern Times* at the Majestic. Laughed so hard at the automatic-feeding machine scene that people must have

thought I was strangling. Chaplin is a genius, immortal even if he
stops now.

March 3—Sent Emil and Freda a belated wedding gift: the
beautiful, new 2,542-page India-paper edition of *Webster's Unabridged
Dictionary*. Wrote Inscription up front: "Words fail…"

March 17—The Connecticut River is in flood. Recent thaws have
broken up great ice jams to the north and the river is full of floes.

March 18—Flood increasingly grave. Whole city alarmed.
Pressed into extra service on the radio tonight with broadcasts at
8:30 and 11:10 p.m.

March 19—Situation worsening. All hands drafted at the
Republican, including myself, on what is usually my day off. Power
outages. Did broadcasts over NBC Blue network at 8:30, 10 p.m.,
midnight and 2 a.m. No power at the house when I got home.

March 20—The flood has peaked and is subsiding. Toured the
flooded areas. As usual in calamities of this sort, the poor are hardest
hit—those who live by the banks of the river where rents are cheapest.
No loss of life, but a terrible mess. Everywhere military and naval
officers on patrol duty, all of them officious and snotty. Their chance
to use authority on civilians.

March 29—Mildred mails me another box of homemade fudge,
along with a funny poem she had written. No wonder she's my
favorite aunt. I responded with a corny imitation of Ogden Nash,
one of my heroes after Keats and Shelley:

I received your delicious fudge
For which I thank you very mudge.
Your poetry may not be as marvelous as your fudge
 or your children or your fish chowder,
but even so it fills me with pride, and there are
 few nephews who could of an aunt be any prouder.
And even though critics may say that you write
 poetry hammily,
At least you are helping to keep the Muse in the family.
I admit this piece is a theft from Ogden Nash,
For which on Atonement Day I will cover my
 head with sackcloth and ash.
I hope all is well in your teepee,
And that you are having no trouble teaching David
 to do peepee in the potty and not in bed.
When I was a kid it took two years to get that
 distinction straight in my head.

April 10—Saul, old school chum, writes informing me of his elopement with a girl whose name he forgot to mention.

April 18—Violation of civil liberties in Belchertown, where a boy was expelled from school for refusing to salute the flag on religious grounds. Gathered enough material to send a long story to the Associated Press and shorter ones to the *Boston Advertiser* and *N.Y. Herald-Trib*, all of which responded to my wired queries asking whether they'd like coverage.

May 27—My last day at the *Republican*. On the assignment book Bill Walsh, city editor, wrote: "Staff note: Norman Corwin leaves staff today after seven years. Came to us in March, 1929." Said

goodbyes, and collected the $1.80 owed me by the Associated Press. Farewell dinner at Walsh's home.

June 15—Started work at the home office of 20th Century Fox on West 55th St. Publicity dept. Pleasantly surprised to find that part of the job is to see movies—Fox product, of course—in a nice theater in the building.

June 27—Outraged by fee for having my eyes examined by Dr. Wood on Park Ave. $10.

July 17. Bought a suit at Macy's. Set me back $13.

August 24—Some nice perks to the job. Was dispatched to meet Loretta Young at Penn Station and conduct her to her hotel. She was accompanied by a woman, and when we met, Loretta said to her friend, "Doesn't he look like Father Brown?" The friend agreed. Recently Sonja Henie came to the office and I heard her bawl out a fellow worker for relaying an offer that she be interviewed on radio for a fee of $100, which figure she found deeply insulting, and said so in a loud voice.

November 8—NBC, celebrating its tenth anniversary, invited a press party including myself to ride on a passenger train between Boston and Providence to witness and overhear a short-wave radio conversation between a man on our moving train and a man on a train traveling between Berlin and Hamburg. The reception from Germany had a little static, but was legible. First time that kind of stunt has been pulled off.

December 18—Tyrone Power, the apple of Darryl Zanuck's eye, to the office today. His visit had been announced yesterday, so all the stenogs had their hair done. Pleasant fellow, with limitless charisma.

December 23–Dinner at Brass Rail with poet David Morton, professor at Amherst College. He graced dessert by saying from memory poems of Houseman, Edna St. Vincent Millay and Arthur Ficke. Said his best writing is done when his conscious mind is weary, during afternoon letdown or following a heavy meal. At such times, he added, his subconscious emerges, and thoughts which have been buzzing in his head take shape. I wish I could say the same for myself.

December 31–Office closed early today. Tonight, having been invited by good friend Richard Himber, bandleader, to a small party at his place, I betook myself there, and among unprogrammed events of the evening, witnessed the making of a deal between Himber and Tyrone Power, conducted as openly and casually as a conversation about the weather. It called for a $10,000 radio contract covering 13 weekly appearances. Strong drink for a publicity flack earning $50 a week.

James Abourezk is a former U.S. senator from South Dakota and is now practicing law in Sioux Falls, South Dakota.

"What kept my father's head above water, despite going bankrupt a couple of times, were the U.S. government and the Indians."

———————◇———————

W̶e lived in Wood, South Dakota, 17 miles southeast of White River, the Mellette County seat. Mellette was still part of the Rosebud Sioux Indian Reservation at that time. Wood's most critical problems centered on preventing drunks from burning mattresses in the county jail and trying to keep enough gravel on Main Street so that it could be navigated during the rains that came infrequently.

Living conditions for Indians around Wood were worse than for whites, except that the government managed to get food to them part of the time. At best, Indian homes were plain, small shacks, made from either logs or sheets of tin. At worst, they were white canvas tents that simply could not keep out the bitter winter cold. One family—Ed Stranger Horse's—lived in a canvas army-style tent. Ed was quite old then and he would make periodic wintertime trips from the tent to my father's store to buy one or two items, all he had money for, struggling desperately to keep warm in the thin jacket that was his only barrier to the cold. His eyes perpetually watered and his nose continually ran, much like that of a small child who had been out in the cold too long. My father gave him credit whenever he needed food and had no money.

It was illegal to sell Indians alcoholic beverages. The federal law prohibiting the sale of liquor to "hostiles" dated from the time when white traders took unfair economic advantage of Indians after plying them with booze. It appeared to me to be a self-defeating law. The poverty that afflicted Indians, combined with the psychological defeatism that the white occupation imposed on them, created a class of Indian alcoholics desperate to escape their condition. The law never stopped Indians who wanted to drink from drinking, yet it often dangerously forced them to drink anything they could get their hands on. Because vanilla and lemon extracts contained alcohol, they were, in our store, big selling items to Indians. Several white bootleggers made a living selling illegal wine and whiskey to Indians. Occasionally, the ingestion of wood alcohol would either kill or blind someone who couldn't get his hands on ordinary booze.

My father's store was known as C. Abourezk Mercantile (the "C" was for Charlie), next door to the post office and nearby to the Central Market which was owned by my cousin Eli Abourezk. It was about 24 feet wide and nearly 100 feet long; the old clerk-behind-the-counter type, in contrast to the more modern self-service markets and supermarkets. The customers would ask the clerk for, say, a can of beans, which the clerk would fetch, put on the counter, write down both the item and price on an order pad, then go for the next item, and on and on. The shelves were stuffed with groceries on one side and dry goods on the other. At the rear of the store was the meat counter with its free-standing butcher block, and adjacent to it were shoes and hardware. Except for canned goods, fruit and vegetables, nearly everything was sold in bulk. Nothing was prepackaged. Flour, sugar, prunes, raisins, peanuts, whatever was all sacked up in paper bags by the clerk and sold by the pound. Vinegar was sold out of a wooden barrel stored in the back room,

provided, that is, the customer brought his or her own empty bottle. The floor was wood planking, which occasionally had to be sloshed with oil to keep it from cracking, and there was the obligatory potbellied wood stove located in the center of the store. The few fresh vegetables available were kept in unrefrigerated bins. Fresh eggs were piled in a cardboard box on the floor without dividers to protect them.

Charlie was a Democrat. He was elected mayor of Wood about the same time Franklin Roosevelt was elected president and he was famous for his unlimited generosity. Not only did he find it hard to refuse credit to both Indians and whites needing groceries, but he carried cigarettes and candy in his pocket to offer to people he met on the street or in the store. In the words of the local Indians, he let them *ikazo* (sign) for their groceries. Whenever anyone, Indian or white, gave him a hard-luck story, he would fill a box with food staples and send them on their way. While his benevolent spirit endeared him to its recipients, it totally exasperated my mother, who was determined never to go through a period of starvation again as she had in Lebanon. She saw every penny he gave away as one that brought the family that much closer to the poorhouse. In fact, his charitable tendencies were the only real bone of contention between them. That and his occasional ventures down to the Bloody Bucket.

What kept his head above water, despite going bankrupt a couple of times, were the U.S. government and the Indians. We had what was called a "boss farmer" in Wood. He was Mr. Lindbloom, a government Indian agent whose job it was to teach the Indians how to farm. Creating Indian farmers was another of the government's failed experiments with the Indian tribes they had subdued in the last 30 years of the 19th century. Sioux Indians, who had spent most

of the previous 200 years living in unrestrained freedom as deer and buffalo hunters, looked curiously at the farming implements that the Bureau of Indian Affairs provided them, their silence communicating something like, "Don't call me, I'll call you." The result was that the boss farmer's job became one of issuing government purchase orders and vouchers to the Indians, who would bring them to our store, among others, and spend them on groceries, hardware and dry goods, all of which Charlie offered for sale. Charlie would present the purchase order to the government, which would then reimburse him.

My mother struggled to adapt herself to an American society defined by the small town of Wood and its surroundings. The leap from the culture and life of a peasant woman in a small Lebanese village to that of "society matron" in a small South Dakota town was for her a gigantic one. She did not learn to speak English for a number of years after she arrived. In the first four or five years of my life I spoke mostly Arabic because that was all I heard from my mother. Eventually she began to entertain the Wood Ladies Aid Society in her formal living room, cooking for them the staple of meat and potatoes, the standard cuisine in that part of South Dakota. Although Lebanese cooking was vastly superior, she never offered it to the Ladies Aid Society, perhaps fearful that, unable to adjust their palates to it, they might ridicule it. But when the Ladies Aid or the Eastern Star was not around, she cooked mountains of Lebanese food, in particular on Sundays—in fact, every Sunday when Sam and Albert Abdnor and their families drove down from Kennebec and Presho to spend the day with us. They were usually joined by my uncle John Mickel and his family, who drove down from White River.

During all those family visits in the 1930s, we behaved very much as I supposed people in the old country did—eating a huge

meal, listening to Arabic music on the wind-up Victrola, the adults talking until nightfall, or as late as they could before the visitors had to start driving back home. Interestingly, I remember no talk of Middle East politics but only of the store business, the Orthodox Church and its leaders in New York, and of the hardships endured by family members who remained behind in Lebanon.

Cousin Eli worked in the store for my father after he emigrated to Wood until 1936, that is, when he argued violently with my parents and resigned in anger to open his own store down the street. His first store, the original Central Market, had a dirt floor and was no bigger than 10 feet by 15 feet.

Next door to Cousin Eli's first store was the famous Bloody Bucket saloon, formally known as the Rosebud Club. I say famous because when I grew up I was certain that everyone in the world had heard of it. It was old George Wang's pool hall and beer joint, so named out of someone's romantic notion of what a tough Western bar ought to be. When I was old enough to pull the door open by myself I started hanging out there, learning to shoot pool and trading stories about how dangerous old George Wang was. We—the boys of Wood—used to tell Bloody Bucket stories to anyone who would listen.

He was once offered a pistol for sale, brought into the Bloody Bucket by the hopeful seller. George asked if he could test-fire it, then shot into the wall over the seller's head. Whether the stories were true or not, they made George Wang someone to fear and respect. I later learned that he was really a gentle old man who spent most of his days sipping beer and collecting a dime a game from eight-ball customers.

Both Indians and whites scraped to stay above the poverty line, trying to keep warm by picking up coal along the railroad track and by cutting wood along the creek east of town. I don't remember our family ever being short of food or fuel, so I never felt the sting of poverty as did much of Wood, South Dakota's population. Neither did I have an appreciation of how badly we whites treated the Indians. I grew up believing it was permissible, even heroic, to ridicule the Indians of Wood. Most of them, like Ed Stranger Horse, tried to stay out of everyone's way, there being no profit in finding oneself on the receiving end of a white's misdirected anger. The most visible Indians were the public drunks, those for whom alcoholism was a shield of armor. I scoffed at Indians who would spend what little money they had on sweet rolls and cold cuts, taking them from the store to their cars to feed small children waiting there. The antics of Indian winos were the staple of our running jokes. We had no sympathy and very little mercy for those less fortunate than we. I belittled Indians until I left the reservation and attended college, where a friend, Peggy Goodart, figuratively slapped me in the face one day, forcing me to realize how destructive my attitudes were.

Caroline Rose Hunt is the founder and president of Lady Primrose's Royal Bathing Luxuries and also the woman behind Rosewood Hotels and Resorts, which operates 17 properties worldwide, including The Mansion on Turtle Creek. Listed as one of the most influential and powerful women in the U.S., she is the daughter of Texas oil tycoon H.L. Hunt.

"My father conceived the idea of dividing the two 12-hour shifts customary in the oil fields into four 6-hour shifts. This doubled the number of men employed."

——————◇——————

In 1936 my family was living in Tyler, Texas, the self-proclaimed "Rose Capital of the World." Tyler, a beautiful old town of about 20,000, was booming from the discovery of the nearby East Texas oil field. Men from all over the country had come to the area seeking work. My mother kept a table on the back porch to feed the desperate men who were unsuccessful. Not bums at all, many were neatly dressed with coats and ties. The Pathé News at Tyler's only movie theater gave me still-remembered images of dejected men standing in the soup kettle lines.

My father conceived the idea of dividing the two 12-hour shifts customary in the oil fields into four 6-hour shifts. This doubled the number of men employed. Though oil was selling for as little as a dollar a barrel, he absorbed most of the difference in compensation. More than once I heard him quote the maxim, "Give not a hungry man a fish but give him a pole and teach him to fish." Several oil companies followed my father's example. Hoping to alleviate the severe national unemployment and spur the economy, my father and other interested persons went to Washington to promote the flexible

workweek as a national policy. Senator Hugo Black of Alabama introduced a bill that passed the Senate, and the Ways and Means Committee of the House of Representatives had reported the bill favorably. President Franklin Roosevelt sidetracked the Black Bill in favor of the NRA (National Recovery Act), and this killed the flexible workweek.

My father was very concerned with the trend of our nation toward socialism. He was especially critical of the new Social Security tax. He explained to me that not only did the tax take away the people's ability to save, but worse, rather than being invested, the funds generated were simply thrown into the general treasury and spent. He warned that these people's own children and grandchildren would be paying the taxes for their benefits.

1936 was the year I left Tyler to attend the Hockaday School in Dallas. Coming from Tyler, Dallas with 347,642 citizens seemed a very big city to me. At the time I was very homesick but now I realize what a wonderful opportunity my parents provided me. The academic program was rigorous, with two hours of required study hall daily. My inspiring English literature and history teachers gave me an appreciation for the past that affected my attitudes the rest of my life.

Dallas was a major site of the celebration of the centennial of the Republic of Texas that year. Buildings constructed in our state fairgrounds for the event with the help of the Works Progress Administration remain today as some of the finest examples of Art Deco architecture in the nation. President Franklin Delano Roosevelt traveled in his private railroad car to Dallas to dedicate a statue of General Robert E. Lee in Lee Park on Turtle Creek Boulevard,

which would probably not be considered politically correct today. On that day he was the guest of Mrs. Carolyn Skelly Burford, whose nearby mansion boasted an elevator and air-conditioning. Today the room in which he stayed is named the FDR Suite in The Mansion on Turtle Creek, the first hotel of the Rosewood Hotels and Resorts properties.

WPA writers found **Henry Houston**, a black publisher of the *Charlotte Post*, in Charlotte, North Carolina. Sixty years later America still waits to fulfill Henry's brave hopes.

"I believe the colored youth of our land has a very hopeful future."

———————◇———————

Steps lead directly from the sidewalk to the large, two-story house of nine rooms, which is the home of Henry Houston. The house is quite spacious but, apparently, no attempt has been made to redecorate the interior according to modern trends. The first floor consists of a double living room, with sliding doors between dining room, kitchen and study. On the second floor there are four bedrooms and a bathroom. In one corner of the yard, near the driveway entrance, hangs a small sign, *The Charlotte Post*. The driveway leads to the back of the house where the printing shop is located in a small frame building. Here the *Charlotte Post* is printed. Henry Houston, stout man of medium height, owns his own home as well as the newspaper. But here is the story as he tells it:

> "My father was killed in a mine before I was born. I was the youngest of 10 children and, strange to say, they are all dead except the oldest boy and myself. After my father died, naturally my mother had to get some place where she could get domestic work to support the family. So that's why we moved to town. I attended the city schools and have never been to nobody's college. But that did not keep me from aspiring to make good in the world. I've made the best out of what little opportunity I've had and I think I've lived a pretty full life. No one in this town has fought harder to

better the educational opportunities for Negro children than I have. My own boy finished the city schools and I have sent him to Livingston College where he got his A.B. degree. I had a girl who died before she finished her college work at the same school."

"I own the newspaper in full as well as my own print shop. My son and myself do all the work. I am editor and he is the managing editor. Both of us operate the press. We do job printing in connection with the other work. The paper is edited weekly and is sent all over North and South Carolina. The present weekly circulation is about 42,000 copies.

"I have entered quite fully into the civic life of the community, I believe. The colored civic league was organized by me and we were the organization that led the fight to tear down those old frame school buildings in the city and build up-to-date buildings. I also helped to organize the Negro Citizen League, the chief purpose of which was to stimulate interest in the Negroes of this town exercising the right of suffrage. When we first began our fight there were not many voters here and now we have about 3,000 Negro voters.

"We are trying to get at the cause of crime, and are centering our attention on the children of the city. I believe the colored youth of our land has a very hopeful future. Most of our children have a pretty bad beginning, in the fact that the majority of their mothers are employed in domestic work. They leave the children early in the morning and return late at night. But in spite of this great handicap I believe that as day nurseries are established for our people, as directed

recreation programs are sponsored and as education continues to lift our people from ignorance, the youth will take advantage of the various facilities now being sponsored for their benefit.

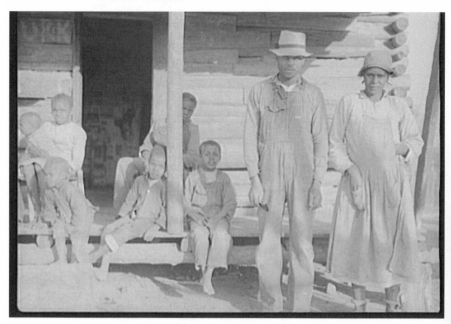

*The state of landless, uneducated African Americans in the South, utterly demoralized by their history and the collapse of the economy, was explored by the WPA in Florida, where **Jason and Lily** and their children squatted in an abandoned shack.*

Jason was disturbed from sleep in a hammock beneath the huge old oak tree that sheltered his desolate two-room house. He lumbered toward the broken gate swinging in the fence surrounding his clearing.

We reached the door and Jason yelled for his wife, Lily. Receiving no response, he simply reached around the corner of the shack and

pulled his 12-year-old son Tilly from his hiding place, shook him gently and told him to "find your ma and tell her we got a visitor." Three little girls, Rosy, Betty and Telly, ages 11, 9 and 8, came quietly around the corner of the house and into the front room shortly after we entered. Jason was lavish in praising them, but they seemed too shy to speak a word. Then in came Lily from the adjoining room with a babe in her arms and another tugging at her shirts. She smiled as she extended a limp hand in greeting. As there were no chairs in the room she indicated that I was to be upon one of the beds while she sat upon the other with the two babies. Jason took the place of the pigs upon the step, and the older children ranged themselves upright and rigid against the wall.

The floor was greasy and grimed with dirt. There were two rickety, lopsided beds with dirty covers. Three girls sleep crosswise on one bed, and Jason, Lily, and the two youngest children sleep in the other bed. At the window openings were starched white curtains. A broken table held an assortment of medicine and odds and ends. A rough shelf leaning against the rear supported a tin pot and rusty bucket. There was no toilet of any kind.

Jason was wearing a patched, faded and dirty pair of blue denim overalls and a faded and soiled blue shirt. Like Lily and all the children, he was barefoot. Lily's loose dress of feed-sacking, from which most of the lettering had been bleached, was soiled, too. Her hair was disordered and a dirty rag closely bound her head. Thin streams of snuff ran down from the corners of her mouth. She had a cold and frequently wiped her nose with a rag or the back of her hand. The baby began to cry and she gave it her breast to nurse.

"I have to talk for Lily as she is so deaf. We got married some thirteen year ago and set out to find a likely spot to farm. Then we

seen this place already built here. We just lit and moved right in and been here ever since. The roof leaks right smart but hit's to put cane under the leaky places ifen hit rains hard. We don't need a larger house than this, hit suits us all right. One room for sleepin' and another for cookin' and eatin' in. Some folks I know haint got but one room and they cooks out in the yard, but we got a fine stove, which a man give me haulin hit away. An see them curtains at the winders? A lady give them to Lily when the last baby was borned. She give Lily and the baby and the girls each a nice dress too. Lily takes right good care of 'em washes and irons 'em when we go to church and each like.

"I don't have to pay no rent, neither. A man did come here and say he owned this land and wanted cabbages for rent. Now I believe that if a man haint usin' land, he hadn't orter charge nobody else what to use hit. But I give him the cabbages to git rid of him and haint seen him since."

"What was the man's name?" I asked. Jason looked surprised. "What's the use to bother that?"

When I asked Jason about his farm he seemed rather embarrassed. He hesitantly pointed out the window to a small cabbage patch and explained that he hadn't had much time for farming lately and his family wouldn't eat much vegetables anyway. "There haint no sale for 'em, neither," he added. "Most everybody round here raises plenty."

He insisted that he was a farmer. He was proud of the fact that he was one of these to whom the "Relief" had given seeds to plant several years ago.

"I didn't make much with that there garden," said Jason. "They just wouldn't give me the kinda seeds I wanted. They just warnt my kind of vegetables."

He maintains that he does not allow his family to go hungry very often. He fishes, catches rabbits and gathers the heads of cabbage that his whole family likes. They are very fond of "flour-dough fried bread," which is made with flour and hog grease stirred up with water and dropped by spoonful into hot grease. If the flour is self-rising, or if there is baking powder in the house, so much the better, for then the fried bread is crisp.

"One time whilst I was workin on the Relief a lady come to tell us what to buy and how to cook hit. Now that made me and Lily mighty mad! How did that woman know what we wanted to eat? Just give us plenty grease, salt pork, a little cabbage, stewed apples, and flour-dough fried bread and we is satisfied."

All of Jason and Lily's children were born in their shack in the hammock without medical aid. Jason is proud that a doctor has never had to come to his home. Jason said that after the death at birth of three babies in rapid succession following the birth of Telly, who is 8 years old, there was a wait of several years before another came. "We done thought the Lord was not sendin' us no more children, but he shore did. And here come Ally bout 13 month ago and then this baby now 2 months old for another little pet. Ifen any more comes we want boys. Just as soon not have no more now but I guess it kaint be helped and the Lord knows best."

When I worked on the Relief they sent Lily to a doctor and he said she had tubes in her ears what was stopped up. That bothers her

eyes, too. The doctor give her some green medicine to put on cotton and stick down in her ears but she said it burned so she didn't use it.

Two of the girls and Tilly had been fitted with glasses by the Relief, Jason said, but they didn't like to wear the glasses and he didn't make them. He took the glasses out of a box and put them on the children to show me how they looked. The children were also given some treatment for hookworm but Jason believes that they are just as well off without it.

"Politics are all one and the same to me," he said, "and what's the use to worry over 'em? Besides I haint got time to find out much about 'em." When election day comes he goes to vote with anyone who comes for him or buys him a gallon of gas so he can drive his car to town. Jason wants his children to "lern readin' and writin'." Tilly is 12 years old and still in the first grade. Jason has never thought of education as a means of making a living, and doesn't believe that education helps people much in any way. His children have to go to school at least part of the time or the truant officer will arrest him.

Although only 40 years old, Jason looks forward to the time when he will be eligible for an old-age pension. He does not know exactly where the pensions come from, but he does know several persons "who are now gittin 16 dollars a month, regular every month, without doin' no work at all. All they need is to be 65 year old and without no money aforehand, and they sure gits all that money."

As I left, the entire family escorted me to the gate, the children still tongue-tied, Lily smiling and Jason insisting that I accept a cabbage from his garden.

Arden S. Russell seized the days the Lord gave her, and they were good.

"We had one dress between us and whoever had a date got that dress."

———————◇———————

I had a darling sister, she was nine years older than me, and she was married to a wonderful husband and he committed suicide. So we made two trips to Hawaii to smooth her down but they didn't work, so she got this brilliant idea. There was a steamship company at that time name the Dollar Line. Now the Dollar Line had many ships, so what they did, every week they left San Pedro Harbor for Manila. Lots of stops. Every other ship returned to the West Coast. The alternating ship could take you around the world. So between here and Manila, every week you could do whatever.

In those days you didn't need reservations. You could stay one week or five weeks, and that's what we did. And she was so gorgeous and just by chance, my maiden name is Swanson, and her name was Gloria. Not *the*. In those days, the big American and European countries, their VIPs they would send home on an R & R every two years. And so the ships were filled with executives returning, and every time we came on shore they had a manifest on the ship and they would post it and the bands met us. "Here's Gloria Swanson." First it was embarrassing and then it was fun. And we were wined and dined like you cannot believe.

I don't know how we kept meeting these people but these introductions flowed from ship to shore and shore to ship. And we

had a marvelous time in Shanghai. On the main street were all French boutiques and the most gorgeous lingerie you've ever seen. But of course, even though we were traveling around the world, we were watching our pennies because we didn't know how long we would be gone. And it was the Depression. So we didn't do a lot of buying.

And when we got to Shanghai we met some darling fellows and two of them were pilots for the Chinese National Airlines and they were pilots for Chiang Kai-Shek. So they went back and forth between Shanghai and Beijing. They were just darling American boys. They wanted us to marry them. So they took us to the Little Club. That was the place, and we walked in the door and they were playing "Stormy Weather." We were so thrilled with Shanghai and China per se that we took the train up to Nanking and then Beijing. On the train we met two very nice women. We were at the Hotel Beijing. There was one main street that is solid bicycles and pedestrians. From our window we could look right out to the Forbidden City. The whole thing spread right out below us and then we each had a rickshaw boy, so there were four boys with our rickshaws right down below our window and they must have been there 24 hours a day.

When we got to Manila, my sister was still grieving quite a bit. We met a great big guy, Peter Cooper. He was like a plantation manager, an American. He had all these great big plantations, like the rubber plantations in Malaysia, the sugar plantations in the Philippines, American owned. He was mad about my sister and his company had a big yacht and he took us along to these Philippine Islands. We went to Zamboanga, where the Sea Gypsies lived. They lived up in stilted houses and they wove wonderful rugs. It's the seashell capital of the world. We got to Singapore and we were given

a letter of introduction to a Joe Fisher and he owned a chain of theaters throughout Southeast Asia. He was wild about my sister. Singapore is a small area in the Malaysian area. There were seven states and each one was ruled by a sultan and the biggest state and the wealthiest was Jahore. It's still in existence. The sultan of Jahore was a very good friend of Joe Fisher's so we went there for dinner one night. The sultan asked us to stay at the palace. We were innocent really and we said, "Oh yes, we'd love it." And it was so gorgeous. It had that Muslim architecture where the windows are scalloped and all inlaid with ivories and jewels. But this sultan had other ideas and my sister couldn't run fast enough, so we left. One night we heard about this monkey refuge in a place called Panang, and we met these two men and they said they would take us to see these monkeys. We had to go by truck so we jumped into the truck and it was hours we drove. But we saw the monkeys. But all the way up and back they had two other men with them who sat up on top of the truck with rifles, it was all bandit country.

In Italy this was the time of Mussolini. The first time I saw the Vatican, we had met these two young men onboard ship. They were Italian. They took us out that first evening in a cab. When we got out of the cab they told us to close our eyes, and they walked us to Vatican Square. So my first look at the Vatican was with moonlight on the dome and it was absolutely incredible. My first look at St. Peter's. They told us that Mussolini had cut the street through to the Vatican, so when you came onto the street you saw the whole Vatican in front of you. They worked in Mussolini's office. They were crazy about him. We didn't like the idea that these two, Guido and Roberto, worked at Mussolini's office but it didn't rub off on them. There wasn't any conversation about it. They wanted to marry us.

I had my 20th birthday going through the Suez Canal at Port Said. In 1936 I guess I was probably home looking for apples. It was a bad time. I went back to school. I had just finished high school, so all my money for college went for the trip. I went to Woodbury's business school. My sister and I had an apartment in Los Angeles over on Kenmore or Normandy, in that area. We would buy apples and put them on the little steam heater and cook them. We had one dress between us and whoever had a date got that dress. Oh, we had a couple of ticky-tacky clothes but we had the one good dress. I don't know how, but we did have stockings. You had to have stockings. You had to be proper.

I worked in a theater, cashiering and ushering. My brother was married and they had two little babies and they lived way over on the east side of town, and he used to come into town every day looking for a job. And he walked. He didn't have five cents for the streetcar and it's the only time in his life, our family's life, that anyone ever stole anything—he stole milk for the children.

Elmore Leonard, the wildly popular writer of crime novels populated by wildly colorful criminals and their scandalous broads, is admired by serious critics and a reading public that has made him rich. Here he seems to explain his lifelong fascination with lowlifes and scoundrels.

"I'm pointing a cap pistol at the camera and have one foot on the running board: a shot inspired by Bonnie Parker's pose..."

◇

I n a photo taken in Memphis in the fall of 1934, my mother, my sister, a family friend and I are standing next to our car, an Oakland; I'm pointing a cap pistol at the camera and have one foot on the running board: a shot inspired by Bonnie Parker's pose that must have run in every paper in the country after she and Clyde Barrow were gunned down in northern Louisiana in May of that year. Bonnie was resting her foot on the front bumper and holding a pistol and a cigar. I'm pretty sure I was influenced by all the desperadoes running around at that time, not only Bonnie and Clyde but Pretty Boy Floyd, Ma Barker and her guys, Machine Gun Kelly and Dillinger.

FINDING ONESELF

Stanley Mosk served on California's Supreme Court from 1964 to 2001.

"She often berated me as 'the child Judge.' I often thought—but did not have the courage to say publicly— that it was better to have a child judge than a judge in her second childhood."

———————————◇———————————

I recall calling my wife one day in 1936 and reporting, "I had a great day today: a $25 case and two small ones." I represented a handsome young German fellow who was applying for American citizenship. He figured that to become a true American he had to change his typically German name. So he did—he changed it to George Washington.

I became interested in politics, Democratic politics in particular. I supported a candidate for the state Assembly from my district. He lost. I supported a candidate for the state Senate. He lost. I supported a candidate for Congress. He lost. I supported a candidate for district attorney. He lost. My record, if not effective, was at least consistent.

Finally, fortune smiled on me. I became friendly with Culbert Olson, a transplant from Utah, who was serving as state senator from Los Angeles. He had been originally elected at the same time that Upton Sinclair *[Sinclair was widely viewed as a Socialist, if not a Communist.—Ed.]* sought the California governorship in a laudable but unsuccessful campaign.

Olson was elected governor of California as people were tiring of the Depression and cast votes in protest. As he took office in Sacramento, he asked me to serve as his executive secretary. It took me about 15 minutes to wind up my law practice and move my wife and modest belongings to the state capital.

Culbert Olson, as governor, proved to be the most honest man I have ever known. But that was his downfall. If a legislator were supportive of him 80 percent of the time, to Olson he was no good because he was in opposition 20 percent of the time. That may be sound philosophically, but in politics it generally proves fatal. And indeed it did.

Earl Warren, then state attorney general, defeated Olson's reelection efforts. Naturally, I then disliked Earl Warren intensely. It was not until some years later that my opinion of Warren changed markedly, and with justification. As Olson left office, he appointed me to the Superior Court in Los Angeles. In my first election campaign, I had two major opponents: Leroy Dawson, a World War I veteran, and Ida May Adams, a perennial candidate. On the stump she often berated me as "the child judge." I often thought—but did not have the courage to say publicly—that it was better to have a child judge than a judge in her second childhood.

The courts of California were relatively conservative. A review of the judicial reports reflects virtually no criminal appeals. That suggests to me that criminal cases were decided with finality at the trial level and, despite the issues that may have been involved, never were able to receive a high court hearing as they do now. Today nearly 50 percent of appeals heard by the higher courts of the state are criminal in nature. I deem it encouraging that the

judicial process and review is available to those persons who are subject to penal punishment.

Not until four years after 1936 was there a marked change in the courts of California. At that time Phil Gibson was appointed chief justice, and Jesse Carter and Roger Traynor were named to membership on the court. It soon became the greatest state court in the nation. For many decades after 1936 the courts of California have been generally responsive to the needs of the people of the state. The judiciary has particularly relied on the constitution and laws of the state, rather than on federal laws, to protect the needs of its citizens. Whether the trends of 1936 will continue indefinitely into the future remains to be seen.

Ring Lardner Jr., a screenwriter (M*A*S*H), grew up as the son of a famous humorist. Ring Jr. was later blacklisted by the movie industry for refusing to testify in congressional hearings investigating purported infiltration of Hollywood by Communists. He served 10 months in prison.

"David [Selznick] intervened in our personal lives to try to dissuade Budd [Schulberg] from marrying a Gentile woman and me from marrying a Jewish one, an unsuccessful effort in both cases."

————————◇————————

G oing to work in Hollywood two months after my 20th birthday was the result of being recommended to David Selznick, who was leaving MGM to form his own company, by Herbert Bayard Swope, a family friend and former neighbor in Great Neck, with whose son, Herbert Jr., I had roomed in my second year at Princeton.

Sure that I would find the movies more interesting than the work I was doing on the *Daily Mirror*, I boarded an airplane for the first time on what was supposed to be a 24-hour flight to Los Angeles. The plane carried its full complement of 14 passengers, among whom were the playwright John van Druten and the movie star Miriam Hopkins. At St. Louis, the second stop, we were informed that because of rough weather ahead we would proceed to Denver by overnight train. About 24 hours later, in Denver, we were put on another plane and flown to Los Angeles with, I believe, only one stop on the way.

Selznick put me to work in his publicity department because of my newspaper experience and because I would have to spend time on the set of whatever picture was shooting, and thus be able to

learn some things about the process of making movies. Actually, it was a very special way of making movies.

There was an auteur on a Selznick picture, and it was not the director or the writer but the producer. Selznick made one movie at a time, participating in or, at the very least, supervising every step of the process, from choosing the subject through script-writing, casting, designing, shooting, scoring, editing and selling the product. There was not a detail in any one of these departments on which he didn't have the final say. The director and the film editor could express their opinions on which was the best of what might be dozens of takes of a single shot, but he had the ultimate say.

Whenever he was asked why—since he exercised such rigid control over the shooting—he didn't direct the pictures himself, his matter-of-fact reply was that he was too busy doing more important things.

His New York story editor, a bright, secure woman named Kay Brown, sent him the typescript of *Gone With the Wind* with an urgent recommendation. Far too busy to read such a long book, Selznick delegated the task to three people: Val Lewton, his West Coast story editor (later the director of cult-favorite horror pictures), his personal secretary, Silvia Schulman, and me.

Val found it poorly written and not worth the money it would cost to produce. I, in my debut as an appraiser of movie material, also advised against purchasing the rights, mostly because I objected on political grounds to the glorification of the slave-owners and later of the Ku Klux Klan.

But Silvia, still some months short of becoming Mrs. Ring Lardner Jr., was so enthusiastic and so persistent in making him read a synopsis that he began to consider it seriously. The clinching factor was John Hay "Jock" Whitney, the principal investor in, and chairman of the board of, Selznick International Pictures, who had read another copy in New York and told David he would buy the rights himself if the company didn't.

So, against my better or worse judgment, the decision was made to meet the price—$55,000, as I remember it. I didn't have an opportunity to make an assessment of comparable significance until about 35 years later when I declined an offer to write the pilot and be head writer of the television version of *M*A*S*H*—I had written the screenplay for the movie, for which I won an Oscar—because I didn't think it had much future as a series.

Two of the people I ran into during my first months in Hollywood were old acquaintances from my childhood, my parents' friends, Scott Fitzgerald and Dorothy Parker. I had seen Dottie, as she was known, a number of times socially before she and her husband, Alan Campbell, came to the studio to write the screenplay of *A Star Is Born* from a story by Bill Wellman, who was to direct it, and Robert Carson. It was a mixed blessing, therefore, when Selznick asked Budd Schulberg and me to read the script as it emerged and see if we had any thoughts on how to improve it. We did come up with some ideas, but when he told us to present them in screenplay form, we asked, and he finally agreed, that Dottie and Alan be advised of the arrangement.

To our surprise and gratification, they professed to be delighted with the setup, maintaining that they were under too much pressure

to get the work done in time. And then, after we did present a few revisions that were incorporated in the shooting script, including the final scene that was used then and years later in the Garland-Mason remake and yet again in the 1976 Streisand-Kristofferson version, they proposed that the two of us be given some kind of screen credit. This Selznick declined to do, and properly so, because we really hadn't done enough to warrant it. He did say, however, that we were no longer a reader and a publicity assistant but writers. Over the next few months he assigned us to prepare various material he never got around to reading.

Budd and I reached the conclusion, which some of our sympathizers felt was overdue, that we deserved more pay than we were getting: $60 a week for me and $75 for him. The sum we had fixed upon as an equitable one was $125 apiece, but in a series of meetings on the subject, the man in charge of contracts, Daniel O'Shea, insisted that the struggling new company, absorbing its loss on the release of *The Garden of Allah,* simply could not afford to pay us that much.

A debate on this point was interrupted by Selznick's voice on the intercom demanding to know whether Sidney Howard had agreed to write the screenplay for *Gone With the Wind.* O'Shea replied that Howard wouldn't do it for $2000 a week; he was demanding $3000. "Then for God's sake, give it to him!" Selznick ordered, and hung up.

O'Shea picked up the thread with Budd and me: "What was I saying? Oh, yes. We're offering you $100 a week apiece, and that's as high as we can go in a shaky year. After all, how many kids your age are making that much?" And he refused to budge from this

position. We accepted $100 apiece as long as we were free to move elsewhere if the boss continued not to read what we wrote.

David intervened in our personal lives to try to dissuade Budd from marrying a Gentile woman and me from marrying a Jewish one, an unsuccessful effort in both cases. Silvia, before our marriage and until she quit her job a few months afterward, had much closer contacts with Selznick than I did, and she provided me with intimate glimpses of him that added significantly to the image I was trying to assemble. She alone, for instance, was present when he burst into tears over the news of King Edward VIII's abdication in order to marry the woman he loved. Selznick was crying, he told her, "because it'll wreck the Empire."

She also had the job of transcribing her boss's legendary dictation. His standard secretarial staff consisted of an executive secretary who would take dictation when she was the handiest person, a stenographer who doubled as executive secretary when the principal one was off duty, a straight stenographer and a file clerk who could take dictation when the memo volume rose high enough to require it. Silvia served in the first two categories at various times.

It took a shorthand expert to keep up with his dictating rate, and Silvia had never really mastered the basic technique. What she did instead was to take notes and then type out his messages in his style but her own words. Since almost all of them went out under the heading "Dictated but not read by David O. Selznick," he never became aware of the differences between his text and hers.

There were never any set hours of work in his office, nor any moment of an employee's time that he didn't regard as belonging to

him. Since he was apt to be working at ten o'clock at night or three in the morning or on a Sunday midafternoon, he felt free to summon anyone he needed at those hours for the particular task engaging his attention. It would be an overstatement to say that he showed no appreciation of that kind of round-the-clock service. Once when she accompanied him on a business trip to New York, taking dictation for three days on the train, he bought her a present at Cartier's.

It was a sterling silver combination flashlight-pencil for recording memos in a darkened projection room.

Harry Steinberg, M.D., a retired ENT surgeon and sculptor, lives in Los Angeles. The Civilian Conservation Corps (CCC) was established to give employment to hundreds of thousands of young men for whom there were no jobs and no available education. They drained swamps, planted forests, built roads and dams. The CCC gave a running head start to tens of thousands of the uneducated and unskilled.

"Gone were the whispered requests of women asking for one of them 'female rubbers.' (Useless when her man came home drunk and raped her.)"

◇

When I heard that CCC camps were being established and that they were being run by the Army, I recalled that I held a First Lieutenancy rank in the medical corps, that I would receive good pay and could leave the service whenever I wished to establish my own practice. I applied and was accepted as a medical officer at a CCC camp at Bastain, Virginia.

I noticed many positive changes in the men sent to the camps. Many were unable to read or write credibly or follow simple orders. With training, they all improved rapidly, developing self-discipline as well.

We are often faced with situations that emphasize man's inhumanity to man. I received calls from the county jail. Sometimes prisoners would be whipped. This required the presence of a doctor. If I were called, after examining his heart I would always declare the prisoner unable to have another stroke after the first. The jailer had

a business. He made it a profitable one. CCC men were occasional victims. The camp men would each donate 50 cents for a quick bailout. Jailers were appointed politically. Being a jailer was a profitable business. The jailer would often appoint a relative to be his assistant. His job, it seemed, was to keep the jail full. The state paid the jailer $1 a day for each prisoner, plus $1 a day for food. The prison fare was a biscuit, gravy and coffee for breakfast and with beans added to the same for supper. A good profit was realized. To keep the cells full, the assistant jailer would frequent the premises of a local inn and when a likely "victim" left the inn, the officer would ask to smell his breath. A fresh swallowed beer or whiskey was sufficient for the officer to declare the person too drunk to drive and he would take the man to the jail to "sober up." If the arrested man resisted or tried to run away, he could be held in the jail awaiting the arrival of the Circuit Court judge. Meanwhile, the arrestee could be placed to work on a chain gang.

I left the service of the CCC camps to take over the duties of a retiring physician for the Virginia Hardwood Lumber Company in Bastain. The medical care I provided included drugs for the 200 workers and their families at the mill, and also the care of the residents of Bastain and Bland County. I became a big frog in a small pond.

Pat and I moved into a pre-Revolutionary log cabin. The walls were covered with hand-adzed wood, floor to ceiling, that was 12 inches wide with a wonderful mahogany luster. There was a cooling house for milk, eggs and meat built of field stone with hand-blown glass for all the windows. A kitchen and bathroom were added to the cabin at a much later date. One day I asked a patient of mine if he ever wanted to live in the city. He said, "Lord no, Doc. Do you know they have their toilets in the house with them?" I could only express my shock!

I received $2 a month for the care of each worker's family, and $1 a month for each single worker. I charged non-mill workers $2 an office visit. The visit was often paid for by barter; a laying hen with 18 eggs for an office visit or a ham of my choosing for the delivery of a child. I had a garden for growing vegetables, cared for by a neighbor's child. The hams were treated to become Virginia hams. The grocer used his grandmother's formula. We received maple syrup, grouse from a hunt, special baked goods and help when wanted. All in all, this was a good life.

I might still be a country doctor had not the problems of world politics put an end to my life in paradise. I received notification to report to Fort Belvoir, Virginia, for a year's service of active duty with the U.S. Army in 1941.

Now gone was the 1:00 a.m. call at my cabin door of "Get up, Doc. My wife's a' birthin'!"

Gone were the whispered requests of women asking for one of them "female rubbers." (Useless when her man came home drunk and raped her.)

Gone were the "Rites of Spring"–the tapping for maple syrup. The Spring Fair. The arrival of the traveling tent show. The fishing when the creek was at "full run!"

Gone were the times when my Ford was flooded out at a crossing in the stream, and my dog, Chunky, left the car to swim across and run, barking, up the road for help.

Gone was the glory of the baby's newborn cry and, though tired, sharing a full breakfast with the happy family.

And, surely, gone was the feeling of fulfillment and the acceptance of mutual appreciation of a service paid for with the coin of gratitude, or with barter of work or a gift of farm products for a service rendered.

And gone was the steam whistle and smell of fresh-cut hardwood, and the camaraderie of the woodcutter's camps that I visited weekly.

Art Linkletter, the radio host and television star of NBC's *People Are Funny* and CBS's *House Party*, discovers the invention that lifted him out of the ranks of the poor into affluence.

"The first portable microphones took me out on the street talking to people who were passing by..."

——————◇——————

Having grown up in a poor family with little security and a deep desire to choose a career that would offer a lot of safety, teacher's tenure was the early answer to my quest. The first portable microphones took me out on the street talking to people who were passing by in San Diego and marked the beginning of the amazing era of audience-participation shows. I rode this wave through the first phases of unrehearsed spontaneous interviews to the quiz shows that began by offering in 1934 a dollar if you knew the answer to a question—and only recently peaked with *Who Wants to Be a Millionaire.*

Those were exciting years, when the broadcast medium was growing into a rich and influential part of the national lives of millions of listeners and viewers. Remarkably, in the often dark and desperate years for most people in the mid-1930s I was becoming rich and famous. My career illustrates once again how important it is (and lucky) to be in the right place at the right time with precisely the right talent.

John Cann, owner and founder of Apex Technical School, serendipitously finds skills that define his life and build an industry.

"I didn't realize that the journey begun with a carnival in 1936 would be a detour around the Depression years."

———————◇———————

In 1936 I was working in a gas station near New York after graduating from the New York State Agricultural School specializing in poultry husbandry. This station was next to the lot where the Frank Buck wild animal show was performing at the time, but this source of business would shortly be gone when they filled their tanks and moved on to the next town. But I had gained some skill as a mechanic, and when another show, a carnival, came through they offered me a job keeping one of their rides, the Whip, operating, and I stayed with the show all the way down to northern Florida.

On the grapevine, I learned that the U.S. Navy was accepting enlistments, only one in a hundred applicants. I took a chance and they accepted me, making me one of a 90,000-man Navy. I didn't realize that the journey begun with a carnival in 1936 would be a detour around the Depression years. Assigned to the engine room, I rose to chief before returning to civilian life, enriched by technical skills learned in the U.S. Navy and the Merchant Marine, where I became a chief marine engineer and a lieutenant commander in the maritime service. This enabled me later to start Apex Technical School, which over the years has supplied 25,000 skilled workers to New York employers, changing their lives and mine.

Oleg Cassini designed clothes for Jacqueline Kennedy at the White House, was married to film star Gene Tierney and was once engaged to Grace Kelly. He is one of the world's great fashion designers.

"....Mother [stood] on the dock as we departed, waving furiously, calling up to me: 'Remember, you are a Cassini! Always remember: Loiewski-Cassini.'"

———————◇———————

I taly was becoming a much less pleasant place for both gentlemen and designers. The country was at war in Africa, Mussolini was suffering from rampaging grandiosity and a campaign was on to destroy all the non-Italian influences that had permeated the culture. American music, for example, was considered "African" and degenerate. Nightlife of any sort was being discouraged. The patriotic Italian stayed home and made babies. Even the idea of wearing a dinner jacket had become un-fascist, un-Roman (the notion of recapturing the glory that was Rome was the centerpiece of the fascist delusion), a vaguely unpatriotic act.

One night I was coming out of the Hotel Ambassadeurs on the Via Veneto, which had one of the better swing bands in town, and was walking down the Via Veneto with a friend named Francesco Bitossi, who was an officer in the colonial service. We were wearing dinner jackets, talking quietly, bothering no one, when the metropolitan police stopped us and asked for documents. I had none; I'd never felt the need to carry any.

I told the police my name was Oleg Loiewski Cassini, that my family lived in Florence and that I had an address in Rome.

Apparently, the "Loiewski" sounded suspicious or the dinner jacket looked suspicious. Pierre Laval, the French premier and fascist sympathizer, was in town that weekend and the police were taking no chances. They said, "You'd better come with us."

Bitossi had his colonial-service identification and, instead of defending me, meekly said he'd call me the next day. I asked him to come along, just in case. But no, he went home and I went to the police station, where they took my shoelaces, belt and necktie—suicide precautions—and threw me into a real dungeon. A very high room, filthy, with a wooden bench and a wooden toilet. The smell and cold were horrifying. The walls were covered with excrement. I stood in the middle of the room, shivering—it was a cold night and all I had was the damn dinner jacket. I screamed at the jailers, I insulted them, I gave them the names of people to call, important people, names they knew. I threatened them, told them they'd be sorry. They laughed or didn't hear me. I stayed there, straight up, in the middle of this dungeon cell for three days without sleeping. I would not allow myself to lie down in filth or lean against it. I was paralyzed with disgust, simply horrified, amazed. Could this be happening to me? I remember thinking about the Carthaginians, who tortured prisoners by keeping them awake until they died. I was not given the opportunity to make a phone call, and Bitossi never called to find out what had happened to me.

I was arrested on a Friday, and it wasn't until Monday morning that I was brought before an official, who apologized. "We know you're of good standing," he said. "This was an unfortunate mistake. The visit of Pierre Laval made us security-conscious, but you shouldn't go *out* without your papers."

I was furious but too exhausted to say or do much about it. I made a lame stab at a speech. "Well, if this is the way you're going to treat people who've lived here for years," I said, "then this is not a fit place to live." So I left with my dignity but was forced to part with my dinner jacket, which was so permeated with the fetid smell of the jail that I had to throw it out. I was also forced to part, finally, with any illusions I'd had about Mussolini and what he was doing in Italy. I knew then that it was going to end badly, and I began to think about acting on a long-standing dream: America.

My brother had recently returned from a year in the United States at the University of Georgia. He had been offered a fellowship there, teaching French and Italian and coaching the tennis team. He and Emilio Pucci returned on the same boat from America dressed identically in camel coats and porkpie hats, white shoes and gray flannel suits. I could not imagine a more elegant look. They brought home records, the latest music. I remember listening to "Moon Over Miami" again and again.

I made arrangements to go. The previous summer I'd met an American businessman named Victor Ridder at a tennis tournament in Venice. He owned some German-language newspapers in New York (his company would merge and become Knight-Ridder), and invited me up if I ever came to America and needed assistance. Of course, he assumed that I was a wealthy young Italian and that the assistance would be social rather than financial...and so when I wrote to him asking if I could use his name as my guarantor on the immigration form, he agreed. Since I'd been born in Paris, I could be included in the French quota and accepted immediately into the United States.

The Italian government had imposed currency restrictions and would allow you to take only $100 from the country. So that was all the money I had, going to the Promised Land, that and letters of introduction from my mother to her old friends plus a tennis racquet, a dinner jacket and a quantity of hope. It seems incredible, but I was not aware that America was in the midst of an economic depression. But then, all my information had come from movie theaters, not newspapers.

I remember Mother standing on the dock as we departed, waving furiously, calling up to me: "Remember, you are a Cassini! Always remember: Loiewski-Cassini."

I arrived in New York on the ocean liner *Saturnia*, Christmas Day 1936, from Florence, Italy. There were mountains of snow, and I felt terribly alone and scared.

Dave Brubeck is the great jazz pianist but didn't always know it.

"I was so happy as horseman and rancher that I never wanted to leave it, not even to go to college."

◇

In the mid-1930s I left a comfortable home in a small California town near San Francisco to move to a 45,000-acre cattle ranch in Amador County in the foothills of the Sierra Nevada Mountains. My father had moved my mother and me (the youngest of three sons) into an entirely new and different environment. As manager of this huge ranch, he was given a simple frame house for his family to live in and meals for the hired help and for us. In the depths of the Depression this guarantee of a roof over our heads and food in our mouths was a great relief to my father. My mother's reaction was quite different. I awakened to the sound of her sobs many mornings. She longed to return to the beautiful home of her childhood, her lifelong friends, her piano studio and a cultural life.

My father and I were extremely happy with this new life. He was a genuine cowboy of the Old West and here on the ranch I could emulate him, I had my own horse and learned to rope and brand and did many other chores associated with ranch life. I was so happy as horseman and rancher that I never wanted to leave it, not even to go to college. After graduating from Ione High School (the entire student body was 86) in 1938, my mother insisted that I, like my older brothers, have a college education. Reluctantly, I enrolled as a pre-med veterinarian student at College of the Pacific, Stockton, California.

All through high school I had worked as a pianist with local dance bands. In order to have spending money and to pay for room and board, I continued to play in bands through my college years. Eventually the love for jazz overtook my love of the cowboy life, and by the time I graduated and entered the Army in 1942, I was committed to jazz for life.

Joe Harnell has been a jazz pianist, composer and arranger for Frank Sinatra, Marlene Dietrich and Peggy Lee, among others.

"My father denounced people as Nazis if they spoke with a non-Jewish accent, like Ingrid Bergman, Charles Boyer, David Niven, and the worst of all, Katharine Hepburn."

———————◇———————

Our piano was a used baby grand of no recognizable manufacturer. It was covered with a fringed Spanish shawl and displayed framed family photos. To get the piano into our apartment it had to be hoisted up with ropes and pulleys and then was placed proudly in the corner of our small living room, furnished with its blanket-covered couch and chair and cellophane-wrapped lamps, "so they shouldn't get dirty." We had a wind-up Victrola with those heavy records (78 rpm).

My love affair with music began by listening to the great jazz pianists of the period. I was determined to learn from my heroes: Art Tatum, Fats Waller, Zez Confrey and other giants in the world of great pianists (with all respect to Uncle Eugene). Some of what I heard I could play; the more intricate, complex technical figures I managed to learn in a very primitive way by holding my thumb lightly against the record so I could slow the music down enough to learn the material laboriously, one note at a time, as well as the fingering to execute the section that had seemed impossible for me on first hearing the music. That's the way I began to learn jazz piano.

Our facility was a 45-minute ride to Brooklyn on the elevated train, during which time I would practice my rudiments, using my drumsticks to play on my thigh as we rode to our destination. People would notice me, and I took quiet satisfaction in that they knew I was a musician! About the same time, I began, under my father's wing, to play in his little band in the Bronx for Jewish and Italian weddings, private parties and Bar Mitzvahs, most often in restaurants, bars, synagogues and catering halls.

His regular job was as a truck driver, delivering yeast to bakeries—places like Pechter's, a bread-baking factory known for their pumpernickel, rye and corn breads.

Every Saturday I would go along with him, leaving home at 5 a.m. to drive our black 1933 Chevy sedan to the location where we'd pick up his delivery truck, load it up and drive back to the Bronx to begin his route. Once in a while he'd let me sit on his lap and steer the truck.

Although I didn't know it, since there was always plenty of food on the table, we, like everybody else in the neighborhood, were very poor. On my birthdays, my treat usually was a trolley/subway ride down to 34th Street in Manhattan, where we would ride the express elevators up and down in the Empire State Building.

The only non-Italians in our little band were Jo-Jo Hittelman and me, before I changed my name. My recollection is that I didn't know that I wasn't Italian, despite the difference in our last names. The first awareness I had of being "different" from my friends was when one of the neighborhood tough kids called me a "dirty Jew." We had a vicious fight, and I proved to myself as well as my friends and opponent that I could fight back. Other than that

incident, I wasn't affected by the anti-Semitism that was so prevalent in the 1930s.

My exposure was to a lack of prejudice among the diverse racial and religious backgrounds of those musicians I was meeting and working with. My father, on the other hand, was bigoted to such a degree that he "knew" who our enemies were. He denounced people as Nazis if they spoke with a non-Jewish accent, like Ingrid Bergman, Charles Boyer, David Niven, and the worst of all, Katharine Hepburn.

I played and wrote arrangements for the Henry Jerome band. It was a fine band and included two saxophone players who didn't make it in the music business and had to go to other fields: Lenny Garment *[Leonard Garment, legal adviser to President Nixon, among other presidents and politicians.—Ed.]* and Alan Greenspan (chairman of the Federal Reserve Board). Greenspan, if you can believe it, was a great jazz tenor man.

Some of the musicians' slang included words like *cats* (musicians), *hot licks, square, groovy, hep-cat, jam* and *dig*—as in "I'll dig you later." There were many variations on the word *marijuana—muggles, tea, joints, shit, Mary Jane, pot, gross.* And any of them would get you "stoned"! Of course, there were many other drugs available that were more lethal—heroin, cocaine, opium, morphine and alcohol.

After we moved from the Bronx, the trip to my piano teacher's studio became more involved. I would walk to the end of the trolley line (usually sneaking a ride on the back of the car in order to save the nickel fare and use the money for a piece of fudge or a malted milk) to West Farms trolley terminal. I would go up the steps to the elevated train platform. Looking out of the "El" train windows one

could get glimpses of people in the apartments near the train tracks—families sitting around the kitchen table, a man in an undershirt smoking a cigar, a child leaning on the sill to see the train go by. There would be awnings over some of the windows to keep out the summer sun. I liked to stand between the train cars, enjoying the rattling motion and the breeze. At 125th Street the train went underground and I continued going downtown to Grand Central Station. Then I took the shuttle to Times Square and got the uptown 7th Avenue local to 50th Street. The trip took an hour and a half each way, but my lessons made it worth every minute of it.

I entered Christopher Columbus High, but I wasn't really interested in anything but music. I took the required academic courses without enthusiasm. I soon became the leader of the school jazz band and we went on to win competitions at the Loew's Paradise in the Bronx and theaters in Brooklyn and Manhattan. That is when I really got my arranging skills honed because I had the freedom to try anything. It was my band! Some of these kids went on to good careers in music, like Shorty Rogers, Harry DeVito, Teddy Sommer and Hugo Montenegro. Then there was Morty Goldapper, who played trumpet and who wanted desperately to play in the band. He'd hang around the bandstand, trying to look like he was part of our group, but he didn't play well enough.

However, Morty went on to change his name to Gary Morton and became a professional stand-up comic for many years. That career ended when he met and married Lucille Ball. I wonder if he still regretted not getting into the band.

Sadly, some of the others did not survive the temptation of drugs and alcohol and died very young.

Les Tremayne, actor on Broadway (*Detective Story*) and in radio and motion pictures, is also an archeologist whose photographs of Aztec and Mayan ruins are hung in museums in the U.S. and Mexico.

"...the three most recognized voices in America. I share this honor with singer Bing Crosby and President Franklin D. Roosevelt."

———————◇———————

I had never heard of radio. Then my dad built our first set, a bunch of wires neatly coiled around what looked like two different-sized oatmeal boxes. One wire he called a cat whisker. You touched it to a hunk of crystal and moved the wire around until sound came out through a set of earphones.

Radio is such an important part of the times. October 1, 1933, was the coast-to-coast premiere of *Grand Hotel*, broadcast in front of a live audience of 500 who stayed after the show to ask for autographs. There is *Flash Gordon* on KYW, *National Barn Dance* on WLS, *The Thin Man* and *The Falcon*. There are thousands of radio shows, and then there is *The First Nighter*, the half-hour show that becomes my signature.

Although this was a radio show, we had to dress formally for our live audience. My leading lady, Barbara Luddy, was dressed in a formal gown, and I wore white tie and tails, white gloves and carried a formal stick my mother's grandfather had made for him in Africa with inlaid designs of rhino tusks.

In 1937 I was voted one of the three most recognized voices in America. I share this honor with singer Bing Crosby and President Franklin D. Roosevelt. I was 24 years old.

283

Howard Metzenbaum

was a U.S. senator from Ohio for 20 years. He is now chairman of the Consumer Federation of America and remains active in Democratic politics. In 1936 he was a poor, bad musician.

"The other fellow was a better player than I...it worked out he did more tooting and I did more dancing with the assistant dean of women, who was supervising the program."

————————◇————————

I was a college student at Ohio State; I squeezed every nickel in an effort to put myself through college. My friends were pretty much those on the Left. I'm not sure if any of them were members of the Communist Party. I never asked. They didn't say. Politics was not my top concern then.

The government had a program in those days called National Youth Administration, and it helped someone like me whose parents weren't able to help financially—I tooted a trombone on a National Youth Administration program and received 50 cents an hour. Some NYA students didn't get that much. They received 30 cents or 40 cents an hour, but as a skilled professional tooting a trombone I was paid 50 cents an hour. Little did the government know what a poor trombonist I was. When we played in the Women's Refectory every Friday and Saturday night for free dances for the students, we had two trombonists and the other fellow was much better than I. Somehow it worked out that he did more tooting and I did more dancing with the assistant dean of women, who was supervising the program. Little did I think that later on I would look back and think of myself as a 50-cents-an-hour gigolo. No romantic involvement,

just plain dancing. The *Saturday Evening Post* hired me as a boy sales supervisor. I received $2 an afternoon for my efforts. I opened a bicycle rental operation just off the campus. You could rent my bikes for a quarter an hour.

The main money that I made came from peddling razor blades to the men who worked in the retail stores along the streets of the small cities of Ohio, Indiana, Illinois, Kentucky, Michigan and Pennsylvania. I would buy the razor blades for about 19 cents or 20 cents a hundred, or a penny for a pack of five, and sell them at four packs for a quarter. The best way I had of proving the sharpness of the blades was by pulling a hair out of my head and running the razor blade opposite to the natural flow of the hair, thus making it possible to split the hair in two. I would load up my car with razor blades and various merchandise, aspirins, breath sweeteners, etc., which I sold to gasoline stations, restaurants and various other stores. I used to load up my 1926 Essex with other kids my own age and drive to the airport for the National Air races. Each of the kids would ride out with me and sell peanuts. One day the Essex wasn't there. Dad had sold it to make a payment on the second mortgage on our home. We subsequently lost the home in a foreclosure action.

My mom, who was over 55 at the time, went back to work at $13 a week in a department store. She had to stand on her feet all day. My dad was a wonderfully sweet guy who loved to play with kids and was a generally warm human being. When he was a kid, he somehow wound up helping his uncle, who outfitted the peddlers who had just arrived from "the old country." The uncle's own kids went on to great success. One of them became a doctor. He created a scissors known to every physician as a "Metzenbaum." Another one argued one of the memorable Supreme Court cases that every

law school student learns about, *Euclid v. Ambler*, a case in which the Supreme Court validated the right of communities to zone. Many of our cities are bad enough in layout, but just think what would have happened if they had no rights whatsoever to zone for specific uses.

Dad never made much of a living but he was a wonderful father, and his relationship with my mother could not have been a more beautiful one. Whenever he came home late, I remember my mother was always waiting at the window for him until she saw his car driving up.

During those college days I was quite a gambler—at higher stakes than I really could afford. I carried on my gambling inclinations all the way through college, and for many years thereafter. Once I was elected to public office, I quit. I felt that if I won I would question whether it was luck, ability or someone trying to "pay me off" for supporting or opposing a legislative proposal. Rather than face or think about that dilemma, I quit.

My political activities were modest then—there just wasn't enough time left from eking out a living.

CAUSES OF THE
GREAT DEPRESSION

Mr. Skinner of Augusta, Georgia,

owned the Skinner Clothing Company, located at 833 Broad Street, an old, established business that was one of Augusta's few remaining home-owned stores. Here he told a WPA interviewer his view of the causes of the Great Depression.

"It was Wall Street against the world, along with a political upheaval, in other words, a Republican trick."

———————◇———————

The chain stores have ruined the independent merchant. The big moneyed men who were on the inside of the political scheme knew the rise and fall of the stock market and when to buy. The results were chain stores in every city and town of any size, selling their merchandise for less than we could buy for.

When my lease expired in 1935, I moved here, and each year business has increased. Today there are seven families getting a comfortable living out of the store and I can't complain. But with the competition and high cost of living, I will not live long enough to regain what I lost during the Depression.

It was Wall Street against the world, along with a political upheaval, in other words, a Republican trick. Millionaires were made overnight from the life savings of others. Politics and the little man being crushed and beggared by the man or men who were in power. Take my business, for instance: before the last depression 14 families were being supported from it; my own personal loss was 50 percent. I was worth around $40,000 with an income of $5,000. That was cut in half and today my average is a little more than $3,000.

The present administration is wise now to all the Republican tricks and there will not be another depression such as Hoover and the Republicans caused. The people in our country know now that it was a political trick to enrich the big man and make beggars out of the little man. We have more unemployed than any other country in the world today, and the cry is that this is a machine age. That is true, to a great extent, but who built the machines? Where did the money come from? Out of the pockets of the working man? Again I say, "Wall Street against the world."

William Werber played third base for the Cincinnati Reds, Boston Red Sox and three other teams. He led the league in stolen bases three times in the '30s. The first televised baseball game was played August 26, 1939, at Ebbets Field in Brooklyn, New York, and Werber was the lead-off batter.

"Depression is a state of mind. There was no depression in 1936."

———————◇———————

In 1936 I played third base for the Boston Red Sox and lived in Boston during the summer season. My home was in College Park, Maryland.

We traveled entirely by train. The Pullman cars were air-conditioned by blocks of ice placed in compartments in the tops of the car. When the train moved, air flowed over the ice and the cars were "modestly cooled."

Depression is a state of mind. There was no depression in 1936. Baseball players in the major leagues were paid in a range from $8,000 to $40,000 with an average of probably $12,500. This was as much as bank presidents and the heads of universities were paid.

The great hitters of my day, and of all time, were Babe Ruth, Lou Gehrig, Ted Williams, Jimmie Foxx, Hank Greenberg, Joe DiMaggio, Roger Hornsby and Johnny Mize. These guys could hit, for an average and a distance. Oddly enough, all of them, with Greenberg excepted, were not overly intelligent.

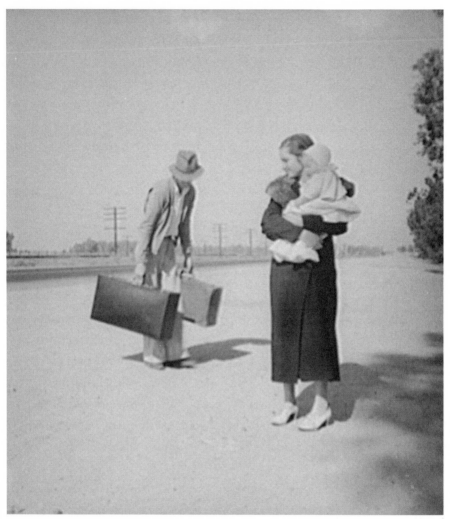

From WPA files: on the road.

Tibor Scitovsky, a great economist, explains the roots of the Great Depression.

"My complicated 1940 paper...no one ever read, because it appeared just when Hitler occupied France, which was too upsetting an event for most people to stoop to reading something as abstract as my paper."

————————◇————————

I was impressed by the elegant logic of the competitive market economy's self-equilibrating mechanism, known as Say's Law, but was disturbed by its inability to explain, let alone suggest, remedies for the mass unemployment and poverty of the Great Depression. I set myself the task of developing a more realistic and useful model without having any idea where to begin. Then the publication of Keynes' *General Theory* in February 1936 revolutionized economic thinking, and I am still proud, happy and satisfied to have fought in that revolution.

The revolution consisted in showing that economists' long-held belief in Say's Law–that the market economy is self-equilibrating because the seller's income that every market transaction provides equals the buyer's spendable income it absorbs and so keeps full-employment income unchanged–was utterly wrong because it ignored financial and speculative transactions, secondhand market transactions, manufacturers' and merchants' inventory policies, none of which is self-equilibrating and so able and likely to destabilize the economy.

At the London School of Economics, the department's chairman, Lionel (later Lord) Robbins, devoted his Monday seminars to discussing Keynes' book, which made them into the year's most important events, consisting of emotionally charged battles between the senior faculty—mainly Robbins, Friedrich von Hayek and the school's director, Sir William (later Lord) Beveridge—on the one side and us students—supported by a young instructor, Nicholas (later Lord) Kaldor and two Polish visitors, Michael Kalecki and Oscar Lange, on the other side.

That was a wonderful way of learning economics because Keynes, whose intuition was better than his ability to present a difficult argument in simple language, left us plenty of scope to clarify and improve upon his statements. I got so immersed in thinking and arguing about why the market economy is not self-equilibrating that I lived from Monday seminar to Monday seminar, spending the rest of the week discussing the arguments of the previous Monday and girding for those of the next.

Today, I am ashamed to admit that the end result of those innumerable discussions boiled down to a not very clear 1939 article by Kaldor and my equally complicated 1940 paper that no one ever read, because it appeared just when Hitler occupied France, which was too upsetting an event for most people to stoop to reading something as abstract as my paper.

We students invited Keynes to come and give a lecture at the school. He accepted the invitation, listing several dates and times when he would be available. We asked the school's chief administrator to reserve a lecture room for one of those dates but she told us rather bluntly that none was available; however, we could invite him

to the rather small graduate students' common room on the fourth floor, next to the stairway, which could hardly hold more than two dozen people.

We were shocked by that hostile answer, because we knew that she had long been the girlfriend (and later became the wife) of the director, Sir William Beveridge, who gave the most devastating review of Keynes' book in one of the Monday seminars. We were convinced that her answer to our request had something to do with his hostility to Keynes' economics. Unfortunately I missed the lecture Keynes gave in our common room because his enormous would-be audience overflowed and crowded up the entire stairway down to the second floor and I failed to arrive early enough to get at least within hearing distance.

DAILY LIFE

Bert Webb is a retired construction management engineer, Corps of Engineers, U.S. Government. His Depression was right in the home.

"He did get a job maybe two years later, but by then we were used to him."

———————◇———————

My great-uncle came to dinner and stayed 10 years. Of course, it was 1936 and he didn't have anyplace to stay, like a lot of other people. He did get a job with the WPA maybe two years later, but by then we were used to him, sort of like the stray cats Mother was always taking in. I was working in a foundry in Dupois, Pennsylvania, about 130 miles from Pittsburgh. I made 40 cents an hour as a moldmaker's helper, shoveling sand. The molds we made were called shapes, not like pigs that some foundries made for the steel mills, all the same shape. Ours were different shapes, whatever a customer wanted; I don't know what they made with them, but they had to be a certain shape. We shipped them out west. My dad was the yard master for the railroad, worked steady all through the Depression. Sometimes he was the only one working in the yard, the railroad wasn't shipping much of anything.

Barbara Tenzer is a retired owner of retail stores and buyer for the Army/Air Force Exchange Service. She has three children, six grandchildren and six great-grandchildren and makes her home in Mesquite, Texas.

"The most fun was playing under the streetlight catching lightning bugs and making rings that would glow in the dark."

———————◇———————

My best friend was Billy Diffee. He lived a few blocks from me in Little Rock, Arkansas. His dad owned a plumbing company. I thought they were really rich. They had a nice home with a fenced yard and a car. Most important to me, Billy had a Shetland pony named Betsy. Billy and I would ride Betsy bareback up to the hill where the rich people lived. We would tie Betsy to a tree, and we would play all day with our friends. Our main entertainment was sliding down the hill on cardboard boxes. The mother of our rich friend, Jerry Cox, would occasionally invite us to lunch. We felt really accepted. We treasured their rich status because they had a piano.

My dad worked for Rock Island Railroad ever since he came to Little Rock at age 13. He was from Paducah, Kentucky, and his mother died when he was 3 years old. He had only gone to school to third grade then had to work in the tobacco fields. In 1936 he was making $286 a month.

I was 9 years old and I lived with my mother, father and younger sister in a small two-bedroom, one-bath frame house at 2519 Abigail Street. Bare floor, but it had linoleum in two rooms. Our heat was generated by a potbellied wood stove that stood in the middle of my

parents' bedroom. We couldn't afford to eat at school, so most of the time we walked home a mile or so for lunch. My mother cooked three meals a day so we had a hot meal for lunch.

Dad was a hunter, and growing up we ate everything that was edible from the woods: rabbit, turkey, deer, squirrel and quail. Hunting season meant little to my dad. He hunted in season or out of season. I can remember my teacher asking me one day after lunch what I had had and I told her chicken. When I went home, I told my mother and she said it was okay to tell her I had squirrel, as it was in season. I was afraid I would get my dad in trouble.

On rare occasions, we would save up until we had a dime and my sister and I would be allowed to walk a couple of miles to go to a movie on Saturday. We never knew what it was to go out to eat, go on vacation and go shopping for new clothes and shoes. I never knew where our clothes came from; they were not new, but we never asked. It was normal to have secondhand clothes. We didn't have birthday cakes and presents or go to doctors or dentists. If we got sick, our mother treated us. I can remember having a boil on my knee. Mother had made me go next door and pick some leaves off a vine. She squeezed the pulp from the leaves and put it on my knee and bandaged it. It cured it. We were fortunate we had no serious illnesses.

We never were afraid, doors were never locked and parents didn't worry about our playing outside after dark. The most fun was playing under the streetlight catching lightning bugs and making rings that would glow in the dark.

A WPA researcher (Dorothy West) took the A train to **the Apollo Theater** in New York's Harlem.

"Big, dark brown Porto Rico, who is part and parcel of amateur night, comes on stage with nothing covering his nakedness but a brassiere and panties and shoots twice at Coretta's feet."

———————◇———————

The Apollo Theater is full to overflowing. The boxes are filled with sightseeing whites led in tow by swaggering blacks. The floor is chocolate liberally sprinkled with white sauce. But the balconies belong to the hardworking, holidaying Negroes, and the jitterbug whites are intruders, and their surface excitement is silly compared to the earthy enjoyment of the Negroes.

It is 11 now. The house lights go up. The audience is restless and expectant. Somebody has brought a whistle that sounds like a wailing baby. The cry fills the theater and everybody laughs. The orchestra breaks into the theater's theme song. The curtain goes up. A WMCA announcer talks into a mike, explaining to his listeners that the three hundred and first broadcast of Amateur Hour at the Apollo is on the air. He signals to the audience and they obligingly applaud.

The emcee comes out of the wings. The audience knows him. He is Negro to his toes, but even Hitler would classify him as Aryan at first glance. He begins a steady patter of jive. When the audience is ready and mellow, he calls the first amateur out of the wings.

Willie comes out and, on his way to the mike, touches the Tree of Hope. For several years the original Tree of Hope stood in front of the Lafayette Theater on Seventh Avenue until the Commissioner of Parks tore it down. It was believed to bring good fortune to whatever actor touched it, and some say it was not Mr. Moses *[Robert Moses, superintendent of New York City parks.—Ed.]* who had it cut down, but the steady stream of down-and-out actors since the Depression who wore it out.

Willie sings "I Surrender Dear" in a pure Georgia accent. "I can' mak' mah way," he moans. The audience hears him out and claps kindly. He bows and starts for the wings. The emcee admonishes, "You got to boogie-woogie off the stage, Willie." He boogie-woogies off, which is as much a part of established ritual as touching the Tree of Hope.

Vanessa appears. She is black and the powder makes her look purple. She is altogether unprepossessing. She is the kind of singer who makes faces and regards a mike as an enemy to be wrestled with. The orchestra sobs out her song. "I cried for you, now it's your turn to cry over me." Vanessa is an old-time "coon-shouter." She wails and moans deep blue notes. The audience gives her their highest form of approval. They clap their hands in time with the music. She finishes to tumultuous applause and accepts their approval with proud self-confidence. To their wild delight, she flings her arms around the emcee and boogie-woogies off with him.

Ida comes out in a summer print to sing that beautiful lyric, "I Let a Song Go Out of My Heart," in a nasal, off-key whine. Samuel follows her. He is big and awkward, and his voice is very earnest as he promises, "I Won't Tell a Soul I Love You." They are both so inoffensive and sincere that the audience lets them off with light applause.

Coretta steps to the mike. Her first note is so awful that the emcee goes to the Tree of Hope and touches it for her. The audience lets her sing the first bar, then bursts into cat calls and derisive whistling. In a moment the familiar police siren is heard offstage, and big, dark brown Porto Rico, who is part and parcel of amateur night, comes on stage with nothing covering his nakedness but a brassiere and panties and shoots twice at Coretta's feet. She hurriedly retires to the wings with Porto Rico switching after her, brandishing his gun.

A clarinetist, a lean dark boy, pours out such sweetness in "Body and Soul" that somebody rises and shouts, "Peace, brother!" in heartfelt approval. Margaret follows with a sour note. She has chosen to sing "Old Folks," and her voice quavers so from stage fright, Porto Rico appears in a pink-and-blue ballet costume to run her off the stage.

David is next on the program. With mounting frenzy he sings the intensely pleading blues song "Rock It for Me." He clutches his knees, rolls his eyes, sings away from the mike and works himself up to a pitch of excitement that is only cooled by the appearance of Porto Rico in a red brassiere, an ankle-length red skirt and a picture hat. The audience goes wild.

Ida comes out. She is a lumpy girl in a salmon pink blouse. The good-looking emcee leads her to the mike and pats her shoulder encouragingly. She snuggles up to him, and a female onlooker audibly snorts, "She sure wants to be hugged." A male spectator shouts gleefully, "Give her something!" Ida sings the plaintive "My Reverie." Her accent is West Indian and her voice is so bad that for a minute you wonder if it's an act. Instantly there are whistles, boos and handclapping. The siren sounds off stage and Porto Rico rushes

on in an old-fashioned corset and a marabou-trimmed bed jacket. His shots leave her undisturbed. The audience tries to drown her out with louder applause and whistling. She holds to the mike and sings to the bitter end. It is Porto Rico who trots sheepishly after her when she walks unabashed from the stage.

James comes to the mike and is reminded by the audience to touch the Tree of Hope. He tries to start his song, but the audience will not let him. The emcee explains to him that the Tree of Hope is a sacred emblem. The boy doesn't care, and begins his song again. He has been in New York two days, and the emcee cracks that he's been in New York two days too long. The audience refuses to let the lad sing, and the emcee banishes him to the wings to think it over.

A slight, young girl in a crisp white blouse and neat black skirt comes to the mike to sing "A Tisket, a Tasket." She has lost her yellow-basket, and her listeners spontaneously inquire of her, "Was it red?" She shouts back dolefully, "No, no, no, no!" "Was it blue?" "No, it wasn't blue, either." They go on searching together.

A chastened James reappears and touches the Tree of Hope. A woman states with grim satisfaction, "He teched de tree dat time." He has tried to upset a precedent, and the audience is against him from the start. They boo and whistle immediately. Porto Rico in red flannels and a floppy red hat happily shoots him off the stage.

A high school girl in middy blouse, jumper and socks rocks "Froggy Bottom." She is the youngest thing yet, and it doesn't matter how she sings. The house rocks with her. She winds up triumphantly with a tap dance, and boogie-woogies confidently off the stage.

A frightened lad falls upon the mike. It is the only barrier between him and the murderous multitude. The emcee's encouragement falls on frozen ears. His voice starts down in his chest and stays there. The house roars for the kill, and Porto Rico, in a baby's bonnet and a little girl's party frock, finishes him off with dispatch.

A white man comes out of the wings, but nobody minds. They have got accustomed to occasional white performers at the Apollo. The emcee announces the song "That's Why"—he omits the next word, Darkies—"Were Born." He is a Negro emcee. He will not use the word "darky" in announcing a song a white man is to sing.

The white man begins to sing, "Someone had to plough the cotton, someone had to plant the corn, someone had to work while the white folks played, that's why darkies were born." The Negroes hiss and boo. The whites applaud vigorously. But the greater volume of hisses and boos drowns out the applause. The singer halts. The emcee steps to the house mike and raises his hand for quiet. He does not know what to say, and says ineffectually that the song was written to be sung and urges that the singer be allowed to continue. The man begins again, and on the instant is booed down. The emcee does not know what to do. They are on a sectional hook-up. The announcer has welcomed Boston and Philadelphia to the program during the station break. The studio officials, the listening audience, largely white, has heard a Negro audience booing a white man. It is obvious that in his confusion the emcee has forgotten what the song connotes. The Negroes are not booing the white man as such. They are booing him for his categorization of them. The song is not new. A few seasons ago they listened to it in silent resentment. Now they have learned to vocalize their bitterness. They cannot bear that a white man, as poor as themselves, should

so separate himself from their common fate and sing paternally for a price of their predestined lot to serve.

For the third time the man begins, and now all the fun that has gone before is forgotten. There is resentment in every heart. The white man will not save the situation by leaving the stage, and the emcee steps again to the house mike with an impassioned plea. The Negroes know this emcee. He is as white as any white man. Now it is ironic that he should be so fair, for the difference between him and the amateur is too undefined. The emcee spreads out his arms and begins, "My people—" He says without explanation that "his people" should be proud of the song. He begs "his people" to let the song be sung to show that they are ladies and gentlemen. He winds up with a last appeal to "his people" for fair-play. He looks for all the world like the plantation owner's yellow boy acting as buffer between the black and the big house. The whole house breaks into applause, and this time the scattered hisses are drowned out. The amateur begins and ends in triumph. He is the last contestant, and in the line-up immediately following, he is overwhelmingly voted first prize. More of the black man's blood money goes out of Harlem.

The show is over. The orchestra strikes up, "I think you're wonderful, I think you're grand." The audience files out. They are quiet and confused and sad. It is twelve on the dot. Six hours of sleep and then back to the Bronx or up and down an elevator shaft. Yessir, Mr. White Man, I work all day while you-all play. It's only fair. That's why darkies were born.

Henry Luce III, the son of Henry R. Luce, co-founder of Time, Inc., was publisher of Time and Fortune and is chairman of the Henry Luce Foundation.

"The most memorable news event of 1936 was not the abdication of King Edward VIII..."

◇

For me the most memorable news event of 1936 was not the abdication of King Edward VIII, Jesse Owens winning an Olympic gold medal, nor the Spanish Civil War, but the invasion of Ethiopia by Mussolini. This is because my mother, Lila, younger brother, Peter, and I were paying a summer visit to the Carlton Palmers in Connecticut near Fairfield, and my mother and Winthrop Palmer wrote a playlet about the emperor Haile Selassie of Ethiopia and his family. We then produced this dramatic work in the barn with all members of both families in the cast. Rosalind Palmer, who had attended my third birthday party and who is my oldest friend—whom I saw just the other day—played the Ethiopian princess and I played the prince.

Now, that is about all I recall from 1936.

David Pressman, as an aspiring actor, walked to Canada to find work in 1936.

"How stupid can you be, telling the immigration people that you are going to work. You should say you are going on a visit."

―――――――――◇―――――――――

After two years of rigorous training with people like Martha Graham and Sanford Meisner at the Neighborhood Playhouse School of the Theater, I graduated and found myself on the street looking for work. There was an offer of a job from the Toronto Theater of Action to teach acting at the summer school of 1936 at $5 a week and room and board with the families of the members of the group. It seemed like a wonderful, immediate opportunity. They sent me a bus ticket, and with $10 in my pocket, I was off.

In Buffalo at the Canadian border the customs inspector asked me where I'm going and why. I said, "To work." Without explanation, they turned me away. I couldn't go back to New York, I had no money, and I was terribly ashamed of this failure at my first job. I really thought that going to Canada was like going to any other city in the United States. Naive and determined, by midday I decided to try another border crossing, hoping they would be nice guys and let me through. The same thing happened, but they did say I needed a work permit. Frustrated, depressed, hungry, I tried a third time by walking across the bridge at Niagara Falls. At that crossing they had phone calls about me. And with a warning, they turned me away.

I found a room in Buffalo for $2 a week, and for five days lived on apples and lettuce. I had an address of one of my classmates from the theater school, Betty Wilson, whose father was the president of the Royal Bank of Canada. I wrote her for help and she wrote to her father, and at the end of the five days, as I lay in bed one morning, a letter was pushed into my room under the door. It was a request from Betty's father to the Immigration Service vouching for me.

When I got off the bus in Toronto, I was met by the president of the group that employed me, whose greeting to me was, "How stupid can you be, telling the immigration people that you are going to work. You should say you are going on a visit." I spent the summer teaching acting at the Toronto Theater of Action and I was thrilled and excited when they asked me to stay and direct their fall production of *Bury the Dead*, by Irwin Shaw, a very popular antiwar play of the '30s. I directed, designed the set, lit the show and did everything to get the play on for a salary of $10 a week. The production was a major success and we entered the Canadian Drama Festival competition. We won first prize in the Ontario region of the Canadian Festival. I stayed on in Toronto for two full years, directing, teaching, acting, lecturing, living and learning.

Sasha Pressman was a dancer in such musicals as *You Can't Sleep Here* (where she met her husband) and *Street Scene*. She taught at Boston University from 1954 to 1959, when her husband, David Pressman, was blacklisted from working in television. While David walked to Canada seeking work, unbeknownst to him, his future wife danced for a federally funded dance company.

"I said that I was 23 years old, born in San Francisco, and my birth certificate was destroyed in the big fire."

———————◇———————

I graduated Wadleigh High School in 1935 at the age of 17 and got on the Federal Theater Project in 1936. I had taken classes with Martha Graham, which I paid for by posing for Rafael Soyer Reginald Marsh and at the Art Students League. Rafael Soyer asked me if I would want a small painting instead of 75 cents an hour. I said I'd prefer the money.

In order to get a job on the Federal Theater, you first had to go on welfare—at that time it was called "home relief." I got on home relief with the help of a home relief investigator I knew. I said that I was 23 years old, born in San Francisco, and my birth certificate was destroyed in the big fire. I used my mother's maiden name, Spector.

My weekly salary was $23.86. On every Wednesday, payday, my dad would meet me and I would give him $10. I no longer lived at home. My parents were really broke at this time. They lost their last savings when the banks failed. Also, the little Russian restaurant that they had on 110th Street, where my mother did the cooking and baking and my father was the waiter, failed.

I danced first with the Federal Children's Theater. I was in a trio with Ailes Gilmore (Isamu Noguchi's sister) and Janet Schaff. The musical conductor was a very handsome white-haired man who in 1941 became my brother-in-law. The end of the year marked the beginning of the Federal Theater Dance Project. In 1937, I danced in Helen Tamiris' *How Long Brethren*, in which a large, wonderful black chorus sang spirituals. The performance ran for 10 weeks at the Adelphi Theater to full, enthusiastic audiences. No modern dance performance, before or since, has run on Broadway for such a long time.

Artie Shaw rode atop the craze for big bands and romantic pop music that distracted the young from the Depression blues.

"Who would have picked a tune as a hit possibility after the public had already heard it in a show and apparently been perfectly happy to never hear it again?"

————————◇————————

I n 1936 I signed a recording contract with RCA Victor (my contract with Brunswick Records had expired by then) and took my band into New York to make our first records on the then brand-new Bluebird label. The first tune we recorded was my own slam-bang arrangement of Rudolph Friml's old "Indian Love Call."

Everybody at RCA was sure it would be a hit. As it turned out, they were all wrong. "Indian Love Call" did have an enormous sale but that was because it happened to be on the other side of a tune by Cole Porter that had made a brief appearance on Broadway in *Jubilee*, one of Porter's rare flop shows. I had liked the tune, though, and insisted on recording it at this first session in spite of RCA's recording manager, Eli Oberstern, who felt it was a complete waste of time and only agreed when I insisted that it would make a nice, quiet contrast to "Indian Love Call."

When this "nice, quiet contrast" turned out to be what actually sold the record and made it a hit and finally one of the biggest instrumental hits ever recorded by an American dance band—well, naturally, everybody was surprised. Who would have picked a tune as

a hit possibility after the public had already heard it in a show and apparently been perfectly happy to never hear it again? How could anybody in his right mind expect to make a hit record out of a dead 108-bar-long tune with a weird title like "Begin the Beguine"?

[In a review panning Jubilee, *the critic for the* New York Times *found the only tune he liked was "the waltz, 'Begin the Beguine.'"—Ed.]*

Monica Lewis Lang

is an actress and was a soloist with the great Benny Goodman band.

"We drove to New York in our last vestige of royalty, a Pierce-Arrow..."

───────────◇───────────

We had moved from Chicago in 1933 after my dad went belly-up after being the head of WBBM Music, a CBS radio station. Now we were literally flat broke. We drove to New York in our last vestige of royalty, a Pierce-Arrow car, which looked in my little girl eyes like a hearse. Upon reaching New York, we sold the damn thing to find a small apartment and pay our rent.

My sister had to leave Northwestern University and my brother had to leave Chicago University, where they both held musical scholarships, to look for jobs in the big city. Mom hocked her jewelry, and I was sent to Public School 6, or 96, or some P.S. where I felt completely lost.

By 1936 I had adjusted and was attending Julia Richman High School for girls. My life was about school, family and listening to everyone's conversation. The talk, when not about our religion, which was simply MUSIC, was about the state of the world. My parents, having survived World War I and the Great Depression and being the artists they were, tried desperately to keep a happy tone around me. I was still the "baby" to all of them, and they saw how keenly I felt things and how frightened I was to sense that true horror was imminent.

When I was 12, I won a citywide contest for an essay titled "Why I Am an American." Fiorello LaGuardia, then mayor of New York, presented me with a certificate and $100. I guess I still feel, at the ripe old age of 78, that America is the last bright, shining hope of the world.

Red Buttons is a comedian, movie actor and bon vivant.

"'Don't get fresh or I'll kick your ass out of the office.' (Adults loved to kick kids in the ass in those days.)"

◇

It was a great year if you didn't care about eating. I wandered into the Strand Theatre building to see what kinds of jobs were open. The answers were uniform, amateur contestants, small-time vaudeville, small-time nightclubs, marathon dancers, variety show one-night stands, "Scratch House" burlesque (the bottom of the barrel, filthy theaters, thus the nickname "Scratch House"), burlesque comics and strippers, men's smokers (stags). The Strand Theatre building was for beginners, "has-beens and never-beens, the show business homeless where Solly Shaw reigned supreme." Solly sat behind his wooden desk surrounded by autographed eight-by-tens of Solly's favorite clients, the most prominent being Jackie Gleason.

Jackie was becoming a draw; young, attractive, quick-witted and unpredictable—all the ingredients an audience bought. Solly was a big-time, small-time booker—short, portly, immaculately dressed, a poker face the acts couldn't read, until his fickle finger of fate beckoned.

An eerie silence pervaded the office. The only sounds were Solly's two phones ringing and Solly making his deals. When the phones rang all eyes were on Solly. Upon hanging up, Solly wrote the assignment contract on a slip of paper, scanned the waiting room. Then he made his decision—"You," his finger said, pointing—

the command to advance through the wooden swinging gate, without a word spoken. Solly handed the act a slip of paper that contained information about the job—salary, report time, travel instructions, address, 10 percent commission to be delivered to Solly within 24 hours of completion of date. Solly worked in pantomime and carried a big stick—unemployment!

Solly gave me the finger. I froze for a moment, then followed his command to enter his inner sanctum. "What are you hanging around here for, kid?"

"I guess I'm looking for a job."

"You guess? You don't know?"

"I know I'm looking for a job."

"How old are you?"

"I'm 21."

"Stop the crap or I'll throw you out of the office."

"I'm 17."

"That's better. Why did you lie?"

"I don't know."

"You don't know? What do you know? What do you do?"

"I sing."

"You sing. What do you sing?"

"Songs."

"Don't get fresh or I'll kick your ass out of the office." (Adults loved to kick kids in the ass in those days, "the good old days.") "Name some songs."

"'Making Whoopee,' 'Please Don't Talk About Me When I'm Gone,' 'Just a Gigolo,' 'When Irish Eyes Are Smiling,' 'Sam, You Made the Pants Too Long.'"

"You do 'Sam, You Made the Pants Too Long'?"

"I do, Mr. Shaw."

"Where'd you get it?"

"In the mountains last summer. I worked on a social staff. The social director did it."

"Okay, kid, I got an amateur night for you. Tomorrow night. Loew's Boulevard in the Bronx. First prize, ten dollars. Second, five, third, three. Here's directions. There's no commission if you win. Good luck. I may be there."

Amateur night was a popular and thriving business during the Depression years. Almost every theater held one. Audiences liked the idea of maybe being in on a new discovery. They enjoyed the

sense of power entrusted in their judgment. They had been stripped of virtually everything else. In a small way this exercise returned to them a modicum of dignity that proclaimed, "I am somebody. I am important. I count." Solly supplied the amateurs.

That night I told my Clarmont Parkway buddies about Loew's Boulevard. About eight or ten showed up; not enough to beat out the two "cripples" who limped off with the ten and five. "Sam, You Made the Pants Too Long" finished third, three bucks was three bucks. Two for Mom. One for me. Solly didn't show. People in the audience laughed.

The next day after school I shot down to Solly's office and made myself visible in the milling throng. The "finger" beckoned me in.

"The manager said you were funny. You got a good show business name, Red Buttons. Where'd you get it?"

"It's a nickname I got working as a singing bellhop in Ryan's on City Island."

"What's your real name?"

"Aaron Chwatt."

"Spell it."

"Big A, little a, r, o, n. Big C, little h, w, a, double t, spells Chwatt."

"Keep Red Buttons!"

That summer I worked the Catskills, and sometime in early July a guy invited me to be his guest for a "joyride" at the local whorehouse located a few miles from the Lakeside Hotel. A big operation, about 20 girls working the "factory" run by the boys. What else? It was $5 a mount. I readily accepted the invitation and fantasized myself into a frenzy. It was my first time in the starting gate. I was losing it to commerce, not to love. I chose a small, delicate-looking young blonde, whom I felt sorry for immediately. She appeared vulnerable in her thin chemise and high-heeled shoes—nothing else, no time for undressing and dressing. Time was money, the customer arrived with his own imagination. We went off to a side room that had a bed, a chair, a bedpan containing water and soap and a rack to hang one's pants. She held my hand on the journey to this workshop and if you could blot out the surroundings, it could have been two childhood sweethearts on an evening stroll down lover's lane.

Once at the location she instructed me to remove my trousers and shorts. She then proceeded to wash and test for gonorrhea by squeezing my penis. I think I broke the record for premature ejaculation. She felt my embarrassment and said, "First time?"

I nodded. She kissed me on my forehead and asked, "Where are you staying?" I told her the Lakeside Hotel in South Fallsburg and why I was there.

"You're an entertainer?"

"Yes, I'm Red Buttons."

"Cute name. I'll be seeing you. I've got to go now."

We left the room, hand in hand. In a strange way I felt fulfilled. My patron asked me how it was. I said, "Great. I could do that all night!"

A few days later I was at the swimming pool when I heard a car horn honking and a female voice calling, "Red, Red Buttons."

Who could that be? As I approached the convertible, I couldn't believe my eyes. It's her. No, it can't be. Yes, it's her. (Holy smokes!) "How are you, baby?"

"What?"

"How are you?"

"Oh, fine." (Holy smokes!)

"What are you doing here?"

"Just drove by to say hi."

"No kidding. Thanks."

"Can I park my car and join you?"

"Sure." (Holy smokes!)

"So what do you do all day?"

"When we're not rehearsing, I hang around the pool and the grounds."

"Where do you do your shows?"

"In the casino. The social hall. You wanna see it?"

Hand in hand, we strolled into the casino, which was not in use at the time. I explained the theatrical bill of fare we presented for the summer and she surprised me when she went on stage and sang a chorus of a plaintive song, which was unfamiliar to me. It sounded Slavic, Polish. I couldn't make it out. At the finish, to my applause she took a low sweeping bow and let go a shrill shriek. I was perplexed by its intensity. She then beckoned me on stage. I complied.

"Where do you sleep?"

"Upstairs."

"Show me."

An hour later, after the most incredible human contact I've ever encountered, 18-year-old Ann from Scranton, Pennsylvania, dried her tears, which flowed rivers all during this indescribable experience. Whores, hookers, hustlers don't lip-kiss clients. She left my mouth numb with the ferocity of her kisses. I was mistaken. It wasn't commerce that inducted me into the delights of sex, it was the hunger for affection from an emotion-starved "white slave." It was love after all. I told her Mondays were the only days the casino was not in use. That summer I experienced a Monday kind of love. She took my virginity and I gave her what she needed—to get in touch with her feelings—in her line of work. A no-no. Monday, Labor Day, I went back to the Bronx and out of her life. Years later I played Scranton and looked for her in the audience. There were nights when I looked for her in the audience. Not a week I don't think of her after all these years.

A WPA interviewer talked with **Maude Cromwell, a high-wire performer** in the circus.

"The times we really did fall we didn't know anything was wrong...it feels just the same when it's an accident as when it's just part of the act..."

———◇———

I had nine falls and still lived. Then my husband and me fell 40 feet twice with Ringling. You know, before we went up we would examine our stuff very carefully. We won't let nobody do it for us. But the trouble is when you buy new parts or hooks, or somethin'; it looks perfect but somethin' is defected so you can't tell when you look the act over before you go up. We laid nine weeks in the hospital and it took one month before we were troupin'. Then we worked fairs and parks. And we done a couple shorts for the movies, like we wuz in *Glorifying the American Girl.*

Now we have a home in Long Island. We have flowers, we both loves flowers, and in the summer we have a trapeze in the backyard, and we go through our acts and keep in shape.

Would you like me to tell you somethin' about circus life? In the circus there's a dressin' tent and everybody has their own trunks. When you come down to the lot your trunk sets in that same place every day. We all have our two buckets for to wash in.

There are so many things people doesn't know, that people on the outside don't realize how circus people live. They think that circus people are just livin' in boxcars. If they wuz to go down to the

cars at night and see how their berths are like a stateroom, why it takes 12 yards of cretonne to cover a berth. And then you bring with you your little things personal to fix it up. Every berth has their little ice water tanks and little cabinets, which are made by a man in the circus. He sells them to the performers for $6 each. Every year he takes them back to winter quarters and puts their names on each tank and each cabinet and every year when the show opens again they will find this cabinet and tank in their berth in their cars.

Another thing, circus people all have box mattresses, costin' $8 to $10 each and sometime more. Also, the berths have electric inside from batteries that's in each car, and we have a privilege car, which is like a club car. As far as eatin', we eat on the lot, family style. But at night, say if you want a sandwich or a cup of tea, you make it up in your own berth in the cars. Everybody goes home in the winter when the show goes to winter quarters. Some has their homes in Sarasota and goes with the circus down there. Others just go here and there, everywhere. We meet at Madison Square Garden when the show opens again.

We do the longest breakaway in any double trapeze act alive. He holds me by the fingers like this and I swing high. I'm hangin' in my hooks; after the fourth swing, he swings loose from one finger and sends me out into the audience for a 40-foot drop. At the end of the drop I scream and it terrifies the audience, it gets them scared. They all think I'm fallin'. Then I run off and jump into the audience and with a great surprise, I run to the front, stand on the ring curb and make my bow, and at that moment the audience is in a gasp of laughter, thinkin' that I've fallen'. The times we really did fall we didn't know anything was wrong until it was all over, it feels just the same when it's an accident as when it's just part of the act, the fallin' I mean.

While mister and I wuz sittin' in the cook house on a Sunday, eatin' our dinner, the side wall wuz up and a lot of people on the outside wuz lookin' in, wonderin' how we eat and what we eat. One man spoke. "Oh, look, they eat with knife and forks." Have you got that? The way they have it in the cook house is actors on one side, sideshow people on the other side, freaks on the other side, cowboys, cowgirls on the other side. Then a partition in between the tents for the working people and they gits the same food as we git.

In the summer we hire a big bus and go out on picnics, swimmin', some golfin', on Sunday. Circus life isn't what people thinks it is. We jest sit around in between shows with our knittin' or sewin'.

The circus has their own doctors and own chief of police, and pressman and in case of an accident, they have their own "fixers" like a lawyer. Put down that in my times they didn't have no compensation but all the times I wuz with Ringling they took well care of me. And if I had to pick, I'd take circus any time, even though the circus pays only 175 and vaudeville 300, 'cause in a circus you get everything for you and when you get your pay it's clear and you kin save somethin'. But in vaudeville, you get, say, 300, and you have to pay your room and your meals, and handlin' of baggage, an' checkin' and everything extra like that and you ain't got a thing when you get to payday. See what I mean?

Lois Carroll worked as a Realtor for more than 35 years in Twentynine Palms, California.

"When the men tired of dancing they would pay the women to stop."

———————◇———————

That summer I was 11 and I went to visit my aunt and uncle who had an Indian trading post in Monument Valley, Utah. Every few years, the Navajo would hold what was then called a "Sing." It was in late summer, and there was a large gathering of Navajo who came from miles and miles around. Uncle Harry furnished yards of colorful material for the women and food and gifts for the others. There were dances where the men were picked by the women to dance—they sang and danced in a circle holding hands. When the men tired of dancing they would pay the women to stop.

I dressed as an Indian child in a multicolored skirt and a velvet blouse decorated with tiny silver buttons, along with child-sized replicas of grown-up silver and turquoise Navajo jewelry. I was the only fair-skinned and blue-eyed "Indian" child to be found. I loved helping with the work trading with the Indians at the post. My memories of the festivities are still quite vivid, especially what was called the squaw race. That summer old White Horse, the leader of the group at the Sing, encouraged me to compete.

I won two watermelons, and in thanks for his encouragement, I gave White Horse one of the melons. Later that day, he motioned for me to come to him and he pointed to the child-sized silver Indian bracelet on my wrist. Then he pointed to his beautiful old sandcast

bracelet, motioning that he wanted to trade. I didn't know what to do, so I asked my uncle Harry. He said that it would be rude for me not to trade, that if I didn't White Horse would lose face and that he needed to be given the opportunity to return my kindness.

I am in my 70s now and that sandcast Indian bracelet is still a prized possession.

Country amusements—rodeos—with cowboys and Indians competing. They were cheaper than going to the movies.

Maxine Crossley, retired now, worked in the garment industry for 40 years.

"Parents disciplined their children back then."

———————◇———————

I was 13 years old. I lived in a small town called Waterloo, Iowa. My parents, from Mississippi, moved north seeking a better life. My dad got a good job working for Illinois Central Railroad; my mother never worked. I was the youngest of five children. We were buying a nice home and the Depression came along and we lost everything.

The year 1936 was sort of a new beginning for me. My dad was hired at John Deere, where he stayed until he retired. I had just started junior high school. We either had to bring our lunch or walk home because we couldn't eat downtown. We had no problems at school. Parents disciplined their children back then.

Most of our activities centered on church. We went to the movies when we could get the money. Sometimes they would have nickel matinees. I remember when we got our first radio that sat on the floor. Whenever Joe Louis would fight, friends would come over and we would crowd around the radio and cheer. He was our hero. Sometimes late at night we would try to get Duke Ellington or Cab Calloway. We also had a Victrola.

I went on to finish high school and entered a training program provided by the government. It was called the NYA. There I learned to operate the power machine. I ended up also working in the garment industry. I made a good living making ladies' ready-to-wear.

Ira Skutch, a television producer and director, was with game show producer Mark Goodson and Bill Todman for 20 years and now writes fiction and edits nonfiction books. He recalls the vicissitudes of running a small business in hard times.

"It looks like ice cream, it tastes like ice cream, and by God, it is ice cream."

————◇————

My father, head of his own small law firm with offices at 40 Wall Street, counted among his clients the Joe Lowe Company, maker of Popsicles. The sherbetlike fruit ices—orange, cherry, lemon—were not only taste tingling but delightfully cooling in the sweltering heat of those pre-air-conditioning days.

Joe Lowe operated under a patent that had been granted in two parts, one covering confections on a stick, the other for ice cream on a stick. Since there appeared to be no way to keep ice cream from melting too quickly, Joe Lowe bought only the confection half. For just an additional $500, he could have purchased the entire patent.

In due time, the melting ice cream problem was solved when the Good Humor Company, which had snapped up the rest of the patent, coated their bar with chocolate. By the mid-1930s, they were greatly out-selling Popsicles, so Joe Lowe brought out its own version of ice-cream-on-a-stick, instantly giving rise to a patent infringement suit.

My father's main line of defense was that the Joe Lowe product was made with less than 3 percent butterfat, the generally recognized standard for ice cream. He prevailed, but the case was appealed and

re-appealed in various venues, some verdicts going one way, some the other.

The final trial was held in Baltimore, Maryland. The judge had the Popsicle bar brought into court and sat at the bench happily licking away. When he finished, he pronounced judgment:

"It looks like ice cream, it tastes like ice cream, and by God, it is ice cream."

The Joe Lowe Company continued in business for years afterward, but its glory days were over.

Josephine Williams
is a retired schoolteacher.
She recalls a disaster
now forgotten.

*"...50 people came and stayed
at our seven-room home.
That didn't include the many
others that just came to eat or
catch a few hours of sleep."*

◇

I n 1936 I was a 7½-year-old
living in Powhatan Point, Ohio,
population 2,000. The town
was on the banks of the Ohio River, and in the spring of that year it
overflowed and reached a height of 57 feet. The river completely
covered the main section of town. Parts of buildings, trees, sometimes
animals and numerous odd things could be seen rushing down the
river. The evangelist Billy Sunday had a tabernacle on Wheeling
Island, which was a little over 20 miles upriver, that was completely
flooded. My family lived in the high section of town. We could see
the roofs of smaller houses above the muddy waters. A two-story

house in the flooded area caught fire and nothing could be done but watch it burn to the water level.

A minimum of 50 people came and stayed at our seven-room home. That didn't include the many others that just came to eat or catch a few hours of sleep. I can remember someone sleeping behind our upright piano, and when he or she got up another person would quickly take that place. A grocer stored part of his inventory in our basement. He was generous enough to donate food for the crowd. I think there was even some furniture stored. My mother made soup and spaghetti in large tubs on our coal-burning stove. People would come in and help themselves and Mom would keep cooking. My 16-year-old brother was busy rowing around the town in a rowboat with his buddies, looking for adventure. The radio was playing music and reporting news about the flood. People talked and laughed and even danced at times. I think that lasted a little over two to three weeks.

People slowly went back to their homes to shovel mud from their water-soaked houses and began the task of making their places livable. The most negative thing I remember was a family of four with two spoiled rotten children, not leaving, but staying and behaving as if they were paying guests in a hotel. The mother as well as the brats never offered to help in any way. My mother would not allow us to be rude. I don't know how my mother finally got rid of them, but I know we all celebrated when they left.

When school finally opened we walked to school on dusty sidewalks with mud piled on the sides. The flood marks were visible on the walls of our school. I believe that 1936 flood was one of the worst, if not the worst, floods in Ohio Valley history.

Elden Auker pitched 10 years in the major leagues with the Detroit Tigers, Boston Red Sox and St. Louis Browns. He helped the Tigers win the pennant in 1934 in the fourth game of the World Series and led the American League in winning percentage in 1935 with an 18–7 record.

"It was club policy that we dress in a suit or jacket with a shirt and tie, at all times, both ballpark or hotels."

———————◇———————

I was pitching baseball for the Detroit Tigers. We had won the American League pennant and beat the Chicago Cubs in the World Series reported on March 1, 1936, to spring training in Lakeland, Florida. Mrs. Auker and I went to Lakeland right after Christmas and spent the rest of the winter playing golf and fishing. A group of other major league players spent the winter in Florida. We used to play together every day. Some of the other players were Mickey Cochrane, Tommy Bridges, Gerald Walker, Paul Waner, Babe Ruth, "Dizzy" Dean, Wes Ferrell and others.

During the baseball season we played the other seven teams in the league, each 22 games at home and 22 on the road. We traveled by train, called "The Tiger Special." It was made up of two Pullman cars (all lower berths), one baggage car and a dining car. Attached to our section was the sportswriters, or press, section. One or two Pullman cars, club car and their own dining car. The "Special" had no regular schedule; it only ran when the team was ready to go to another city or back to Detroit. While on the road, we stayed in the best hotels with the very best accommodations. It was club policy that we dress in a suit or jacket with a shirt and tie, at all times, both ballpark or hotels. On the road, we had a curfew or a rule to be in

our rooms by 11:00 p.m., unless we had special permission to be elsewhere by the manager. Consumption of alcohol was limited mostly to a beer after the game. Illegal drugs were unheard of. All the players were first-class gentlemen. All but a couple were happily married with very beautiful wives and some with children. We were like one family. We worked together, played together and traveled together. We were world champions and conducted ourselves as such. We had thousands of wonderful fans in Michigan that filled the stadium almost every day. They loved us and we appreciated their support. Baseball has changed and I am now 90 years of age. I am grateful to have been a part of the Tiger tradition.

Forrest Ackerman is 81, a legendary character in the world of science fiction films and publishing.

"She said breathlessly, 'Oh, Forry, I've told a little white lie to get myself a part in a picture: I've said I can speak Polynesian!'"

◇

I f memory serves me correctly, it was around 1936 that I saw Jon Hall's first film, *The Hurricane,* co-starring Dorothy Lamour. Now I live in his 18-room home in Griffith Park, Hollywood, which I have converted into what *Smithsonian* magazine has called "one of the 10 most interesting museums in America"–300,000 items of science fiction and fantasy (pulps, posters, movie props, paintings, 50,000 books, imagi-movies).

I was a charter member of Chapter No. 4 of the Los Angeles Science Fiction League, still functioning today as the Los Angeles Science Fantasy Society after 3,000 weekly meetings, of which I've attended half. We made the Broadway Clifton's Cafeteria famous by holding weekly meetings there. At Clifton's we pioneering sci-fi fans first became acquainted with legendary Martian Chronicler Ray Bradbury.

Clifton's featured a free lime punch, as I recall, and all-you-can-eat lime sherbet for a nickel; schoolboys like Bradbury and Bruce Yerke made meals of crackers and freebies and are both still alive, thanks to Mr. Clifton's generosity. A good-hearted boozy old broad (she wouldn't have objected to the description), Lucie B. Shepherd, was the proprietress of a little hole-in-the-wall secondhand book, magazine and movie photo shop in the middle of the block on the

south side of Hollywood Boulevard, west of Western, that I frequented. She had a bulbous red nose that would have been the envy of W.C. Fields and, like Cab Calloway's Minnie the Moocher, a heart as big as a whale.

One night as I approached her cash register she was engaged in conversation with a dynamic young man with a shock of hair rivaling her schnozzola. He was telling her how he had just established a world record for gliding (going highest? longest time in the air? traveling greatest distance?) and also was telling her about having stories in western, mystery, romance, foreign legion and other pulps. I was waiting to hear the magic words "science fiction" but when Lafayette Ron Hubbard (the founder of Scientology) didn't utter them, I mentioned them and he was off and running on the spur of the moment: "Well, 35,000 years from now Southern California could have another ice age and…!" I eventually became his science fiction literary agent and was so at the time of his death.

In the April 1930 issue of *Science Wonder Stories* I read a story by Francis Flagg titled "Adventure in Time." In his story he had mentioned that in the future the citizens of the world would be speaking Esperanto. Esperanto? That was the first I'd heard of it, and I thought it was simply a made-up name like "vizigraph," "mentanical," "The Necronomicon," etc. It was one of the longest days of my life when, in 1935, *mia avo* (my grandfather) read me a *notizo* (notice) in the newspaper that a *kurso* (course) in the *universala lingvo* (universal language) Esperanto would be taught that *nokto* (night) in a nearby university! In the days when I could still run (I now have a pacemaker after half a dozen heart attacks on the way to my 50th birthday), I ran six or eight blocks to L.A. City College to sit in the center seat, first row.

Quixotically, to me it was like time travel, to hear the language of the 21st century and bring it back in my memory to 1935. In 1987, the hundredth anniversary of the creation of Esperanto by Dr. Zamenhof of Poland, I was in *Varsovio* (Warsaw) for one week among *sep mil* (7,000) people from *sesdek* (60) countries...and we could all talk to each other!

On one occasion when I was varityping the *Players Directory* for the Academy of Motion Picture Arts and Sciences, I received a phone call from a girlfriend, the only eschatologist I ever knew (I would have preferred an ecdysiast). She said breathlessly, "Oh, Forry, I've told a little white lie to get myself a part in a picture: I've said I can speak Polynesian! But I know they wouldn't know the difference if I said it in Esperanto, so help me out!" I lived to hear my two words of Esperanto come from the lips of Jan Rader being mistaken for Hedy Lamarr in *Lady of the Tropics*. If you're still alive, Jan, please contact me! English will do...

At San Diego in 1933 they had a nationwide fair. The first night, I broke away from my family to solo. A teenager with genes in turmoil, I ignored scores of other attractions and beelined it straight for a sideshow that advertised a naked lady. The promise was fulfilled to my ever-grateful satisfaction. Across a gulf of 65 years, after love, death, earthquakes, awards, international sites (the Eiffel Tower, Moscow's Hermitage, the Yangtze River, the Blue Danube, the White Russian Ballet, the tulips display of Holland, Jules Verne's tomb, Mary Shelley's tomb, the tomb of Napoleon, the *Queen Mary*, the Empire State Building, the Great Buddha, the Arc de Triomphe, the Champs-Elysées, the Forbidden City, the Bouchard Floral Gardens, the Great Wall of China, the Hollywood Bowl, Victoria Falls, the Louvre, Liechtenstein, Rio de Janeiro, the City of 2,000,

Gerry de la Ree's science fiction collection, the Imperial Fountain Gardens of Russia, the Folies Bergére, Ziegfeld and Earl Carroll nudes and *Playboy* pinups), I still treasure my first glimpse of feminine nudity. About 20 feet away from us viewers was a bed in which a young girl lay. She rose languorously and approached the window separating us and stood there for my awed gaze: 100 percent nude, fully frontal, complete with the dark triangular curly hirsute adornment intended by Nature. I never saw a more pulchritudinous vision in my life. If by any chance that great-great-grandmother is still alive and reads these words, please contact me: in appreciation I want to send you a bouquet of red roses to match my blushing cheeks that enchanted evening.

Where is the Damifino bar (pardon my French) of yesteryear and my favorite cookies, the hard nutty calaroxes? Can you still get a soft drink called Green River? How about a Delaware Punch? For a short period there was a craze for a wax bar in the triangular shape of a harmonica. You could play a tune on it–"The Music Goes Down and Around"–and eventually chew it when you got tired of playing it.

Alas for the lost road to yesterday and the youthful pleasures of 60 years ago.

WOMEN'S LIVES

A resident of Harlem
was interviewed by a
WPA writer.

*"They'd catch some sucker,
like a Pullman porter or
longshoreman who had been
lucky in a game, and have
him jim-clean before the night
was over."*

———————◇———————

When I first came to New York from Bermuda, I thought rent parties were disgraceful. I couldn't understand how any self-respecting person could bear them, but when my husband, who was a Pullman porter, ran off and left me with a $60-a-month apartment on my hands and no job, I soon learned, like everyone else, to rent my rooms out an' throw these Saturday get-togethers. I had two roomers, a colored boy and white girl named Leroy and Hazel, who first gave me the idea. They offered to run the parties for me if we'd split 50-50.

We bought corn liquor by the gallon and sold it for 50 cents in a small (cream) pitcher. Leroy also ran a poker and blackjack game in the little bedroom off the kitchen. An' on these two games alone, I've seen him take in as much as $28 in one night. Well, you can see why I didn't want to give it up, once we had started. Especially since I could only make $6 or $7 at the most as a weekly part-time worker (domestic). The games paid us both so well, in fact, that we soon made gambling our specialty. Everybody liked it, and our profit was more that way so our place soon became the hangout of all those party-goers who liked to mix a little gambling with their drinking

and dancing. An' with all these young studs out to find a little
mischief, with plenty of cash in their pockets, we soon learned
not to leave things to chance.

Hazel and I would go out an' get acquainted with good-looking
young fellows that we'd see sitting alone in the back of gin-mills
looking as if they had nobody to take them out but that they also
would like a good time. We'd give them our cards and tell them to
drop around to the house.

Well, wherever there are pretty women you'll soon have a pack
of men. And so, we taught the girls how to wheedle free drinks and
food out of the men—and if they got them to spend more than usual,
we'd give them a little percentage or a nice little present like a pair of
stockings or vanity case or something. Most of the time, though, we
didn't have to give them a thing. They were all out looking for a
little fun, and when they came to our house they could have it for
nothing instead of going to the gin-mills where they'd have to pay
for their own drinks.

And we rented rooms, sometimes overnight and sometimes for
just a little while during the party. I have to admit that, at first, I was
a little shocked at the utter boldness of it, but Leroy and Hazel
seemed to think nothing of it, so I let it go. Besides, it meant extra
money—and extra money was what I needed.

I soon took another hint from Hazel and made even more. I used
to notice that Leroy would bring some of his friends home with him
and, after they'd have a few drinks, leave them alone in the room
with Hazel. I wasn't quite sure that what I was thinking was so until
Hazel told me herself. It happened one day when an extra man came

along and there was no one to take care of him. Hazel buzzed to me and asked me if I would do it. I thought about it for awhile, then made up my mind to do it. Well, that was the last of days-work (domestic work) for me.

I figured that I was a fool to go out and break my back scrubbing floors, washing, ironing and cooking when I could earn three days' pay, or more, in 15 minutes. From then on, it was strictly a business with me. I decided that if it was as easy as that, it was the life for me.

The landlord's agent had been making sweet speeches to me for a long time and I began to figure out how I could get around paying the rent. Well, I got around it, but that didn't stop me from giving rent parties. Everything I made then was gravy; clean, clear profit for little Bernice. I even broke off with Leroy and Hazel. She began to get jealous and catty, and I think he was holding out on profits from the game. Anyway, we split up and I got an "old man" (sweetheart) of my own to help me run the house. An' when he took things over he even stopped the girls from going into the rooms with the men, unless they were working for us. That is, unless we were getting half of what they made. Still, the men had to pay for the rooms.

I've seen some of those girls who made enough on Saturday night to buy themselves an entirely new outfit for Sunday, including a fur coat. They'd catch some sucker, like a Pullman porter or longshoreman who had been lucky in a game, and have him jim-clean before the night was over. Naturally, I got my cut.

It was a good racket while it lasted, but it's shot to pieces now.

Constance Crawford
is a writer of fiction and
memoirs who lives in
Palo Alto, California.

*"Alone in the forest at
twilight, I lay on my back
in the snow, and an eerie
sensation came to me...the
whole round planet was
at my back and I was
one with it."*

———————◇———————

My father, who had married late, was a telephone man. In 1936 he was working as a telephone switchboard installer and technician, a troubleshooter. He had kept his job through the Depression, and the hard times—which he understood, having grown up poor— actually gave him the opportunity to begin investing in the stock market, which interested, inspired and profited him for the rest of his life.

He was an avid lover of mountain wilderness, and he introduced my mother to camping and fishing expeditions early in their marriage. They bought a lot at Lake Arrowhead in the San Bernardino Mountains, which was then quite a remote area. In spring and summer of 1936, the Arrowhead house was under construction.

We were to move into the new house in the fall of 1936, in time for me to start first grade in the small mountain school. My aesthetically gifted mother was the chief overseer in the building of the Arrowhead house. I remember that my father was proud of her

for going to the lumberyard to choose cedar and pine paneling, board by board. She and the stonemason, a poignantly lonely Italian workman with few teeth and fewer words of English, somehow communicated well; every year or so for a long time afterward he would show up, greet my mother shyly and smile at the beautiful walls and chimney he had made for her. The chief carpenter, a pale Swede, lived in a tiny trailer on the building site; he invited me inside to see a similarly pale, old-fashioned wax doll he had hanging on the wall. That strange, creepy interior showed me that all people did not live as my family lived. My mother's subsequent reserve toward the Swedish carpenter had an edge to it that I did not understand.

I have long wondered about my parents' original intent for the Arrowhead house—vacation place or permanent residence? It was a good, handsome house, much more substantial and carefully finished than the ordinary vacation cottage. But how did they discuss the move, what did each expect? How did they decide that the mountain house would be a year-round home? Mother told me that she did not like life in small-town Pomona and needed the more natural surroundings in the mountains. All well and good, but my father kept his telephone company job in Pomona, too far in those days for a daily commute. Instead of joining us for ordinary weekends, he chose to take four days off every two weeks. During the workweek I think he lived in an apartment or perhaps at the house of friends. Strange that I have no memory of visiting the place where he stayed "down the hill," as we mountain people denigrated all places of lower elevation.

We moved up the mountain early in the fall of 1936, just after my sixth birthday. The new life began. For the first winter—one of exceptionally deep and thrilling snows—we slept under open rafters

in the unfinished upstairs, but we each had a hot-water bottle and a down comforter. I already loved the lake, the wildness, the freedom of the place, but how did it strike me, the realization that my father would only be home "four days every two weeks"? I remember accepting this phrase—it was what the grownups had decided and so it was a given, a fact I never sought to question. I have little memory of what I felt about this new arrangement. I do remember hearing Daddy's car arrive on the magical every other Thursday afternoon, remember running out and throwing myself into his arms. I never doubted that my mother could and would take good care of us in our new, more remote home—but my father was my pal, the sharer of projects, the giver of piggyback rides, the teller of stories, the teacher of rowing and swimming and the tying of knots, the taker of pictures, the caller of nicknames, the enjoyer of food, the digger of snow, the giver of warm, solid hugs.

I didn't know how my father felt about this separation from his wife and children. It was only years later that he said to me, "I don't want you to think that this is the way people should live."

I entered first grade at the Arrowhead public school in the village. We had three grades to a room. For a while I was sick in the mornings, terrified of the new place, the new kids. But the sheriff's wife, Mrs. Honey, was my teacher, and I grew to love her. I remember how suddenly reading dawned on me, drawing with colored chalks and learning to write not only my first name but my last, which seemed a great advance in the knowledge of the world.

Once, alone in the forest at twilight, I lay on my back in the snow, and an eerie sensation came to me that I have never forgotten: the whole round planet was at my back and I was one with it.

Except, except…that a shadow, the absence of my father, lay over the family, absence not by his own wish, but because of my mother's unhappiness. It was my parents' partial marital separation that I experienced, however unconsciously, in 1936.

"Girls' lives were very different from the boys'."

Alice Harnell is a retired real estate agent and bank loan officer, and wife of jazz musician Joe Harnell.

My father was a pharmacist and my mother a housewife. My mother's father had been born in Poland and her mother in Germany, so as a first-generation American (she was born in New York), she was very conscious of not appearing or sounding "foreign." "People won't take what you say seriously if you talk with a Bronx accent." So when I was 6, I had elocution lessons, as well as dramatic lessons at the YWHA. I also "took" ballet and tap. ("Let's hear those taps, girls. You should sound like Ruby Keeler!")

Girls' lives were very different from the boys'. While the boys were out in the street playing stickball and Johnny-on-the-pony, we would play with our cardboard dolls of Alice Faye and Betty Grable with their beautiful cut-out paper gowns, or play jacks or pick-up-sticks. I was an only child, which I relished, and was the envy of my friends who had siblings they had to share their things with. Our skates were metal and screwed on to our shoes with a key. We carried our skate keys on strings around our necks. I loved to read and got my first library card when I was 6. I would skate to the library and hook the skates over my shoulder while I looked through the stacks to decide which ones of the treasures I would borrow for two weeks. The smell of the library paste and book bindings was heaven.

We lived on 161st and Walton Avenue in the Bronx, across the street from Joyce Kilmer Park, very near the Bronx County Courthouse and Yankee Stadium. We could see the games at the stadium from our apartment house roof. The tenants would bring up folding chairs and binoculars to see the Yankees play. In summer the black tar roof would get hot and sticky under our feet, and the boys would take chunks of the soft tar to chew.

Saturday mornings I heard my radio favorites, *Let's Pretend* followed by *Grand Central Station*. When I listened to *The Aldrich Family*, there in our fourth-floor apartment with our windows looking out on the windows of the red brick building next door, more than anything in the world I wanted to live in Centerville, in a house with a yard and trees and flowers. I tried repeatedly and unsuccessfully to grow marigolds from seeds in a wooden cheese box, but all that sprouted were a few scraggly weeds.

In my child's mind some things were absolutes. FDR would always be president, Joe Louis would always be the heavyweight champ and the New York Yankees would always win the World Series. And my parents would always be together. But as a grown-up, I learned that nothing is for always.

A WPA writer gets an earful about **women and cards** from Mr. and Mrs. R of the Bronx.

Mrs. R: "If they wouldn't have to see their husbands they would play all the time." Mr. R: "Sure—they got to see their husbands to collect the pay."

◇

Mrs. R: "If they wouldn't have to see their husbands they would play all the time." Mr. R: "Sure—they got to see their husbands to collect the pay."

Three-room apartment on street floor, modestly but well furnished. Neighborhood on an adjoining Grand Concourse, the Bronx. All Yiddish population. Middle-class psychology with slightly lower-than-middle-class incomes. Highest rents on Concourse, three rooms $45 to $60. Many little businesses set up in ground floor apartments spot this section. These are usually millinery shops, corset shops, beauty parlors, dress shops, one or two fur dealers, etc. Two cafeterias and a few restaurants. Baby carriages everywhere, particularly in front of the Automat around noontime. Two movie houses, well attended. Political life is majority New Deal Democrat. A good second is American Labor Party. Communist Party runs third, Republican fourth and Socialist fifth. Political corner is at 170th St. and Walton Ave. Here are held all the street meetings and here congregate the sidewalk philosophers and tacticians. Other points of unorganized get-togethers are the candy stores, where the unemployed pass the time playing pinball games and gabbing. The two pool rooms are high-class joints offering Ping-Pong, ladies

invited. This is not a heavy drinking section. The Depression is not evident as a coloring factor to the casual observer. It is not considered good taste to be on relief. You can sit at any table in the Automat and hear an animated discussion concerning the numbers or last night's game. The small-time gangsters, number runners, race track followers and the seven or eight, well, prostitutes, gather nightly in the Belmore Cafeteria, which stays open all night.

The neighborhood as it is now is an outgrowth of the postwar exodus of the Jewish population from the East Side to the Bronx. Before the Depression it was considered populated by upper-middle-class Jews with incomes ranging from five to fifteen thousand. Those who survived the crash gradually moved down to West End Ave. and Riverside Drive when the rents began to go down and people of a lower income level began to move in. The Concourse is a sort of doctor's alley. Every house has its ground floor occupied by at least one doctor. The talk is best described by saying that in accent and inflection it is a shade or two more American than Arthur Kober's caricatured Jews. As people, however, Odets has probably come closer than anyone in getting them down in his plays *Awake and Sing* and *Paradise Lost.*

Mrs. R is a lively, stout woman around 50 years of age. She is a businesswoman; prefers not to have mentioned which business. Mr. R is a thin man of around 50. Retired laundry man for reasons of health. Assists wife in her business doing odd jobs. Has a yen for any kind of machine. The kitchen has every kind of modern gadget.

(Interview started with Mrs. R. Mr. R was in the same room laboriously pounding out addresses from Mrs. R's customer mailing list. They were sending out the customary Jewish New Year greetings.)

Mrs. R: The lights went out all over and you should see. The boys broke all the trees on the Concourse. I was here working. They bothered all the girls in the street. It was dark. They thought they had a chance now. R went to a card party. I'll bet he had fun when the lights went out. What did you do when the lights went out, Mr. R?

Mr. R: (laughing secretively) What do you think I did?

Mrs. R: That's what he says. He didn't do nothing.

Mr. R: (still teasing) That's what you think.

Collector to Mrs. R: I'm interested in the card games, etc. etc.— (Mr. R looks up interestedly from his typing, is about to say something but Mrs. R beats him to the punch.)

Mrs. R: The women and the cards. What do you want to know? About the kitty houses or the traveling games. But you shouldn't give my name if I tell you. My customers, some of them run kitty houses. How would it come out if they saw my name telling all their business? The kitty houses are the real ones. Traveling games you know a bunch of women, they play in each other's houses. A kitty house is already a regular business. A kitty house is where the woman where they play, she don't play. She gives food and service and charges admission. Yes, poker. Women in the afternoons, men in the evenings. Regular furniture. Two, three tables, ten to a table. I go sometimes, sometimes for business and sometimes frankly I'll tell you for pleasure, but I don't like to win money. I like better to lose a little bit and enjoy myself. R is already different. He has got to win. Otherwise it is very bad. I don't like when people get so excited and angry over a game. R goes all the time. He has a cousin. She runs a

small kitty house. You got to be recommended. Sure they're afraid. But mostly they shmear here and there. Sure, you know, a little shmear. I suppose the cop gets his and he don't bother them. They have a chain on the door with a hole. They look you over first. Mr. R he knows just how it works.

Mr. R: Listen, you know what it means, a "kitty." When you play they put money from every deal in the kitty.

Mrs. R: If they wouldn't have to see their husbands they would play all the time.

Mr. R: Sure—they got to see their husbands to collect the pay. Some houses they play all the time anyway. Listen. This is a true story. One man gave his wife $250 to buy a fur coat. She was after him for that fur coat for a long time. So I suppose he got tired from being annoyed and he gave her the money. Anyway, she goes out with women what play already a big game, a dollar and two, in a club they used to have here over the Automat. And I suppose these women, they talk it into her, you know, if she wins more money she'll be able to buy a better coat. So she goes to the club and she gets wiped out, every cent. You know how it is. Every woman got an enemy. So I suppose one goes to the husband and tells him. You can imagine. He called the police and they had to close the club up on account of that.

Mrs. R: And a good thing, too. A regular gambling place. You could lose everything there.

Mr. R: Where I play by my cousin, is not like that. A poor woman. She makes a few dollars. Some places after two o'clock you

pay for electric again. Some play until 4 and 5 in the morning. They pull down the shades. They have a fight once in a while. In a fight one woman called another woman a name. You know.

Mrs. R: Not a nice name. Well–(laughing)–a whore, like you would say. So the other one says, I am an open book. But you, you are the one. You have a husband and you–at least everybody knows about me.

Mr. R: Yes, they talk numbers, too. Most of the women play the numbers. Well, my cousin, she makes maybe $30 or $40 a week. And you want to know something, most of the men, they need a woman they can get them in a kitty house. They're not professionals in these houses, amateurs. They need the money to play. I'll tell you something. The women are even bigger crooks than the men. Look at this. (Mr. R showed me a feature article in the Yiddish paper *The Day*. The article was captioned, "The women of New York alone gamble away over six hundred million dollars a year.") Read that if you think the kitty houses is something. Read that about the horses.

Doris Haddock, "Granny D," is a persistent advocate for social justice, walking 3,200 miles across America in 1999 in an effort to draw attention to the need for campaign finance reform. In 1936 she briefly worked as an interviewer for the WPA.

"…he was spending more of his time revisiting the few women he had sold appliances to than with any new customers."

⸺⸺⸺⸺◇⸺⸺⸺⸺

I was 26 years old, married with two children, a girl 3 years old and a boy aged 1 year. We had moved the previous year to Nashua, New Hampshire, which was then a very modest small town and nothing like the Nashua of today—a sprawling, burgeoning city. My husband worked for the Public Service Company of New Hampshire. We set up housekeeping with a few pieces of furniture, surplus stuff from my folks and some things from a secondhand furniture store. I remember when a young man who was in my husband's class at Amherst dropped in to visit, looking tanned and rich and not working yet. I was embarrassed and ashamed of our apartment—it was sooooo bare.

My husband, Jim, was not built to be a salesman and he was making heavy work of it. In fact, as far as I could see, he was spending more of his time revisiting the few women he had sold appliances to than with any new customers.

I looked for a way to work. The WPA project for writing the history of every town of every state was advertising for help, and I found a baby-sitter and went to work on the writing project. However, the baby-sitter turned out to be very mean to the

children, so my husband and I agreed it was not a time for me to be working.

So I managed to make his $25 a week do—making the children's clothes and mine, and eating very little meat and things like Jell-O for dessert. We owed for our college and we would save out $4 to $2 for mine and $2 for Jim's to pay on account. Jim studied electrical engineering at night and in a couple of years he shifted from trying to sell appliances to working as a load forecaster, running the system. He had managed to buy our first car ($25) a beat-up, old secondhand Chevrolet, and with transportation he was able to drive down nights to classes at Lowell Tech to round out what he had been able to teach himself from books.

I was in a local mom-and-pop store one day and a small radio was playing. We all stood transfixed when the announcer said Edward VIII was coming on. We heard him say, "I can no longer serve as your king without the woman I love"—or some such. A customer said breathlessly, her hands clasped bosom high, "Just think, she and I are exactly the same age. It could have been me!"

DAILY DIARY

Glenn T. Seaborg, a nuclear chemist, Nobel Prize winner, prime contributor to the Manhattan Project (which produced the first atomic bomb) and later chancellor of the University of California, Berkeley, 1958–1961, was a second-year graduate student in chemistry at Berkeley in 1936. He was dependent on a teaching assistant's job that paid $50 a month.

"I walked the streets of Berkeley for hours, alternately exhilarated by the beauty of the discovery, despairing over my lack of insight and intrigued by the import of this exciting new fission reaction."

———————◇———————

It is difficult to describe the exciting, glamorous atmosphere that existed at the University of California at Berkeley. It was as if I were living in a sort of world of magic with continual stimulation.

On Tuesday, November 10, 1936, it was my turn to speak at the Research Conference. I described the very interesting work in Germany by Otto Hahn, Lise Meitner and Fritz Strassmann on the so-called transuranium elements. They claimed to have found, following neutron bombardment of uranium (atomic number 92), isotopes of the "transuranium" elements with atomic numbers 93, 94, 95 and 96. They used the tracer technique to study the chemical properties and, in my talk, I emphasized these properties of these remarkable elements, on which I considered myself a minor expert.

Then, at the Journal Club meeting in the Department of Physics on a Monday night late in January 1939, my mastery of the "field" vanished in a moment. The information had come through by word

of mouth that Hahn and Strassmann in Germany had identified some of the radioactivities as isotopes of barium and lanthanum, and that what actually happened upon the bombardment of uranium with neutrons was the splitting of the uranium nucleus into two approximately equal-sized fragments, with the release of a large amount of nuclear energy. The nuclear scientists had been looking at fission products, not transuranium elements.

I cannot possibly describe either the excitement that this produced in me or the chagrin I felt in realizing that I had failed to interpret correctly the wealth of information that I had studied so assiduously for a number of years. After the seminar was over I walked the streets of Berkeley for hours, alternately exhilarated by the beauty of the discovery, despairing over my lack of insight and intrigued by the import of this exciting new fission reaction.

I entered almost by accident the mainstream of my career as a nuclear scientist. One day in April 1936, I was suddenly confronted by Jack Livingood, a physicist who was favored by ready access to the 27-inch cyclotron. He literally handed me a "hot" target, just bombarded by the machine, and asked me to process it chemically to identify the radioisotopes that had been produced. Naturally, I jumped at the chance. The facility he offered in Le Conte Hall was hardly luxurious. The resources consisted of tap water, a sink, a fume hood and a small workbench. With some essential materials bootlegged from the Department of Chemistry, I performed the chemical separation to Jack's satisfaction. In the course of my collaboration with Livingood, covering a period of five years, we discovered a number of radioisotopes that proved useful for biological explorations and medical applications.

Iodine-131 has given me special satisfaction. On one occasion during this period, in 1938, the late Dr. Joseph G. Hamilton, one of the outstanding nuclear medical pioneers, mentioned to me the limitations on his studies of thyroid metabolism imposed by the short lifetime of the radioactive iodine tracer that was available. He was working with iodine-12, which has a half-life of only 25 minutes. He inquired about the possibility of finding another iodine isotope with a longer half-life that would last long enough in the body to do its work but decay fast enough to leave the patient essentially unharmed. I asked him what value would be best for his work. He replied, "About a week." Soon after that, Jack Livingood and I synthesized and identified iodine-131, with a half-life, luckily enough, of eight days. This isotope came to be widely used for the diagnosis and treatment of thyroid disease. I have the added satisfaction that my own mother had her life extended by many years as the result of treatment with iodine-131. President George H.W. Bush and First Lady Barbara Bush both were successfully treated for Graves' disease, a thyroid disease, with iodine-131. Radioactive iodine treatment is so successful that it has virtually replaced thyroid surgery.

My experience as a radioisotope hunter led eventually to the transuranium elements (including plutonium), a nuclear field that was to become my lifework, including the move to Chicago in 1942 to work on the Plutonium Project to produce the atomic bomb.

I now add some of my experiences outside the laboratory in the 1936 era.

On January 1, 1936, I, along with my parents and sister, Jeanette, attended the Rose Parade in Pasadena, California. Later in the day, I listened on the radio to the Rose Bowl game,

in which Stanford University defeated Southern Methodist by a score of 7 to 0.

On Monday, March 9, 1936, I saw this headline in the morning paper: ARMIES FACE EACH OTHER ON THE RHINE.

On Tuesday, March 10, 1936, I noted in my journal, I suffered from a severe migraine headache, probably caused by an allergic reaction to something I ate at Berkeley's Drakes Restaurant the preceding Sunday.

On Saturday night, March 20, 1936, I went dancing with my girlfriend, Christine Haselden, in the Rose Room of the Palace Hotel in San Francisco, traveling by ferry boat.

On June 6, 1936, the newspaper reported: CHINESE TROOPS MOVE TO BATTLE JAPANESE AS CANTON DECLARES WAR.

On Saturday, June 20, 1936, a sports story described the defeat of Joe Louis by Max Schmeling in the 12th round.

On Monday, July 13, 1936, a headline read: HITLER, MUSSOLINI IN NEW GROUP, HEAD ALLIANCE TO CONTROL CENTRAL EUROPE.

On Sunday, September 20, 1936, I played a round of golf with my UCLA classmate Stanley Thompson at the Chabot Golf Course. I shot 106 for 18 holes—a tough course!

On Tuesday, November 3, 1936, I voted (my first year of voter eligibility) for Franklin D. Roosevelt for president of the United States.

On November 12, 1936, the San Francisco–Oakland Bay Bridge officially opened. President Roosevelt opened the bridge by pressing the telegraph key with which President Taft had opened the Alaska-Yukon Exposition, President Wilson the Panama Canal and President Roosevelt the Boulder Dam (now Hoover Dam).

On Thursday, November 19, 1936, I read the following headline: FRANCO RECOGNIZED! ITALY, NAZIS BACK REBELS.

On Sunday, November 29, 1936, I read the first issue (November 23) of the new magazine LIFE, which I found fascinating because of the fantastic number of photographs. The first article described the work-relief project in Montana and the issue included truly human-interest photographs by Margaret Bourke-White.

On Thursday, December 10, 1936, I read the headline in the *San Francisco Chronicle*: EDWARD VIII ABDICATING TODAY; KING TRADES THRONE FOR LOVE; CABINET NOTIFIED OF DECISION.

During 1936 I attended, with my girlfriend Christine Haselden, movies on a weekly basis, usually on Friday evenings. These included, on Friday, January 24, 1936, *The Big Broadcast of 1936*, starring George Burns and Gracie Allen; Friday, February 7, *The Last Days of Pompeii*, starring Preston Foster and Basil Rathbone; February 14, *Ah Wilderness!*, starring Wallace Beery and Lionel Barrymore; February 28, *Collegiate*, starring Joe Penner and Jack Oakie; March 6, *Rose of the Rancho*, starring John Boles and Gladys Swarthout; March 20, *The Story of Louis Pasteur*, starring Paul Muni and Josephine Hutchinson; March 27, *Thanks a Million*, starring Dick Powell, Ann Dvorak and Fred Allen; May 1, *Klondike Annie*, starring Victor McLaglen and Mae West; May 16, *Small Town Girl*, starring Janet

Gaynor and Robert Taylor; May 22, *Magnificent Obsession*, starring Irene Dunne and Robert Taylor; June 5, *Anything Goes*, starring Bing Crosby and Ethel Merman; June 12, *A Message to Garcia*, starring Wallace Beery and Barbara Stanwyck; June 26, *The Great Ziegfeld*, starring William Powell, Myrna Loy and Luise Rainer; July 10, *Little Lord Fauntleroy*, starring C. Aubrey Smith and Freddie Bartholomew; July 24, *A Connecticut Yankee*, starring Will Rogers and Myrna Loy; July 31, *San Francisco*, starring Clark Gable, Jeanette MacDonald and Spencer Tracy; September 3, *Modern Times*, starring Charlie Chaplin and Paulette Goddard; September 18, *Captain January*, starring Shirley Temple and Guy Kibbee; September 25, *Poor Little Rich Girl*, starring Shirley Temple and Alice Faye; October 9, *Of Human Bondage*, starring Leslie Howard and Bette Davis; October 16, *Ramona*, starring Loretta Young and Don Ameche; October 23, *Mary of Scotland*, starring Katharine Hepburn and Fredric March; October 30, *Dimples*, starring Shirley Temple and Frank Morgan; November 6, *A Tale of Two Cities*, starring Ronald Colman; November 13, *China Clipper*, starring Pat O'Brien and Beverly Roberts; November 20, *A Midsummer Night's Dream*, starring Jimmy Cagney, Joe E. Brown and Hugh Herbert; December 11, *My Man Godfrey*, starring William Powell and Carole Lombard.

Thus 1936 was a very eventful year.

Alvin Sargent is the Academy Award-winning screenwriter of *Julia* and *Ordinary People*.

"Should I forget living in this modern age and return to 1936, when I was a comfortable, neurotic 9-year-old..."

————————◇————————

Should I forget living in this modern age and return to 1936, when I was a comfortable, neurotic 9-year-old who knew that America would forever be beautiful and girls were something for my brother and his friends, although I was in love with Dr. Sharpless' wife, who was blond and prettier than a magazine cover and her husband was handsome and she got pregnant, which was a dirty word, and I knew how she got that way but never let on and she got big and I secretly waited for the baby. Her baby died and she and Dr. Sharpless moved away and the king of England was doing something with a mean-looking woman, or should I join in the human race and try to understand words like "download" and "Steadicam"?

POSTSCRIPT

Stanley Sheinbaum and I are the editors and part authors of this anthology, but Mamie Mitchell, our co-editor, is the principal collector and communicator. She shares equally the credit and the blame; we are forever grateful she was available and willing to undertake a task that began impulsively three years ago and turned into full-time work. Larry Sloan and Leonard Stern, who saw in our concept something personally challenging and valuable, invested their actual money to research and publish this book. Their faith and enthusiasm pulled us through. To Betty Sheinbaum, our sharpest critic, thanks for reading and evaluating submissions with your unique mix of tact and savagery. And to our contributors, our thanks and salute as brothers and sisters.

Frank Pierson

PHOTOGRAPHY/ART CREDITS